FROM HARDANGER TO HARLEYS
A SURVEY OF WISCONSIN FOLK ART

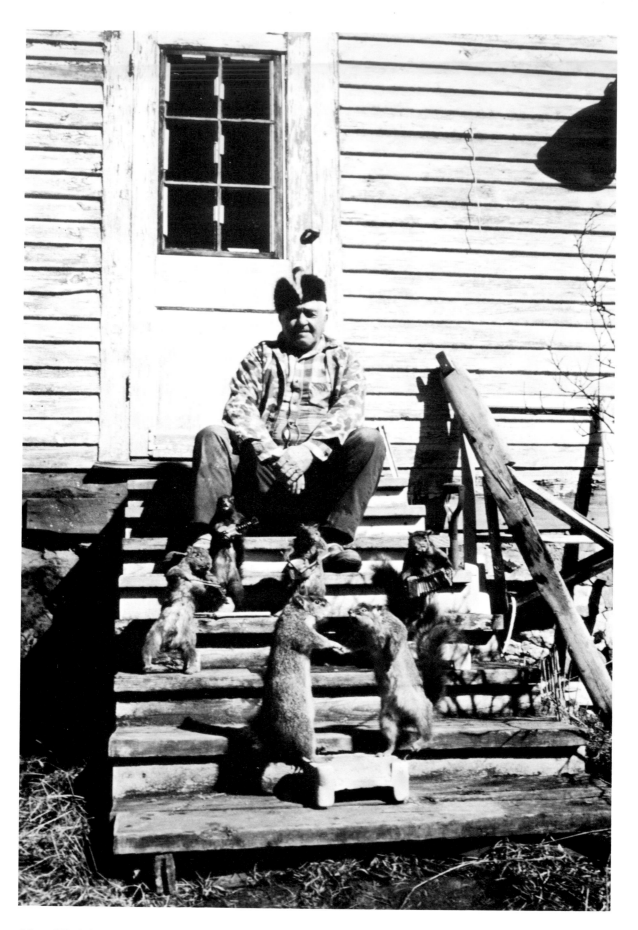

Edward Henkelman sits on the steps of his home with his squirrel band and dancers.

FROM HARDANGER TO HARLEYS
A SURVEY OF WISCONSIN FOLK ART

John Michael Kohler Arts Center
Sheboygan, Wisconsin

EXHIBITION TOUR

John Michael Kohler Arts Center
Sheboygan, Wisconsin
8 March – 17 May 1987

State Historical Museum
Madison, Wisconsin
6 June – 30 August 1987

Milwaukee Public Museum
Milwaukee, Wisconsin
31 October 1987 – 10 January 1988

LIBRARY OF CONGRESS CATALOGING-IN-PUBLICATION DATA
From Hardanger to Harleys.

Catalog of the exhibition organized by the John Michael Kohler Arts Center, held Mar. 8-May 17, 1987.

Bibliography: pp. 107, 108.

1. Folk art — Wisconsin — History — 20th century — Exhibitions. I. John Michael Kohler Arts Center.

NK835.W6F76 1987 745′.09775′074017569 87-3117 ISBN 0-932718-20-5

Published on the occasion of an exhibition organized by and at the John Michael Kohler Arts Center, 608 New York Avenue, Sheboygan, Wisconsin, 8 March–17 May 1987. Supported in part by grants from the National Endowment for the Arts and the Wisconsin Arts Board.

A portion of the Arts Center's general operating funds for this fiscal year has been made available through a grant from the Institute of Museum Services, a federal agency that offers operating and program support to the nation's arts centers and museums.

Printed in the United States of America.

TABLE OF CONTENTS

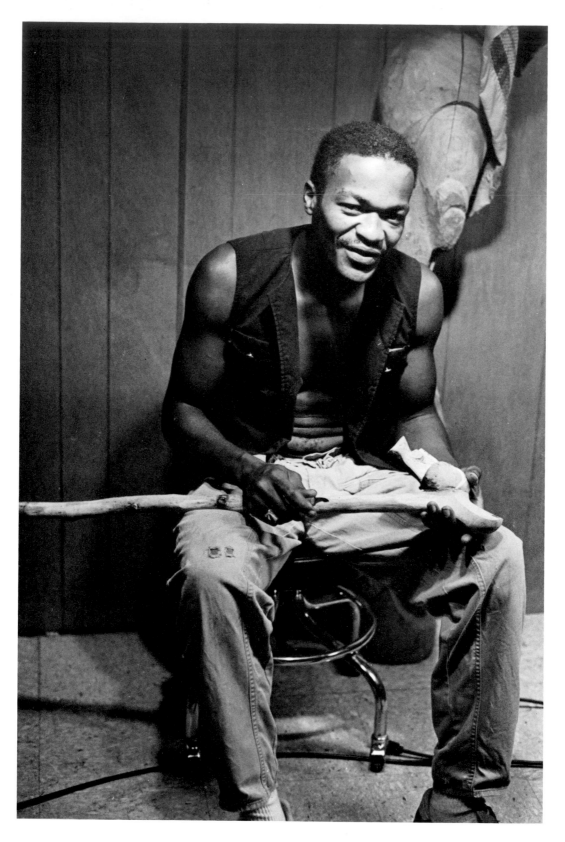

Clifford Bell carves a walking cane in the Afro-American tradition.

PREFACE AND ACKNOWLEDGEMENTS

FROM HARDANGER TO HARLEYS: A SURVEY OF WISCONSIN FOLK ART celebrates the beauty, complexity, and vitality of the many traditional arts· currently being practiced by ethnic, regional, occupational, and religious communities throughout the state. The exhibition encompasses both long-established traditional arts, like Norwegian Hardanger needlework, and folk art forms of more recent vintage, like customized versions of Wisconsin's own Harley-Davidson motorcycles.

The first major traveling exhibition of contemporary Wisconsin folk art, FROM HARDANGER TO HARLEYS is based upon a systematic one-year field survey of traditional arts and artists. Beginning in October 1985, two professional folklorists, Janet C. Gilmore and James P. Leary, spent twelve months traveling throughout Wisconsin, interviewing traditional artists and photographing their work. In the course of their research, they documented over two hundred artists from fifty counties and thirty-five ethnic groups. They amassed nearly five thousand color slides and six hundred black-and-white photographs which now form a special collection within the Resource Center of the John Michael Kohler Arts Center. These slides, photographs, and field interview summaries are available to artists, scholars, ethnic groups, and community organizations for research at the Arts Center.

During the course of the yearlong field survey of Wisconsin folk arts and artists, a series of regional presentations was offered at five sites throughout the state. The State Historical Society of Wisconsin in Madison, the Marathon County Historical Museum in Wausau, the Barron County Historical Society in Rice Lake, the Milwaukee Public Museum in Milwaukee, and the John Michael Kohler Arts Center in Sheboygan hosted programs between February and November 1986. Intended to share the results of the field survey with members of the communities which were documented and with other interested audiences, each presentation included a slide-lecture by field researchers Leary and Gilmore, a musical performance by one or more traditional artists from the particular region, and a demonstration of traditional crafts, also by regional artists. The performances ranged from Norwegian piano accordion music to Austrian schrammel guitar and vocal music. The demonstrations encompassed crafts as varied as Menominee beadwork and Mexican-American piñatas. Together they exemplified the remarkable diversity of ethnic tradition still being actively practiced in Wisconsin.

The exhibition FROM HARDANGER TO HARLEYS: A SURVEY OF WISCONSIN FOLK ART consists of approximately two hundred seventy objects by seventy-five of the contemporary folk artists documented in the field survey. As such, it is a cross section of the folk arts currently being created throughout the state and demonstrates the significant role which the traditional arts play in the lives of many individuals throughout Wisconsin. The exhibition suggests the ways in which artifacts extending from quilts to fish decoys and eagle feather dance

bustles come to represent the heritage, values, and structure of their communities. And it maintains that Wisconsin's folk arts are vital symbols of traditional patterns of living, patterns simple and straightforward or intricate and involved.

A wide variety of programming was developed in conjunction with the exhibition while it was on display at the John Michael Kohler Arts Center. The opening day celebration alone involved an enormous array: demonstration/discussions devoted to the carving of balls-in-cages by Adolph Vandertie and Norwegian costumes, embroidery, and Hardanger lace by Oljanna Cunneen; performances of Austrian and Bavarian zither music by Elfrieda Haese and Heidi Schlei, German button accordion music and schuhplattler dance by the Hacker-Mueller family, black gospel music by Barry Ward and "The Voices," and Norwegian storytelling by Oljanna Cunneen; and delectable foods of the local German, Greek, Hispanic, and Hmong communities.

Shortly after opening day Gloria Ahooska spent four days in residence at the Arts Center, telling Winnebago tribal stories and providing her audiences of children and adults with a glimpse into tribal history. In doing so she clearly illustrated the importance of storytelling in passing on traditions from generation to generation. In addition, she showed and discussed baskets and costumes made by four generations of Winnebago craftspersons. Betty Pisio Christenson conducted a fascinating Ukrainian egg decorating workshop, and a performing arts series included the Sarajevo ensemble in two concerts of Yugoslavian tamburitza music, the Jerry Schneider Orchestra in two concerts of "good old-time" German music, the Puerto Rican trio Andando Solo in a concert of traditional Caribbean music, and Gerald Hawpetoss performing traditional Menominee Indian songs and dances.

From the John Michael Kohler Arts Center, FROM HARDANGER TO HARLEYS will travel on to the State Historical Museum in Madison and the Milwaukee Public Museum. There, too, their staffs and volunteers are planning a variety of interpretive and educational programming to enhance the exhibition.

FROM HARDANGER TO HARLEYS calls upon all Wisconsin residents to consider the ways in which familial, ethnic, religious, and occupational traditions affect their daily lives. And it reminds us all of the enormous contributions which the state's folk artists have made to conserving and creating our cultural heritage.

The encouragement, support, and cooperation of many individuals and organizations have been crucial to the development and realization of the exhibition FROM HARDANGER TO HARLEYS: A SURVEY OF WISCONSIN FOLK ART and its associated publications and programming. The Board of Directors and staff of the John Michael Kohler Arts Center gratefully acknowledge the generous financial assistance provided in support of the Wisconsin folk arts survey and resulting exhibition by the National Endowment for the Arts, the Wisconsin Arts Board, and numerous corporate and individual contributors.

We also express our sincere appreciation to the more than two hundred artists who participated in the field survey, including the seventy-five artists who generously loaned examples of their work for the exhibition. They graciously shared their time and expertise:

John Allen, Madison
Sylvia Anderson, Stoughton
Tim Anderson, Madison
Mary Arganian, Madison
Ivan Bambic, Milwaukee
Merrill Bartels, Mikana
Robert Becker, Rice Lake
Clifford Bell, Milwaukee
Earleen Bellard, Milwaukee
Ove Bergerson, Hixton
Anton Beringer, Poy Sippi
Else Bigton, Barronett
LeRoy Blom, Blair
Bruce Bollerud, Madison
Ella Schrock Borntreger, Cashton
Joseph Borntreger, Cashton
Herbert Bothe, Onalaska
Epaminontas Bourantas, Milwaukee
Helen Wieczorek Boyer, Stevens Point
Harold Breitenbach, Alma Center
Will Brewer, Madison
Tom Brousseau, Monona
Terry Bruce, Milwaukee
Milton Bruni, Iron Ridge
Peter Buch, Milwaukee
Joseph Buresh, Luxemburg
Ben Chosa, Lac Du Flambeau
Betty Pisio Christenson, Neenah
George Clark, Cameron
Charles Connors, Madison
Marilyn Cooper, Madison
Terry Cross, Madison
Allie M. Crumble, Milwaukee
Oljanna Cunneen, Blue Mounds
Pascalena Galle Dahl, Mineral Point
Richard Dantuma, Randolph
Willie G. Davidson, Milwaukee
Alice Davis, Milwaukee
Bertha Davis, Milwaukee
Marvin DeFoe, Bayfield
Russell Devroy, Suamico
Richard Dieckhoff, Fall River
John H. Diehl, Ferryville
James J. Drewek, Wausau
Robert Egan, Monona
George Ellefson, Washington Island
Lee Emery, Madison
Maxine Engstrom, Washington Island
Stefan Eusch, Milwaukee
Maria Fafendyk, Sheboygan
Patrick M. Farrell, Green Bay
John R. Feavel, Neenah
Mary Fellenz, Loyal
Clara Feuling, Sun Prairie
Leonard Finseth, Mondovi
Jannie Foster, Milwaukee
Juan Franco, Milwaukee
Matt Fuchs, Brookfield
Georgianna Whitewing Funmaker, Wittenberg
Jo Marie Galinsky, Brookfield
Sol Gause, Milwaukee
John Genz, Sauk City
Milton Geyer, Green Bay
John Giacalone, Amherst
Tamer Givens, Milwaukee
Alexander Gokee, Bayfield
Margaret Greengrass, DeForest
Bernice Gross, Hillsboro
Paul Grossenbacher, New Glarus
Eli Gruber, Milwaukee
Karl Hacker, Sr., Menomonee Falls
Elfrieda Haese, Colgate
Edith Hakamaa, Ironwood, MI
Eino Hakamaa, Ironwood, MI
Alvina Hammann, Watertown
Gerald Hawpetoss, Keshena

Richard L. Hazaert, DePere
Edward Henkelman, Merrill
John Henkelman, Merrill
Inga Hermansen, Racine
Alvin J. Herschberger, Westby
Emma Herschberger, Westby
Jacob Herschberger, Westby
John Herschberger, Westby
Naomi Schrock Herschberger, Ontario
Dennis Hickey, Baileys Harbor
Charles Hoff, Stoughton
Rozona Hooker, Milwaukee
Fielding Lowry Huesmann, Waunakee
Phillip Iturbide, Madison
Rudolph Jackson, Blair
Svend Jacobson, Rice Lake
Agnes Grube Jensen, Monona
John Jerovetz, Luxemburg
Mary Jerovetz, Luxemburg
Tom Johanik, Ashland
Bernard Johnson, Richland Center
Glenn E. Johnson, Prairie du Chien
Jesse "Curly" Johnson, Watertown
Vita Kakulis, Bayside
William Kangas, Iron River
Leonilda Kelly, Cashton
Elizabeth Keosian, Milwaukee
Branislav Kevich, Grafton
Ewald Klein, Barron
Ryszarda Klim, Milwaukee
Albert Kolberg, Howards Grove
Robert Kolitz, Beaver Dam
Miriam Koskela, Tripoli
William Koskela, Tripoli
Victoria Kreiziger, Watertown
Sophia Kubinski, Madison
Ethel Kvalheim, Stoughton
Albert Larsen, Milwaukee
Sidonka Wadina Lee, Lyons
Stephanie Lemke, Mazomanie
Bruce LePage, Belleville
Ching-Ho Leu, Madison
John Lewan, Lublin
Patricia Llamas, Madison
Rosa Llanas, Waukesha
Tumika Love, Milwaukee
Felicia Lowe, Milwaukee
Hugo Maki, Washburn
Herbert Mansfield, Weyerhaeuser
Thomas Marincel, Ashland
Paul Marx, Madison
Robert Mathiowetz, Ashland
Edmunds Mednis, Warrens
Mara Mednis, Warrens
Vera Mednis, Warrens
Howard Meitner, Lowell
Rosemary Menard, Eau Claire
Berta Alicia Mendez, Waukesha
Maria Mercado, Milwaukee
Felix Milanowski, Ashland
Richard Miller, Madison
Nikola Milunovich, Milwaukee
Karl Minnig, Mt. Horeb
Clarence Mirk, Wauwatosa
Art Moe, Stone Lake
Mike Montano, Bayfield
Mary Montez, Waukesha
Frances Morschauser, Sun Prairie
William H. Mosby, Milwaukee
Albert Mueller, West Allis
Alexandra Nahirniak, Waunakee
William Nahirniak, Waunakee
Lauretta Neubauer, Sparta
Herbert Neuenschwander, Hustisford
Elsie Niemi, Dane
Doug North, Madison

John Norton, Green Lake
Phillip Odden, Barronett
Hortensia Ojeda, Waukesha
Eino Okkonen, Herbster
Stephanie Olig, Shorewood
Julian Orlandini, Milwaukee
Dorothy H. Pauls, Lone Rock
George Perkins, Madison
Emil Pirkel, Watertown
Kenneth Platz, Watertown
Ronald L. Poast, Oregon
Rose Pokrzywa, Milwaukee
Ray Polarski, Three Lakes
Agnes Poler, Crandon
Sr. Mary Crucifix Polimeni, Milwaukee
Anselm ''Andy'' Polso, Hurley
Simcha Prombaum, La Crosse
Edward B. Reinerio, Pence
Herman Reiser, Cameron
Delbert Richardson, Madison
C. C. Richelieu, Oregon
Rich Riemenschneider, Oconomowoc
John Ritchie, Wisconsin Rapids
Leslie Rondau, DePere
Michael Rudy, New Glarus
Samuel Rust, Rice Lake
Heidi Haese Schlei, Colgate
William Schlueter, Watertown
Romie Schmidt, Rice Lake
Dan Schmitt, Beaver Dam
Lovina Schmucker, Medford
Jerry Schneider, Chilton
Rita Scholz, Grafton
Velma Seales, Milwaukee
Bernice Seaman, Thorp
Harvey Seaman, Thorp

Robert Siegal, Jr., Mequon
Henry Sillman, Waterloo
Leona Smith, Oneida
Sheila Smith, Green Bay
Selma Spaanem, Mt. Horeb
Ronald Steinberger, Woodruff
Ray Steiner, Argyle
Duane Stenroos, Hurley
Eugene Stenroos, Hurley
Alvin Stockstad, Stoughton
Sigvart Terland, Frederic
Elisabeth Till, Cumberland
John Till, Cumberland
Ola Tyshynsky, Shorewood
Ulanna Tyshynsky, Shorewood
Alma Upesleja, Milwaukee
Adolph Vandertie, Green Bay
Jacob Varnes, Ridgeland
Myrtle Lee Varnes, Ridgeland
Anna Vejins, Greenfield
Carl Vogt, Madison
Nick Vukusich, Milwaukee
Kathryn L. Ward, Milwaukee
Jeff Weborg, Ellison Bay
Genevieve Weum, Madison
Ethel Storm Whitewing-Weso, Wittenberg
K. Wendell Whitford, Cottage Grove
Anna Wigchers, Rice Lake
Thomas Winter, Oshkosh
Florian Wisniewski, Wausau
Anton Wolfe, Stevens Point
Shoua Chang Yang, Sheboygan
Song Yang, Sheboygan
Martha Yoder, Amherst
Richard Young, Manitowoc
Dorothy Zakrzewicz, Thorp

In addition to the artists themselves, the Arts Center wishes to thank those organizations and individuals who lent works of art to be included in this exhibition:

Gloria Ahooska, Wittenberg
Harley-Davidson, Inc., Milwaukee
David Hodge, Oshkosh

Richard A. Ledet, Des Moines, IA
Hannah and Edward Pickett, Shorewood
Red Cliff Buffalo Art Center, Bayfield

Countless individuals and institutions provided assistance of various kinds during the course of the Wisconsin folk art survey and in conjunction with this exhibition. Folklorists Janet C. Gilmore and James P. Leary worked to document Wisconsin's contemporary folk artists. The State Historical Society of Wisconsin, the Marathon County Historical Museum, the Barron County Historical Society, and the Milwaukee Public Museum hosted the regional presentations discussed above. The staff and volunteers of the State Historical Museum and the Milwaukee Public Museum worked diligently to present the exhibition on tour. Many undertook tasks ranging from donating food and beverages for the opening celebration to mounting needlework on panels:

Linda Anderson, Lake Bluff, Illinois
Sister Marie Andre, Sheboygan
Branch Cheese Co., Branch
Marjorie Brandl, Sheboygan
Edith Campbell, Milwaukee
William Crowley, administrator, David Mandel,
 exhibitions coordinator, Anne F. Woodhouse,
 curator of decorative arts, and James Sefcik,
 development officer, State Historical Museum,
 Madison
D.A.N.K. Organization, Sheboygan
Clyde Fessler, director of trademark licensing,
 Harley-Davidson Motor Co., Milwaukee
Folklore Village Farm, Dodgeville

Friends of the Hispanic Community, Milwaukee
Cheryl Fritsch, Sheboygan
Ken Gebhart, St. Nazianz
John Green, Kohler
Elfrieda Haese and Heidi Schlei, Colgate
Steven Harrison, Sheboygan
Hmong Mutual Assistance Association, Sheboygan
Ann Marie Jacobson, Sheboygan
Barbara Jaeger, Sheboygan
Johnsonville Sausage, Inc., Sheboygan Falls
Kohler Co., Kohler
Kohler Foundation, Inc., Kohler
Marie and Greg Lee, Sheboygan
Carolynn Lisberg, Sheboygan

Scott Luchterhand, Sheboygan
Richard March, folk arts coordinator, Wisconsin Arts
 Board, Madison
Phil Martin, Mount Horeb
Members of the Greek Community, Sheboygan
Members of the Hispanic Community, Sheboygan
Members of the Hmong Community, Sheboygan
Christel Miske, Sheboygan
Jim Morgan, Sheboygan
Old Wisconsin Sausage Co., Sheboygan
Eleanor and Howard Olson, Viroqua
Alfred Pach III, Madison
Jim Passmore, Sheboygan
Rev. Donald Peters, Sheboygan
Poth Meats, Inc., Sheboygan
Elfriede Radke, Sheboygan
Susan Roy, Sheboygan
St. Clement Parish, Sheboygan
Robert Salzwedel, Kohler
Thomas S. Schleif, director, Marathon County
 Historical Museum, Wausau
Sheboygan Area School District, Sheboygan

Ken Shibilski, Stevens Point
Jerry and Roxanne Shimek, Kellnersville
Martha Spiller, Oostburg
Kenneth Starr, director, Lee G. Tishler, special
 exhibitions coordinator, and Lori Meisinger, adult
 education coordinator, Milwaukee Public Museum,
 Milwaukee
Ralph C. Stayer, Sheboygan Falls
Stevens Point Brewery, Stevens Point
Andrew Taylor, Milwaukee
Linda Tiboris, Sheboygan
Mary Vinson, Sheboygan
WHBL Radio, Sheboygan
Lee Wendt, Kohler
Paulette Werger, Madison
Wisconsin Folk Museum, Mount Horeb
Wisconsin Folklore-Folklife Society, Stevens Point
Wisconsin Indian Craft Traditions Project, Logan
 Museum of Anthropology, Beloit College, Beloit
Mayva and Song Yang, Sheboygan
Kevin Zimmermann, Sheboygan

As always, the Arts Center has been blessed with the generous assistance of volunteers who contributed their time, energy, and extraordinary skills to interpreting the exhibition FROM HARDANGER TO HARLEYS for school groups and other visitors. Without the assistance of these dedicated docents, the impact of the exhibition could never have been as great:

Dorothea Brukardt, Sheboygan
Anne Buchen, Sheboygan
Judy Conger, Sheboygan
Marie Felzo, Sheboygan
Eileen Hocevar, Sheboygan
Ann Howell, Sheboygan
Peggy Jones, Sheboygan

Rinda McLain, Sheboygan
Lois Pauls, Sheboygan
Lorene Rackow, Sheboygan
Janet Ross, Sheboygan
Susan Roy, Sheboygan
Jean Swenson, Cleveland
Heather Teske, Kohler

Finally, the dedication and diligence of the Arts Center staff must be recognized. Throughout the two years of preparation prior to the exhibition and the eighteen-month tour, nearly every member of the staff worked on the project. Among those most involved was Associate Curator of Exhibitions Robert Teske who coordinated the folk art survey and accompanying regional presentations and organized the exhibition FROM HARDANGER TO HARLEYS. Curator of Exhibitions Joanne Cubbs assisted in the review of field survey data, advised on the conceptual basis of the exhibition and on the selection of objects, and edited written materials. Registrar Larry Donoval arranged the shipping, insurance, and installation of objects for the exhibition, tasks complicated in at least one instance by Wisconsin's winter weather. He and Physical Plant Supervisor Roger Krueger, Technical Coordinator Eric Johnson, and Technicians Ron Krepsky and Steve Serketich carried out the complex construction and installation of the exhibition.

Associate Curator of Performing Arts and Education Jean Lorrigan Puls coordinated the performance series, storytelling residency, and opening day celebration with the assistance of Performing Arts Administrator Deborah Pankey Stewart. Publicity Administrator Juli Leet carefully orchestrated media coverage of all events, and Resource Center Coordinator Eric Dean furnished photographic documentation. Publications Designer Rex Wickland designed this book as well as the related publications. Assistant to the Director Sara Bong assisted in the preparation and dissemination of promotional materials, and Signature Gallery Coordinator/Education Assistant Gayle Ziegler coordinated a small sales exhibition of Wisconsin traditional arts.

Manager-Administrative Services Mary Jo Ballschmider helped in raising funds for the project through her administration of the corporate fund drive. Accountant Sally Bohenstengel carefully administered the project budget, and Administrative Assistant Nancy Dummer meticulously proofread the copy for this book, labels, wall statements, and more. Word Processing Supervisor Dorothy Hellauer and Secretary/Receptionists Jane Andrews and Jan Zimmerer devoted countless hours to typing correspondence, catalogue copy, labels, and educational materials for the project.

The teamwork and active involvement of volunteers, contributors, Board, and staff have been critical ingredients in realizing the goals of the Wisconsin folk art survey and the resulting exhibition and programming. Our boundless admiration and appreciation to all of you.

Ruth DeYoung Kohler
Director

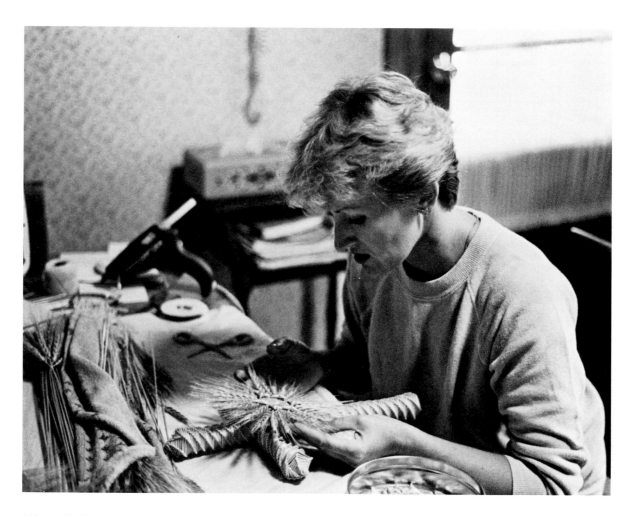

Sidonka Wadina Lee fashions a woven wheat cross like those she first observed in Czechoslovakia.

WISCONSIN FOLK ART: CONTINUING A CULTURAL HERITAGE

Throughout Wisconsin today, in large cities and small towns, on farms and in factories, around campfires during summer fishing trips and around dining room tables during holiday celebrations, thousands of people add beauty and joy to their communities by playing music, telling stories, and observing customs which have been passed along to them. In the town of Freistadt, approximately thirty-five miles northwest of Milwaukee, the community brass band "Die Alte Kameraden" regularly performs a repertoire of tunes brought over from Germany more than one hundred years ago. Along the shores of Wisconsin's lakes and rivers and in the woods "up north," fishermen and hunters like John Diehl and Edward Henkelman please and puzzle their friends with fabulous accounts of the fish trap that held ninety-one Mississippi River catfish and of the band of squirrels spotted playing country music in the Merrill area (cat. nos. 250-255). And every Easter in the Stevens Point home of Helen Wieczorek Boyer, family members gather to hold "egg fights" in which eggs decorated according to Polish custom are tapped end-to-end by two people until one egg cracks, forcing the loser to relinquish one of his or her eggs to the winner.

In much the same way, others who live within Wisconsin's boundaries create an enormous variety of traditional objects which fulfill everyday needs, serve as symbolic elements in secular and religious celebrations, or function simply as artistic objects. Often identified with one or more of the state's ethnic, religious, regional, or occupational groups, these craftspeople employ techniques learned mostly by informal observation and imitation of parents, grandparents, neighbors, or friends who had mastered these skills previously. Alexander Gokee watched his father fashion Ojibwa lacrosse sticks from ash and rawhide when he was a boy. Now that the game is enjoying a revival on the Red Cliff Reservation, Gokee has returned to making lacrosse sticks and is teaching a younger Ojibwa his skills (cat. no. 266). Milton Geyer began making duck decoys in his teens. He used the birds to hunt the marshes which once bordered the east side of Green Bay. Modeled after functional decoys created by his father and other hunters in the area, Geyer's bird carvings now grace collectors' mantels as well as the waters of northeastern Wisconsin (cat. nos. 268-271).

These objects, like the songs, stories, and customs cited above, manifest traditions extending back in time. They are, however, slightly different from those versions which have come before and which may follow. Each object is the outcome of an informal transmission of skills, one more reliant upon apprenticeships and observation than upon formal classroom teaching or the study of textbooks. And each object is the product not of a personal or individual aesthetic but of a communal one. It is an aesthetic shared by a group of craftspeople (whether part time or full time) and their frequently local audience, an aesthetic shaped and reshaped over time through direct contact and communication between the makers and their audience. Each object — each piece of needlework,

1

tamburitza, fishing fly, wooden chain, and feed basket — is, therefore, inextricably interwoven in the fabric of life within a given community. It not only fulfills a basic function such as holding chopped hay or covering the dining room table, but it also represents in material form the heritage of a particular group, its values, beliefs, and structure. And each object communicates that heritage to members of the community's current generation and those to follow.

Because of the integral association of these forms with comunity life as well as their traditionalism and the informality of their transmission, they are frequently designated "folk art," just as the forms of expressions described earlier are appropriately termed "folk music," "folk dance," and "folk custom." While alternative definitions of the term abound, it is the contemporary "folk art" of Wisconsin defined in this manner which forms the subject of this essay and the exhibition which it accompanies. And it is our intent not only to bring to the attention of the people of the state the traditional arts still being practiced among them but also to honor the folk artists of Wisconsin and the contributions they have made to the maintenance and expansion of a rich cultural heritage.

Tradition

The traditional art forms practiced by many of Wisconsin's contemporary folk artists originated long before the state became the thirtieth addition to the United States in 1848. Members of Wisconsin's Indian tribes, from the time of their first appearance in the region, created everyday and ceremonial costumes from hides which they tanned and decorated with quills and feathers. They also fashioned utilitarian objects such as canoes and baskets from the bark and wood of Wisconsin's forests. The ancestors of European immigrants to the state were a part of largely peasant cultures which had been formed over generations in Germany, England, Scandinavian countries, and the Mediterranean basin. Regional costumes and styles of cookery, methods of building homes and barns, and countless distinctive varieties of functional and decorative accessories were part of the cultural inheritance brought to Wisconsin by immigrant populations. Emigrants from Africa and Asia, too, introduced long-established craft traditions, especially weaving, woodcarving, and needlework, into the United States and ultimately into Wisconsin.

Because a substantial number of folk art forms rooted or transplanted in Wisconsin's fertile soil represented slowly developed, communally generated expressions, the tradition bearers responsible for their continuation made few changes in them. Backed by the generally conservative nature of their own communities, Wisconsin folk artists clung to the forms, colors, decorative motifs, materials, and techniques which had long been used in the creation of their arts. In knitting her elaborately patterned woolen Latvian mittens, Alma Upesleja adheres closely to the treasured work of her grandmother, who first taught her the skill. Similarly, Upesleja's daughter Anna Vejins knits mittens and gloves which vary only slightly from those of her mother (cat. nos. 5-8). In like manner, Tamer Givens and other quilters from Milwaukee's black community create "strip quilts" which recall African cloth assembled from long, narrow, woven strips of fabric (cat. no. 60). And Sigvart Terland continues to make wooden shoes which closely approximate those his father Peder made in Norway (cat. nos. 108-111).

While Wisconsin folk artists shun gratuitous change in their artistry and value the models passed down to them, they are not prevented from introducing some variation into their work. In some instances, these changes have come about

by the creative experimentation of individual artists within the limits of the tradition. For example, fly-tier Delbert Richardson of Madison has developed a number of unusual variations on well-known dry flies, including his "Black Bomber," which adds wings of white rubber bands to the girtle bug pattern (cat. nos. 205-243).

In other cases, change in Wisconsin's folk arts has arisen out of need. The unavailability of customary materials has necessitated a number of intriguing substitutions. Eino Hakamaa, of the Finnish-American community in the Hurley-Ironwood area, replaced the particular type of pine used to fashion farm baskets in Finland with the far more plentiful cedar of northern Wisconsin (cat. no. 168).

Technological innovations, especially in recent years, have also led to change in the traditional arts of Wisconsin. Commercial dyes have displaced their natural equivalents among many Indian basket makers and eastern European egg decorators. Synthetic cord, with its greater strength and durability, has supplanted cotton among net makers and commercial fishermen. And power tools have greatly aided carvers in roughing out basic shapes that are later finished by hand.

Whatever the cause of the variations in Wisconsin's traditional art forms, the change has usually been gradual. In each instance, after the folk artist has introduced the modification, his or her audience has weighed the newly created object, considered the acceptability of the new material, design, or color, and finally granted or denied its approval. This process of negotiation between artist and community is largely responsible for the conservative character of folk art and the preservation and continued growth of myriad older traditional art forms in Wisconsin today.

In addition to folk arts which originated hundreds of years ago, the state boasts a number of traditional art forms of more recent vintage. Just as older traditions once emerged and now continue, slowly growing and changing and occasionally dying and disappearing, new traditions also evolve both among established and newly formed communities. Given the faster pace of contemporary life and the speed of communication today, these new traditions often bud and flower in a far shorter period than was required by earlier forms. How long these traditions will continue in existence is an open question. The relative brevity of their life span does not disqualify them as folk art but merely underlines the influence of contemporary American life on the emergence and evolution of new folk art forms.

Among the younger traditional art forms being practiced in Wisconsin today is the customizing of automobiles and motorcycles. The "chopping and channeling" of all types of cars and trucks and the similar alteration and decoration of motorcycles have been a favorite pastime for several generations. Although not united by a particular ethnic or occupational heritage, these automobile and motorcycle enthusiasts form an identifiable community based on their shared interest in modified cars and bikes. As in other folk communities, these folk artists learn their skills by observation, imitation, and experimentation, and the traditional aesthetic governing designs, forms, and decorative motifs is shaped and reshaped over time. Willie G. Davidson, design director and vice-president of Harley-Davidson, epitomizes the motorcycle customizer. A lifelong rider and frequent participant at motorcycle events throughout the country, he understands and values the aesthetic of motorcyclists. His own 1982 Shovelhead Wide Glide reflects not only his own personal concept of power and beauty in a motorcycle,

but the attitudes and reactions other cycle enthusiasts expressed during the two years "Willie G." rode the customized Wide Glide (cat. no. 58).

The carving of life-size figures with chain saws is another recent folk tradition. It is a practice which has emerged in Wisconsin over the last several decades as gasoline-powered saws have become more widely available. Art Moe of Stone Lake in Sawyer County made his first chain-saw carving in 1961, translating by means of a new technology and larger scale the whittling skills acquired as a boy under the tutelage of his father, who was a carpenter, cabinetmaker, and building contractor. Like other north-woods carvers, Moe creates images of the region's wildlife including muskies, eagles, and snapping turtles; images of regional characters like hunters, fishermen, loggers, and Indians; and images stemming from his Norwegian ethnic heritage, such as Viking figures and creatures from Norse mythology. The winner of various chain-saw carving competitions in the area, Moe is highly regarded by his regional audience. He has donated some of his carvings to local organizations and has sold others to customers at his restaurant and resort, but most of them he keeps to decorate the grounds of his home and place of business (cat. no. 191).

Whether longstanding or more recently evolved, Wisconsin's many folk arts retain a strong element of tradition. Unlike academically trained artists who often place primary value on the new and original, folk artists in Wisconsin seek to retain the best of the old, to improve upon or add to it when creativity and technology allow, and to obtain the approval and acceptance of their fellow artists and community audience in the process. In this way, their work is at once old and new, familiar but not fixed, community based and individually creative.

Community

Because all folk arts are based upon an aesthetic shared and shaped by a given community and reflect the values and beliefs of that community, an overview of Wisconsin's contemporary folk arts is perhaps best accomplished from the perspective of the communities in which the traditional arts flourish. In addition to the Native American and ethnic communities mentioned in the preceding section, a number of other types of communities in the state continue to support the active practice of folk art forms. Foremost among these are occupational communities, especially dairy farmers, lumbermen, and commercial fishermen, who have developed a range of utilitarian yet beautiful artifacts to assist them in working Wisconsin's fields, forests, lakes, and rivers. Communities of sportsmen, too, have retained an active interest in traditional art forms — decoy carving, gunsmithing, fly-tying, and net making — associated with their recreational pursuits. Certain religious communities provide the base of support for a variety of folk arts, ranging from Eastern Orthodox icon painting to the hand lettering of Jewish wedding certificates called *ketubahs*. Regional communities continue to exert a distinctive influence upon the folk arts of their geographical areas, whether they happen to be a quilting group in Hillsboro which has continued to meet for over forty years or ice fishermen from Green Lake who design and build fishing shanties unique in design and decoration.

Within each of these communities — ethnic, religious, occupational, recreational, and regional — a smaller, more personal unit plays an instrumental role in the transmission of folk art forms and instills within each member the group's beliefs and values. This group is the family. So central is its role in the continuation of traditional arts that it merits first consideration in this review.

Families: Extended families have frequently provided crucial links for the uninterrupted continuation of folk arts within various Wisconsin communities. The Slovak tradition of wheat weaving, for example, persists here because of Sidonka Wadina Lee's close relationship with her grandmother, who taught her the art of weaving crosses, house blessings, and other forms (cat. nos. 119-121). The making of black ash baskets among the Winnebago is a direct result of the efforts of families like the Whitewings, who have handed down the craft through five generations (cat. nos. 1-3). And the ongoing creation of the fish decoys long used on northern Wisconsin's lakes by members of the Ojibwa tribe is an important familial tradition handed down to Ben Chosa by his father and grandfather (cat. nos. 202-203).

While certain family traditions like these achieve a substantial degree of visibility, many remain more private and personal. These folk arts are intended for use in the home. They find an audience often limited to family and close friends. Especially notable among these forms of folk art expression are the many uses of food and fiber generally perpetuated by the women of a family as well as various forms of decorative woodworking practiced by the men. In Mineral Point, Pascalena Galle Dahl, her sisters, and their families continue to grow many of the same vegetables once raised by their mother, occasionally using seeds brought over from Italy by the first generation. They preserve vegetables "just like our mother," putting up jars of mushrooms, tomato sauce, and combinations of peppers and tomatoes. Moreover, they make use of these foods in preparing traditional dishes. The tomato/pepper mixture, for example, is cooked with whisked eggs to form the filling for *sepoli*, a kind of fried bread. It is also used as the basic sauce for preparing chicken and pork. Such traditional "foodways" effect a multigenerational bonding among members of a family. They afford a means not only of acknowledging family background and history but also of expressing pride in that heritage (cat. nos. 90-92).

Similarly, the enormous range of quilts, rugs, linens, doilies, dresser scarves, and borders created by women who learned their traditional needlework skills from siblings, parents, and grandparents expresses symbolically the unity of the family past and present. Edith Hakamaa's woven rag rugs with their Finnish "big lake wave" pattern, Selma Spaanem's Norwegian Hardanger lace, and the *deshilado* designs of Rosa Llanas also provide a practical vehicle for personal creative expression (cat. nos. 61, 66, 69). Within the framework of an established ethnic tradition handed down and shared within the family, each woman is able to exercise her imagination and to demonstrate a level of accomplishment which brings individual recognition and personal satisfaction.

In much the same manner, male family members find an expressive outlet in the fashioning of chip-carved wooden frames, inlaid plaques and boxes, and shelves with elaborate cut-out designs. Made from inexpensive and readily available materials, these traditional woodworking exercises occupy the mind and hand during the process of construction and produce a usable, decorative, finished product.

Ethnic Groups: Among many of Wisconsin's ethnic groups, the natural context for the creation and sharing of folk arts is the home, and the customary audience is the immediate or extended family. However, within most of these same communities, other forms exist which address a larger audience. These include special artifacts created for communitywide celebrations such as musical instru-

ments, costumes, and devotional objects. Whatever the precise nature of these forms, each serves related purposes: to remind makers and audience that they belong to a larger community with whom they share a culture; to allow the expression of allegiance to and pride in the ethnic group's cultural heritage; to differentiate members of a particular ethnic community from members of other groups; and to continue a mode of expression which retains symbolic or other significance.

Given the role of the church as the social and cultural center of many ethnic communities, it is not surprising that traditional art forms created especially for religious celebrations are among the most widespread of the state's ethnic folk arts. In the Polish communities of Milwaukee, Stevens Point, and Pulaski, straw ornaments in the shapes of stars, animals, and human figures are prepared to decorate the Christmas tree. Among Danish-Americans in the Racine area, heart-shaped baskets constructed of cut and interwoven strips of red, white, and green paper serve the same purpose. And in Mexican-American communities in Madison and Waukesha, vibrantly colored piñatas are still fashioned for religious holidays and birthday parties.

Perhaps the most visible of traditional art forms created for holiday celebrations within Wisconsin ethnic communities is the decorated Easter egg. Several styles of decoration, conforming to different ethnic traditions, are actively practiced in communities around the state. For example, Stephanie Lemke of Mazomanie follows the Croatian tradition, with brightly colored threads wrapped about the eggs to form squares, diamonds, and other geometric shapes (cat. nos. 130-133). Sidonka Wadina Lee of Lyons draws upon two styles of Slovak egg decorating. In addition to painting floral designs on some of her eggs, she dyes others red, blue, or black and overlays them with bits of straw cut into various patterns (cat. nos. 122-129). A number of Ukrainian-Americans — Betty Pisio Christenson of Neenah, William Nahirniak of Waunakee, Maria Fafendyk of Sheboygan, and Ola and Ulanna Tyshynsky of Shorewood — create the elaborately patterned eggs characteristic of their ethnic group (cat. nos. 38-57, 144-158, 159-165). The designs and symbols developed by Ukrainian egg decorators through the time-consuming repetition of the wax-resist method symbolize Christ, spring, rebirth, and regeneration. The eggs constitute the symbolic center of the group's entire Easter celebration. Equally important, however, the eggs have come to symbolize the survival and rebirth of Ukrainian culture among Ukrainian-Americans who have escaped their Soviet-dominated homeland. As such, they have grown from traditional religious symbols understood within the ethnic community to declarations of national identity recognized and appreciated by a broader American audience.

Celebrations represent the context in which two other folk art forms regularly appear in Wisconsin's ethnic communities. Traditional musical instruments and ethnic costumes, once articles of daily use in the homes and villages of the "old country," are now more typically part of large, public celebrations among American ethnic groups. The traditional instruments contribute to the preservation of specialized forms of ethnic folk music, and they suggest the integrated, systematic nature of folk culture. Within Wisconsin's ethnic communities, craftsmen like Epaminontas Bourantas, C. C. Richelieu, Nick Vukusich, and Anton Wolfe create bouzoukis, Hardanger fiddles, tamburitzas, and concertinas — works of art themselves — which allow other artists within the community to play the tunes which are part of their cultural heritage (cat. nos. 112-115).

Ethnic folk costumes frequently prove an accurate barometer of a group's level of acculturation. Among some groups like the newly arrived Hmong, the fabrication of traditional, regionally distinctive costumes for festivities such as the New Year celebration is generally expected of women and girls within the community (cat. no. 104). It is their responsibility to maintain the traditional needlework skills — appliqué, reverse appliqué, batik, and cross-stitch embroidery — which have characteristically been utilized in costume making. Among many ethnic communities, years of residency in this country and a desire to "blend in" and "become American" result in the loss of skills and knowledge required to create an appropriate regional costume. In these instances, generalized national costumes have sometimes been developed and are employed in conjunction with group celebrations or public performances by ethnic dance ensembles. Ironically, the loss of that regional ethnic identity and resulting disappearance of distinctive costumes have prompted research into authentic costume traditions as well as the use of costume kits obtained from the mother country to satisfy the need for these traditions.

Whether they take the form of decorated Easter eggs, musical instruments, or ethnic costumes, the folk arts practiced by members of Wisconsin's ethnic communities attest to the continuing importance of ethnic identity within America's generalized and diluted mass culture. They create a sense of belonging to one group and of being different from others, feelings which reduce life to a more workable, comprehensible scale.

Occupational Groups: If the traditional arts actively being practiced among Wisconsin's ethnic groups are related most directly to holiday celebrations, to breaks in the everyday routine, the folk art forms within the state's occupational communities are just the opposite. They include containers and tools to aid in the accomplishment of one's daily tasks, useful and frivolous objects intended to show off skills traditionally acquired on the job, and miniatures documenting types of equipment and mechanical processes once or presently used by the model builder in his or her occupation.

Examples of traditional containers and tools can be drawn from several of Wisconsin's major occupational groups. Among farmers, a variety of baskets are presently produced for carrying chopped hay, gathering vegetables, and other tasks. Joseph Buresh of Luxemburg makes enough pounded black ash feed baskets during "mud season" each spring to satisfy his own needs and those of his Bohemian neighbors. So popular are the large four-legged baskets that Buresh is teaching his second cousin to carry on the trade (cat. no. 166). Eino Hakamaa of the Finnish community along the Wisconsin-northern Michigan border produces shallow, square cedar baskets, some of which nest within others, for gathering vegetables (cat. no. 168). Ray Steiner of Argyle creates a variety of willow baskets in a manner learned from Ernest Lisser, a neighbor who, in turn, was taught willow basket making in his native Switzerland (cat. no. 167). In addition to baskets, farmers utilize various specialized tools. Alvin Stockstad makes tobacco axes and tobacco spears used by farmers from Vernon to Dane Counties in the harvesting of their crops (cat. nos. 169-173).

Commercial fishermen, too, continue to produce certain tools of their trade, although mechanization and mass production have reduced the range of handmade equipment. Members of Door County's Hickey family make their own net winders and marker buoys as well as such specialized devices as "jiggers" used to set and retrieve nets under the winter ice (cat. nos. 175-179).

The logging industry in Wisconsin, as in many other states along the northern tier of the United States, has generated several forms of folk expression still being practiced. Especially noteworthy are Eugene Stenroos' "bucksaws-in-bottles." Similar to ships-in-bottles produced by sailors, these tests of skill and patience require the carving of a tiny sawhorse, axe, bucksaw, and other tools as well as the assembly of these carvings in a balanced construction within a short-necked whisky bottle. Other tests of skill frequently associated with lumbering also appear in Wisconsin, although at times they are transmitted via other groups. Carved wooden chains, balls-in-cages, miniature pliers — all carved from single, solid pieces of wood — are among the puzzles created by Adolph Vandertie of Green Bay (cat. nos. 15-33). Vandertie, however, learned his skills not from lumbermen but from hobos who made carvings from readily available bits of scrap lumber to pass the time and to trade for food or shelter.

Miniatures created by Wisconsin lumbermen, farmers, and fishermen offer their creators an opportunity to demonstrate occupationally related skills and to display their specialized knowledge. Miniatures are frequently the products of older men retired from their particular occupations. As such, they also provide a vehicle for reminiscence, a means to review lives spent mastering a trade and to recall the extensive changes which took place in the course of a lifelong occupation. Thus, the models of skid teams and top-loading rigs by John Henkelman depict a way of life once familiar to him (cat. no. 190). The operating traction engine of Carl Vogt attests to his firsthand familiarity with the technology of his trade, his skill as a craftsman, and his desire to communicate his special feeling for this occupation to others (cat. no. 174). Not surprisingly, given their love of the work and interest in sharing its fascination, a number of these miniature makers regularly take their models to thresherees, to agricultural fairs, and even into classrooms to explain the way it once was done.

The products of skilled tradesmen who learn their occupations informally and who serve the needs of an identifiable community also may be considered occupational folk arts. For example, the hinges, hooks, tools, railings, and gates which blacksmith Bob Becker creates for the members of the farm community around Brill deserve this designation (cat. nos. 192-200). So, too, do the ornamental plaster gargoyles and moldings developed by Julian Orlandini on the basis of examples passed down over several generations within his family (cat. no. 257). The fact that these utilitarian and decorative forms are produced commercially and provide a steady income for their creators does not disqualify them as folk art. While other folk artifacts may be more personal, more casually produced, and more ephemeral, the businesslike manner of producing and marketing these objects does not diminish their traditionalism or community base.

Recreational Communities: The traditional art forms practiced by Wisconsin's sports fishermen and hunters have a strong utilitarian focus. Recreationally based folk arts take the form of tools of the trade, equipment necessary to successfully pursue the game fish and animals which inhabit the state's lakes, rivers, forests, and fields. While many of these implements once were available only from local craftspeople, most are now mass produced and widely marketed. Thus the handcrafted guns, nets, boats, decoys, fishing flies, and ice fishing "tip-ups" produced by traditional artists have multiple significance: they are alternatives to standardized commercial products, and they serve as a valued reminder of earlier times when people relied on themselves or their neighbors for the goods

they needed. Samuel Rust's gunstocks bear distinctive hand carving which mass production cannot achieve due to cost limitations (cat. no. 245). Duck decoys by Rich Riemenschneider and Milton Geyer and fish decoys by Ben Chosa and Tom Winter reflect years of careful observation of the creatures depicted and a long-term commitment to the acquisition of the necessary carving and painting skills (cat. nos. 202-204, 246-249, 268-271). Various types of fishing gear also demonstrate the minor adaptations to local conditions which cannot be achieved through large-scale production. Delbert Richardson's fishing flies address needs so limited and markets so small that major manufacturers could not economically service them (cat. nos. 205-243). Thus, by adhering to the higher standards of an earlier time, Wisconsin's traditional craftspeople not only find an appreciative audience but also reflect the attitude of many of the state's sportsmen and sportswomen toward quality, individuality, and self-reliance.

Transmission and Transition

Within Wisconsin communities, most folk arts are passed from generation to generation via informal means. Alvin and Jacob Herschberger acquired their skills as Amish furniture makers through apprenticeships with two master craftsmen in the community. Julian Orlandini became skilled in ornamental plaster work through a similar apprenticeship within the family business. And Eugene Stenroos learned how to encapsulate bucksaws in bottles by observing and imitating techniques practiced by a Finnish-born neighbor. While some situations are more structured than others and may even involve some form of payment for services, all of these introductions to the folk arts involve face-to-face interaction, a stronger reliance upon observation and imitation than upon the study of texts, and continual feedback from the master.

Through these informal methods of instruction, the master folk artist passes along to his or her student the techniques and processes as well as the traditional aesthetic which governs the creation of the object and the knowledge of designs and symbols requisite to a full appreciation of the meaning of the object within a community's culture. By insisting that her daughter tear out incorrectly done stitches and redo them, Allie Crumble's mother conveyed to her the importance of precision and neatness in her needlework (cat. no. 14). By creating her sampler of *deshilado* stitches, Hortensia Ojeda recorded the tradition's basic repertoire of forms so that she might pass it along to her daughters (cat. no. 256). By taking her granddaughter with her to various public demonstrations of the making of her Slovak Easter eggs, Johanna Birksadsky introduced Sidonka Wadina Lee to their symbolic meaning and place in the springtime celebration in addition to the allowable range of colors and motifs imposed by tradition (cat. nos. 122-129).

Folk artists generally are not solely dependent upon the instruction of master artists for their knowledge of a tradition. Informal learning from other artists in the community and from audience members, along with creative experimentation, lead to the gradual but constant change which characterizes folk traditions. Since no enclave in the state is totally isolated from the world around it, a variety of outside influences may occasionally alter even those art forms intended exclusively for in-group use. Patricia Llamas' piñatas, for example, sometimes take the form of cartoon characters such as Dumbo and Winnie-the-Pooh (cat. no. 262).

Attitudes once widely held by the American public regarding the need for immigrant groups to abandon their native languages and otherwise conform led members of many ethnic communities to discard or hide evidence of their cultural heritage. Technological advances led to less expensive substitutes for folk art forms and the subsequent abandonment or reapplication of certain traditional skills. For example, the ready availability of cheap plastic duck decoys has diminished the need for their handmade equivalents and has led indirectly to the growth of decorative bird carving.

Despite interruptions in the transmission of folk arts from generation to generation, many communities have developed alternative methods for perpetuating traditional art forms. Ethnic pride and the need for cultural conservation have prompted Norwegian-Americans in the Madison area and the Ojibwa on the Red Cliff Reservation to "revitalize" or "revive" folk art forms. While these two terms have not always been used with consistency, "revitalization" has usually meant the resumption of a traditional art form by a former practitioner after a lengthy interruption. For instance, a member of the Ojibwa, who had once made lacrosse sticks but had ceased due to the decline of interest in the game, returned to his art form to fulfill the new demand for equipment. "Revival" has usually implied the resumption of a folk art after its complete disappearance and the departure of all who had practiced it. Revivals are undertaken either by outsiders who find the traditional art forms quaint or by members of the community to which the art form is indigenous. Hardanger fiddle making among Norwegian-Americans is an example of the latter. Community members studied earlier examples of the work, researched their construction in books and other publications, and occasionally even sought instruction from active practitioners in the old country.

The interest in reviving traditional art forms inside and outside their original communities has led to the availability of a host of instructional aids and opportunities which can supplement, or supplant, the traditional transmission process. The presentation of workshops in costume making, egg decorating, paper cutting, and other folk art forms is intended to increase public access to certain folk arts. So, too, is the preparation and sale of kits. However, when such methods become the sole means of learning, there is danger of much being lost. The tendency is toward precise execution of specific instructions rather than experimentation and creative elaboration within a traditional range. The object is divorced from its cultural significance. Consequently, while some efforts at revitalizing or reviving particular folk art forms within the original host communities represent an extension of the traditional transmission process, other revivals grow so far removed from the original culture, so unrelated to the personal interaction inherent in the folk arts, that little resemblance exists. Given their basic relationship to the original art forms and their close ties to the community, the former efforts deserve consideration here. The latter, because of their more generalized, secondhand relationship to the traditional arts of Wisconsin communities, need only be recognized as derivatives.

Mass media, mass producers, and marketers have recently done the folk arts something of a service by bringing them to the attention of a much broader audience. While the definitions which mass producers and distributors have used to define folk art do not often agree with the one proposed here and while these entrepreneurs have foisted countless cheap imitations of authentic folk arts upon an unwitting public, they have occasionally brought to the attention of the Ameri-

can people truly traditional artists who are still actively practicing their art forms. Perhaps more important, they have made "country" furnishings and "folk art," however defined, a popular phenomenon. Such promotion has opened new markets for folk artists who once created objects solely for friends and family or sold work only within their own communities.

In some instances, where the traditional values of the artist and his or her ties to the community remain strong, this new promotion has meant little more than additional income. The nature of the art forms has remained relatively stable. In other instances, the demands of wholesalers and retailers upon traditional artists have prompted increased production, simplified designs, and the adoption of popular color schemes in lieu of the traditional. The control of the art form — Hmong needlework might serve as an example — has slipped from the hands of the artists and their community into the hands of those with a commercial rather than cultural interest in the work.

Conclusion

The changes which have recently confronted Wisconsin's contemporary folk artists are in many ways no more substantial than those which faced their predecessors. New materials, technological innovations, heightened visibility, and expanded markets are sometimes difficult to integrate into a longstanding artistic tradition, but they may not represent more of a challenge than transplanting a European peasant culture into a newly settled, largely unknown land. Change has always confronted the folk arts, yet their centrality in many cultures has allowed them to survive. Indeed, they have done more than merely survive: many folk arts continue to flourish in Wisconsin today, adding immeasurably to the richness and variety of the daily lives of Wisconsin residents. While the practitioners of many of these art forms may not even think of themselves as "artists," they have nonetheless brought to us extraordinary beauty, an appreciation of heritage, and perhaps a recognition of the similarities and differences which unite and distinguish all peoples.

Will the folk arts continue to survive in Wisconsin? The extraordinary endurance of earlier forms and the complete commitment of the artists who created them surely argue that they will continue to be part of the state's cultural mosaic. So too, does the continual evolution of new traditions and the creativity of the artists who have embraced them. If the kaleidoscope of Wisconsin folk art does survive and does continue to grow and change, the state and its people can only be richer for it.*

Robert T. Teske
Associate Curator of Exhibitions

* Many of the examples cited in this essay are drawn from field research reports compiled and submitted by James P. Leary and Janet C. Gilmore. Complete field reports are available for research purposes in the Resource Center of the John Michael Kohler Arts Center.

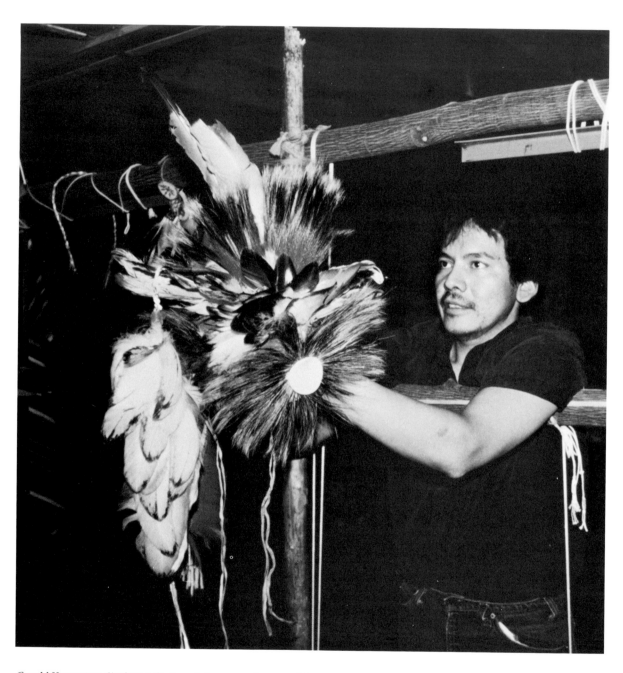

Gerald Hawpetoss displays a feathered dance roach, part of the traditional Menominee dance regalia.

CULTURAL FORMS, PERSONAL VISIONS

Wisconsin is recognized by residents and outsiders alike as "America's Dairyland," "Old World Wisconsin," part of the "Rust Belt," and a place of woods and waters inviting "escape" from urban congestion. It is a state whose folk artists reflect its complex agrarian, ethnic, industrialized, arboreal, and maritime makeup. Woodland Indians excel in basketry, leather work, and beadwork. Urban and rural residents of African-, Asian-, European-, and Latin-American descent decorate their homes with their carvings and embroidered linens and celebrate festive occasions with homemade pastries, preserved produce, spirits, and costumes. Farmers, loggers, and seamen create miniature scenes and equipment reminiscent of their occupational lives. Welders, machinists, and carpenters make their own tools and conjure occupational symbols from scrap. And hunters and fishers fashion decoys, lures, gunstocks, knives, nets, and skiffs.

Despite such an abundance of traditional activity, Wisconsin is hardly a 1980s cultural backwater teeming with quaint "folk" who practice their arts because "everybody else does it and that's the way it's always been." Change is a constant for the state's residents. Most dairy farmers have become "milk producers" with mechanized, cost-efficient operations, or they have left the land for industrial and service jobs. Native peoples have grown as knowledgeable in the thickets of government bureaucracy as in those of nature. Ethnics have left tight enclaves, intermarried, and become mainstream Americans. Factory hands have found scant use for increasingly specialized occupational skills beyond industry. And hunters and fishers have learned that it is easier and cheaper to buy their gear ready-made.

In the face of these trends, a few of Wisconsin's folk artists have acted as stubborn loyalists to a bygone era, but most have adapted their old-time skills to suit modern conditions. That they have relied at all on traditionally acquired forms and have found ways of extending their communities' artistic pasts into the present is a testament to their strength as individuals and to the power of their culturally informed yet ultimately personal visions.

In the early 1960s, young Gerald Hawpetoss was charged by his father to leave Milwaukee, travel to his Menominee homeland, and serve his grandparents who did things "the old way." His grandmother told him: "Learn your own customs. That's something no one can take from you. They'll take your land, they'll take your home, they might even take your life." Two decades later we find Hawpetoss making moccasins, a skill even his father's generation had abandoned. He pulls a scraped deer hide bundle from the frozen cab of an old car outside his back porch. His wife, Marjorie, cooks calves' brains from a slaughterhouse in cheesecloth on the electric stove. Then brains and hide are tossed into the washing machine for a full cycle, for the brains break down the fibers. The washer's brief agitation supplants days of intermittent hand stirring. The hide is stretched on a

frame and smoked outdoors with birch chips. Thereafter, it is cut to size by using paper patterns, sewed, and decorated with the flat red and green beadwork of the Menominee (cat. no. 99). Hawpetoss tells his children tribal stories as he teaches them his skills. He dreams of a new generation of Menominee who will maintain their customs. His children wear moccasin liners in their running shoes and beaded moccasins to powwows.

Gerald Hawpetoss may differ in age, gender, and ethnicity from other Wisconsin folk artists. The forms he creates may embody different media, methods, and aesthetics than those of other artists. Yet apart from accidents of birth and evidence of culture, all are energized by parallel experiences and compelled by personal visions. Their collective lives and work describe a pattern of actions and concerns, many of which are common to all artists, folk or otherwise: early steeping in a tradition, the necessity of inspiration, the command of technology and design, the inclination to make time for artistic work, the fascination with the history and significance of one's artistic tradition, the problem of what to do with one's creations, and, finally, the desire for personal recognition and expression.

Many of the folk artists in Wisconsin today began acquiring their skills when they were children. In keeping with age-old gender distinctions, boys were commonly encouraged to shape wood and metal while girls were expected to manipulate food and fabric. Grandfathers and fathers often gave pocketknives to young boys who had reached the age of six or seven. "Keep it sharp and you'll never cut yourself," admonished Art Moe's Norwegian-American father. Within a few years boys were helping their elders with more practical tasks. At age eight Sam Rust assisted his gunsmithing uncles by sanding stocks which he soon learned to "checker" and to fit with a gun's metal "action" (cat. no. 245). By age eleven, after disassembling toy cars and hanging around his father's garage, Tim Anderson was a rookie pit mechanic at stock car races. About that time he learned to weld, tinkering with scrap pieces, then changing the form of his own cars, and finally working on the machines of others to the point where he has altered "just about every hot rod in Madison." High school shop classes, when available, served to validate and expand boys' skills in wood and metal.

Cooking utensils and needles were likewise thrust into young girls' hands. When only two years old, Sidonka Wadina Lee would toddle down the block in her Milwaukee neighborhood to help Grandmother Birksadsky bake: "I was ready to peel potatoes for Slovak dumplings whether any needed to be made or not." At six or seven, most girls learned basic sewing skills, cutting out and piecing quilt blocks by hand, as Afro-American Allie Crumble did, or cutting out and basting together clothing pieces, as Latvian-American Alma Lacis Upesleja did (cat. nos. 5, 14). Some youngsters acquired the rudiments of knitting at the same age; both Anna Upesleja Vejins and Anna Nelsen Wigchers produced simple scarves and socks for themselves and their siblings until, Vejins said, she got sick of making the same old bland basics. Maria Fafendyk commenced helping her mother with Ukrainian cross-stitch embroidery at the age of six, but girls generally learned more complex needlework skills — embroidery, drawnwork, crocheting with fine thread, tatting, weaving, the actual quilting of bed covers, and the construction of clothing from beginning to end — at age eleven or twelve, or even as late as their early twenties (cat. nos. 135-136). If girls were not exposed to needlework skills at home, they learned them at school as part of a female's basic training, or just as likely, from friends, neighbors, and other relatives. Elsie Niemi picked up tatting

from an older neighbor girl, and Sister Mary Crucifix Polimeni learned bobbin lace making from the nuns who taught at her school in Reggio Calabria, Italy (cat. nos. 70-79).

For most, the acquisition of handiwork skills was mandatory. The majority were brought up on self-sufficient farms, under circumstances where "you had to do everything." Farm boys who expected to be farmers had to be jacks-of-all-trades, able to do a little carpentry, some blacksmithing, some mechanical work, and plenty of rough-and-ready improvising, especially when there were breakdowns in a busy season or when a lack of cash precluded buying anything new. Tool handles were carved. Trucks and tractors years ago were often "bugs" or "doodlebugs" cobbled out of the engines, bodies, and drive trains of other vehicles with the addition of plenty of scrap metal and solder. In cases of necessity there were, as Bob Becker put it, "no such things as training, schools...you had to learn by doing or you didn't work."

Mothers were often too busy with farm work and child care to exercise a full repertoire of household skills. Older children seen as particularly capable or gifted with their hands were assigned specific tasks and carefully monitored by watchful parents. Frequently children voluntarily learned to knit or sew not only to help their mothers but also because, according to Alma Lacis Upesleja, "if you needed or wanted something, you had to make it yourself." Brought up on a farm in Latvia, she knitted her own socks and mittens, sewed her own school clothes, collars, blouses, and underwear (cat. no. 5). Similarly in this country, Tamer Givens, reared in a Louisiana sharecropping family, made all her own clothing, bedding, and even her own mattress (cat. no. 60). Even when the necessity of producing household and occupational amenities was less acute, many children were expected to acquire some handiwork skills simply, as parents reasoned, to keep their hands busy and out of trouble.

These early years of informal apprenticeship gave young adults a firm foundation upon which to develop these and related art forms. But producing functional artifacts and practicing related skills did not ensure that a child would perpetuate a traditional art form. For example, boys "raised into" commercial fishing often left home and the ready jobs there as soon as they graduated from high school in the hope of finding something better for themselves. Many people became so absorbed in child rearing, farm work, or wage-earning jobs that they had to abandon a pleasurable traditional skill altogether. In some cases, artists set aside familiar handicrafts in favor of new, often related art forms of greater interest or practicality. More often, however, Wisconsin's folk artists have tirelessly practiced one or several traditional art forms regardless of the shape of their lives — relatively stable or constantly changing.

Indeed, artists who make a living by their craft practice their skills regularly as integral aspects of their occupation. In farming and commercial fishing, handwork has always been an evening, after work, and winter activity. Luxemburg's Joe Buresh, a Bohemian farmer, has been making pounded black ash baskets for carrying feed to cattle "off and on whenever a neighbor needs one," but most commonly during "mud time": in the early spring when "you can't get outside" (cat. no. 166). Similarly, just before the ice "makes" in late fall and when it breaks up in the spring, many commercial fishermen retreat to their gear sheds to build, repair, and clean their nets and related components.

As adults, most of Wisconsin's folk artists have sacrificed, struggled, and waited to find the time and space to develop their crafts. Since he works in unheated outbuildings and outdoors, Alvin Stockstad of Stoughton waits until late spring or early summer to fabricate the tobacco spears and axes local farmers employ at harvest time. And because he earns his living as a factory worker, Stockstad must compress his toolmaking still further, into the weekends (cat. nos. 169-173). Rosa Llanas has raised fifteen children yet somehow has managed to create decorative dish towels and tortilla covers during her few free moments (cat. no. 69). Although holding a full-time job, Anna Vejins knits mittens while watching the news on television (cat. nos. 7-8).

For many, the opportunity to pursue the traditional arts of their youth comes only late in life or after a major life change: upon getting the last child out of the house, retiring, moving off the farm, changing to a less demanding job, being laid off from a factory job, or being laid up due to disability or illness. Confined at home with her newborn child, Vera Mednis found that she could weave while caring for her infant. She set up her loom in the kitchen and worked solidly until her child was nearly two (cat. no.107). His wife's involvement in weaving carpets stirred retired lumberman Merrill Bartels to whittle lumber-camp figures of the sort he had made as a kid: "She was always cooped up with that loom...I had to do something." When Adolph Vandertie gave up smoking, he, too, "had to do something" with his hands and remembered the elaborate whittling — chains, balls-in-cages, key rings — that had so fascinated him when he had visited Green Bay's hobo jungles as a jackknife-toting boy (cat. nos. 15-33). Forced idleness following serious surgery and long stints in waiting rooms while awaiting chemotherapy treatments have similarly prompted several to take renewed interest in old stand-bys like embroidering, knitting, quilt piecing, and leather tooling.

Such persistence and growth in the folk arts invariably draws upon the early inspiration of master artisans, a genuine fascination with a particular handicraft, a gift for working with one's hands and learning by observation and experimentation, and a real affinity for tradition. The grandfathers and fathers who dispensed jackknives and advice were often early heroes. Ed Henkelman and Carl Vogt both noted that their fathers knew how to do things; they "could make practically anything out of wood or metal." Mothers and grandmothers, too, were revered because, like Oljanna Venden Cunneen's mother, "she was an artist at handwork," or like so many, "she always had a project going," "she kept her hands busy," or "she could make something out of nothing." Stern masters made a particularly strong impression: Allie Crumble's mother not only kept her inside learning to quilt instead of playing with a younger sister but also made her resew improperly pieced blocks until she got them right.

Integrally related to the guidance proffered by a respected teacher is a profound interest in a particular kind of artifact or craft. Milt Geyer's father and older brother hunted in the sloughs and marshes near their home on the northeast side of Green Bay. "They'd throw their ducks on the floor to pluck the feathers. I couldn't get enough of looking at their shapes and their colors." During the Depression, store-bought decoys were too expensive, so Geyer began to make his own in 1934: "I knew what ducks looked like and how to paint, but I didn't really have any skill yet." Geyer learned by "chewing the fat" with Jack Van Caughenburg, a sporting goods salesman who made decoys to sell, and Jack Kearney, a commercial fisherman and decoy carver with a hunting shack along the East River,

whom he "used to watch to get the hang of" carving bodies and painting feathers (cat. nos. 268-271).

When Betty Pisio Christenson was a little girl on a cutover homestead near Suring, her Ukrainian-born mother spent the weeks prior to Easter in cleaning, cooking, and making eggs so that the family could feast and visit for eleven days following the holiday. The eggs delighted Christenson, and she has fond memories of jars of vegetable dyes — made from cabbage, onion peel, walnut bark, blueberries, and blackberries — on shelves in the root cellar and of egg baskets hidden in the barn on Easter morning. She learned stories about how the eggs were a way of welcoming the spring, of expressing gratitude for having survived the winter, and of hoping for flowers and a good harvest. Christenson's mother taught her to make one- and two-color eggs as a child; she also heard about, but never saw, more elaborate, multicolored *pysanky*. They were like images in a dream, pictures her mother could draw with words but never in reality. When Christenson finally saw examples while visiting relatives in Canada in 1974, she was determined to make them. Fortified by observation and forty years of experience, she did (cat. nos. 38-57).

In addition to receiving encouragement from elders or friends and enjoying particular art forms, most folk artists experience a strong inclination to work with their hands or to create specific forms. Oljanna Venden Cunneen believes the ability to work with one's hands is hereditary, something with which one is born. Alma Upesleja, the only one of five children who took to handiwork, thinks that the ability is a special gift. Johnny Diehl was repeatedly attracted to commercial fishing even though he was not raised in the business. On the other hand, Jeff Weborg, brought up in the fishing business, tried unsuccessfully to make a living in another line of work; he found that commercial fishing was "in the blood."

Armed with the skills and time to practice their traditions, Wisconsin's folk artists have proven themselves to be inveterate "tinkerers" with a fine command of technique and a flair for design. Men and women alike have been inclined toward improvement and innovation as the result of necessity, dissatisfaction, curiosity, prolonged experience, and boredom. Anton Wolfe began making concertinas after his instrument broke and he could not get repair parts (cat. no. 115). Del Richardson started tying his own flies when none were available during World War II (cat. nos. 205-243). Epaminontas Bourantas could not abide the "sour notes" of his Greek bouzouki, so he drew upon his own woodworking and mechanical experience and his familiarity with the original artifacts to make his own instruments (cat. no. 113). Curiosity led Nick Vukusich to disassemble a Yugoslavian tamburitza so that he "could figure out how it was made" (cat. no. 112). Similarly, Amish chair maker Alvin Herschberger gradually transformed the double rocker pattern he had learned from master craftsman Aden Yoder into a sturdier version of his own (cat. no. 62). Alma Upesleja is fascinated by unusual needlework and duplicates its stitches or pattern as soon as she returns home. Allie Crumble finds great pleasure not only in inventing quilting patterns but in making up names for them. Anna Vejins, who had been bored with knitting socks of one drab color, was spurred on to learn to knit the fancier multicolored mittens traditional among Latvians. After mastering knitting with three colors of yarn per row of stitches, she surpassed peers and mentors by becoming nimble at knitting with four colors.

In contrast to the widely held notion that industrial labor invariably spells the demise of folk artistry, some men have been able to utilize skills acquired through their occupation in a traditional craft. This has been particularly true of farm boys who were raised around jacks-of-all-trades with wood and metal and who later became urban laborers. Thirty years as a machinist and cabinetmaker gave Carl Vogt the skills to fashion models of the farm equipment he had operated in his youth (cat. no. 174). Clarence Mirk's dad owned seven acres, a sawmill, a large threshing machine, and a traction engine; he also drilled wells and moved houses. Mirk became a maintenance man for industrial sewing machines, repairing them "on the floor," and remaking and machining parts in a shop. When he bought a metal lathe in the late 1930s, he began, slowly, meticulously, with the aid of old pictures and measurements, to replicate old farm equipment in miniature.

Since the sustained exercise of skills and design leads almost inevitably to the production of more desirable objects, what may start as an intensely private exercise usually finds a wider audience. Women especially produce traditional artifacts for the benefit of others, not only as useful or helpful items but as tokens of affection or recognition within the family. Quilters who have spent their lives keeping their families in pretty but practical blankets and bed coverings turn in retirement to creating a celebratory quilt for each family member, often conferring the gift on a special occasion such as a graduation, marriage, birthday, or baby shower. Some women produce handiwork to exchange with friends in acknowledgment of their relationship. And many artists, both women and men, support churches, social and relief organizations, and civic causes by donating works of art to raffles and benefits.

Receiving recognition, encouragement, and tangible support for their art, many folk artists persist in their work only to find greater renown outside their immediate family and circle of close friends. Soon they must cope with requests for custom work by neighbors, friends of friends, acquaintances, and outright strangers. They must grapple with questions of whether to restrict their audience or take on a broader one, to continue to give work away or to sell it. While only a handful of Wisconsin's folk artists earn a living at what they do, most sell at least a portion of what they make. Relations with clientele, the determination of price, and decisions about whether to compromise the quality of work or the value of one's own time are major concerns.

When Bob Becker purchased his blacksmith shop in 1959, the previous owners "still made sleds and wagons" for local farmers. He does neither today; nonetheless, work for farmers comes first. Besides sharpening sickle bars, mowers, and ploughshares, Becker can take a mangled piece of equipment — a hayrake or a mower euphemistically described as the victim of a "runaway" — and make it "like new" by cutting bent pieces, reshaping them in the heat of the forge, reassembling, and welding. There is a tremendous call for such work in the spring and summer when farmers need their machines, when they cannot get replacement parts quickly, and when they cannot afford new equipment. Even without advertising his skills, Bob Becker is backed up for weeks, and his telephone rings constantly throughout the busy season.

Although he is able to make a respectable living at his trade, Bob Becker is not entirely satisfied. Because many farmers he serves either run large operations or supplement income from the land with some other job, the blacksmith shop is no longer the rural hangout of old where sociability was as important as labor. In

addition, some customers are more concerned with low prices than with patronizing their community's shop; as a result, Becker must now compete with numerous other shops. Many jobs are also routine and leave little time for more challenging ornamental work. And even when he does make fences, gates, railings, spiral staircases, planters, cooking utensils, and fireplace tools, Becker must strike a balance between what he might be able to do and what local people can afford, since he is committed to serving a local clientele (cat. nos. 192-200).

Perhaps the most common artist/customer pattern involves an occasional sale in the artist's home to a local friend or word-of-mouth acquaintance. Local and regional buyers may also be reached through retail outlets and seasonal festivities. A range of stores regularly carries Alvin Stockstad's tobacco axes and spears. The sales of Stephanie Vuljanic Lemke's decorated eggs in a Cross Plains gift shop inspired her not only to continue production but also to increase it in response to custom orders (cat. nos. 130-133). Dozens of other artists attract customers through church bazaars, county fairs, historical society demonstrations, and flea markets.

Else Bigton and Phillip Odden have saturated the local market for their durable, expensive, elaborately carved Norwegian mangle boards, log chairs, chests, and corner cupboards, so they must appeal to a clientele beyond their community. By traveling considerable distances to demonstrate and show their work at ethnic events and institutions, they have attracted heritage-minded Norwegian-Americans in the upper Midwest and across the country (cat. nos. 63-65). By contrast, many Amish — like the Herschberger families who make furniture, quilts, and rugs in the Cashton-Ontario-Westby area — stay at home but rely heavily on the business of "English" tourists and increasingly on dealers who see their signs while passing through the region.

People have told Alvin Herschberger that in urban shops his bentwood Amish furniture sells for double and triple his prices, yet he is steadfast about what he charges. "I think I sell my work at a fair price, and that's what I want to do." Others are not so sure, wondering if $125 is too much or too little for a quilt, suspicious that some customers might attempt to exploit them, or concerned that others might not be able to afford the asked price. Solutions to the dilemma of how much to charge vary widely. Sidonka Wadina Lee turns out numerous straw and ribbon ornaments that are within everyone's price range, but she makes only a few complex straw crosses and is reluctant to sell them unless the price is right (cat. nos. 119-121). Edmunds Mednis quit working in leather because he could not get what he needed in payment for his labor; instead, he began making jewelry, for which he knew there was a steady market.

The desire to control one's work and time is perhaps the most critical factor of all in determining the nature of artist/client relations. Whether they work for pay or not, Wisconsin's folk artists overwhelmingly prefer to do what they do in their own way and at their own pace. Bernice Gross revels in filling custom orders, adapting patterns for quilt blocks and adjusting color schemes to meet the customer's wishes (cat. no. 13). But most traditional practitioners would rather sell their own designs or be given considerable freedom in executing a commissioned piece. Phillip Odden delighted in a recent order for a *drake kist* (dragon chest) in which the customer not only gave him full rein in tailoring the decorations to her life story but also did not restrict the price. In addition, most Wisconsin folk artists do not like to work on demand. If Afro-American carver Clifford Bell has to work

when he is not in the mood, he says this work — by which he makes his living — becomes "too much like a job" (cat. nos. 105-106). Else Bigton rues the imperfections she sees in work turned out too quickly simply to meet deadlines. Those seeking Anton Wolfe's concertinas must content themselves with a two-year wait. Rosemaler Ethel Kvalheim now refuses to work on demand, since she enjoys experimenting with design (cat. nos. 258-259).

Many artists actively resist expanding their clientele in the face of real or anticipated pressures to change their work or accelerate their pace. Norwegians Oljanna Cunneen and Selma Spaanem both try to curtail word-of-mouth knowledge about their skills for fear of having to deal with requests for custom work that they will have to refuse (cat. nos. 66, 101-102). Basket maker Joe Buresh is content to sell a limited range of forms to regular customers on an occasional basis. Likewise, gunstock carver Sam Rust avoids new work, since he labors meticulously "for love, not money" and earns only a pittance for his time. Similarly, chain-saw carver and supper club owner Art Moe will not sculpt a figure unless an interested party has made repeated, and sober, requests (cat. no. 191).

Other traditional artifacts are not used, sold, or given away but are kept for display as mementos and as things of intrinsic beauty. Nikola Milunovich's carvings of Serbian peasants transport him imaginatively to the village of his youth (cat. no. 117). A painted egg, a carved bucksaw-in-a-bottle, an exquisite piece of Armenian needle lace framed and mounted on the dining room wall are likewise contemplated for their own sakes as beautiful examples of objects human beings have made through the generations.

This latter fascination with "things of beauty" has compelled many folk artists to become informed practitioners and a few to become amateur historians of their own traditions. Besides making his own fish lures and fish and duck decoys, Tom Winter avidly collects them (cat. no. 204). Ryszarda Klim reads extensively about the Polish paper cuts called *wycinanki* which she makes (cat. nos. 260-261). These artists and many like them delight in understanding precisely how their own art links them with present and bygone styles and practitioners.

Not surprisingly some combine their artistic and scholarly inclinations by arranging what they make into formal exhibits. Rich Riemenschneider's entire basement serves as the "Duck Hunters Hall of Fame," where ample shelves present decoys of more than fifty species, the labor of half a century, carved in a variety of media and styles (cat. nos. 246-249). Adolph Vandertie likewise treats his home as a museum, guiding school children, scouts, and senior citizens through living room, kitchen, and bedrooms to marvel at the roughly 2,400 pieces that he has whittled since the early 1950s. The "world's longest carved chain" made from a single piece of wood is a special attraction: 217 feet long, weighing less than 2 pounds, possessing 2,821 links. Merrill Bartels takes his show, a complete model of old-time logging operations and the lumber camp, on the road to schools and community events where he relies on his own experience as a woodsman, his voracious reading, interviews with "shanty boys," and the carvings themselves to explain "what it was like."

Beyond seeking to acquire and convey a heightened understanding of the work they do, some folk artists have come to regard themselves as curators of their traditions. Edith Hakamaa learned to weave rugs and linen tablecloths at the age of ten in Finland from her mother, Maria Ketola. Ketola had, in turn, learned from her mother who had learned from her mother and so on through the generations. The

family loom, now kept by a sister in Finland, is reputedly several hundred years old and was acquired by trading flour with itinerant weavers during a time of starvation. Hakamaa realizes that her daily hours at the loom keep her female ancestors' art alive (cat. no. 61).

This sense of responsibility for maintaining a given folk art may reach beyond one's immediate or extended family to include entire ethnic groups, regions, and genres. Sidonka Wadina Lee was inspired by her grandmother, Johanna Birksadsky, a Slovak peasant woman who was determined to preserve her old country traditions in urban Milwaukee. Today, following Birksadsky's lead, Lee teaches wheat-weaving and egg-painting classes to a largely Slovak group at Milwaukee's International Institute, and she demonstrates both art forms for Czech and Slovak societies throughout the state. Emil Pirkel faithfully weaves fish nets year-round out of enjoyment and because he realizes there "ain't a soul around the territory what makes nets no more" (cat. no. 244). And Sigvart Terland clings tenaciously to the techniques he has always used for wooden shoemaking because he considers himself the practitioner of a "dying art" (cat. nos. 108-111).

The assumption of a curator's role, even the practice of folk arts as ubiquitous as chain carving and quilting, invariably confers status — some measure of recognition that one is doing something significant. Nearly all folk artists have a public with whom they seek communication, from whom they wish acceptance, and without whom they cannot be satisfied. That public may be as broad as "from Maine to California," the span of dispersion for Sam Rust's gunstocks. Indeed, men and women alike are thrilled that their handiwork has been found worthy by the many and the distant. Yet many would despair if their creations were not valued primarily within their immediate family, community, and region.

Betty Christenson's Ukrainian eggs have been depicted in folklore brochures, displayed in museum cases, and featured in newspaper articles, yet none of this celebratory attention by outsiders has pleased her nearly as much as that given by her ninety-year-old mother, the teacher she surpassed. Elizabeth Keosian eagerly anticipates Milwaukee's annual Holiday Folk Fair where she will demonstrate the intricacies of making needle lace to throngs of festival goers. The "oohs" and "aahs" of passers-by delight her, but she is more gratified by the praises of fellow Armenian women who work the booth with her. Their attention will persist beyond the brief event. They or their mothers have tried the art, know its difficulty, and are informed judges of excellence.

Beyond recognizing the excellence of a given art, these passionate and knowledgeable judges, these fellow "folk," are able to discern the individual touches that distinguish one practitioner from another. They are able to understand the stylistic nuances that make Elizabeth Keosian's work her own personal expression within a larger tradition. For the uninitiated, one decoy or doily may look like any other, but for those who know, differences are highly evident. No wonder many of Wisconsin's folk artists stress the personal, not the collective, aspects of their work. As Emil Pirkel remarked about his fish nets: "I got my own way to make them."

One's own way may entail making some object in its entirety and according to strict personal standards. Sidonka Lee spends hours in late summer viewing wheat fields for straw of just the right shade and thickness for woven ornaments. Anton Wolfe makes all of the parts of his concertinas — from steel reeds die-

punched on his specially made presses to basswood, birch, and maple boxes milled from his wood lot — in order to achieve the requisite combination of old-time sound and modern appearance.

Just as some of Wolfe's handiwork is hidden within his instruments' interiors in addition to adorning their exteriors, many other traditional artists stamp what they make by means of trademarks which are either apparent or concealed. Edith Hakamaa's Finnish rag rugs uniformly employ the vivid *saimaan allot* or "big lake wave" pattern. In contrast, Bob Becker combines carefully hidden welds with hand painting to give his sectioned spiral staircases a seamless look. Patricia Llamas hides the opening to each piñata's hollow center, but her price tags are prominently decorated with motifs that match the larger artifact's design (cat. no. 262).

The dynamic between overt and covert display as a means of self-expression for some folk artists is paralleled for others by the tendency to vary a given form each time it is made. Carvers typically delight in the grain and luster of diverse woods. Ray Polarski executes the same fiddle pattern from maple and walnut, while bouzouki maker Epaminontas Bourantas adds teak to this duo (cat. nos. 113, 116). Quilters like Sylvia Anderson enjoy producing endless versions of the "grandmother's flower garden," each with its own distinct color combination.

Besides varying materials and colors, some folk artists experiment with scale both as testimony to their own quirky individuality and in friendly competition with others. Eugene Stenroos, his father-in-law Ivar Lehto, his neighbor Steven Maki, and his son Duane Stenroos all constructed model bucksaws-in-bottles ranging from one pint down to two ounces. Duane broke six thin crosspieces for the smallest version before whittling a seventh that held. His signature and date on the artifact stress anything but anonymity; indeed, they express a hope that the maker's name and work will last (cat. nos. 9-12).

Perhaps this lasting notoriety is what John Henkelman had in mind when he carved himself as the top-loading logger of a miniature crew (cat. no. 190). Perhaps this is what Vera Mednis had in mind when she said that each Latvian potter, by individually varying traditional designs, "puts his own face" on a pot. Perhaps this is what Emil Pirkel had in mind when, in praise of the nets he learned to weave from Johnny Schwab, he reckoned: "Store-bought ones wear out. These last." Perhaps this is ultimately what all of Wisconsin's folk artists have in mind by persisting in what they do; by making useful, satisfying objects when ready-made ones might do; by joining their cultural forms and their personal vision with a continuum of practitioners, past, present, and to come.

James P. Leary and Janet C. Gilmore
Field Researchers

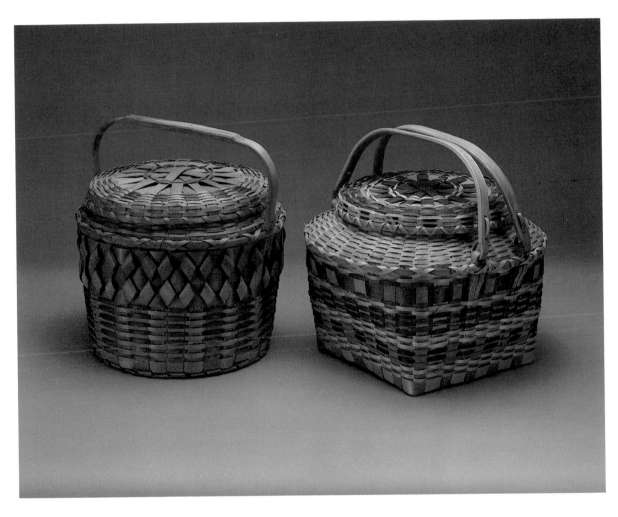

*1-2 Florence Boyce Whitewing and Ethel Storm Whitewing-Weso, PICNIC BASKETS, 14¼ x 14 x 13½" and
13⅞ x 14½ x 14¾"*

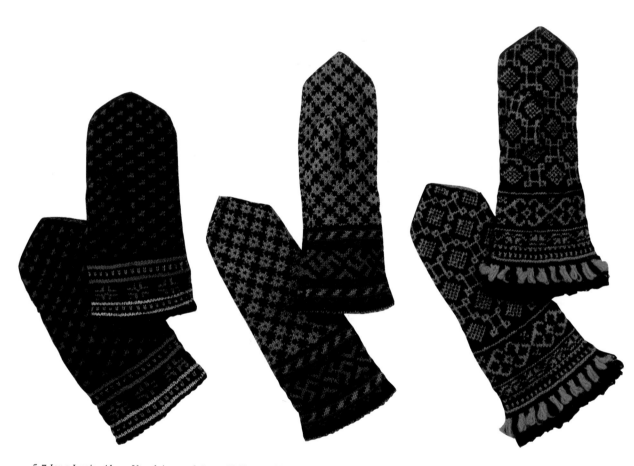

5-7 Ieva Lacis, Alma Upesleja, and Anna Vejins, LATVIAN MITTENS, 9½ x 4½", 11 x 4¼", and 11¾ x 5½"

14 Allie M. Crumble, NECKTIE QUILT, 87 x 72"

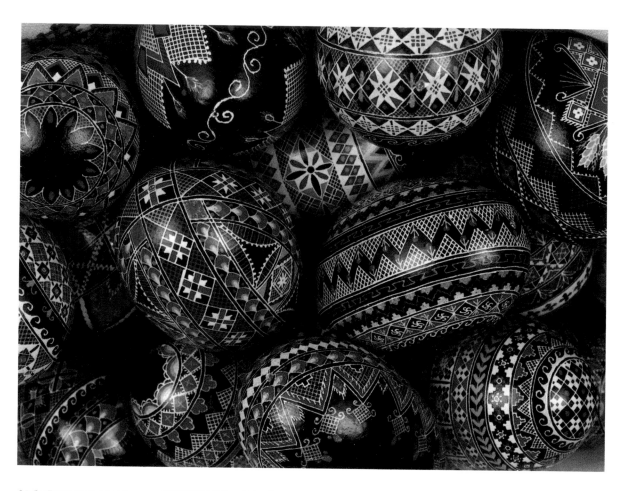

38-57 Betty Pisio Christenson, PYSANKY, 2½ x 1½" dia. to 3½ x 2¼" dia.

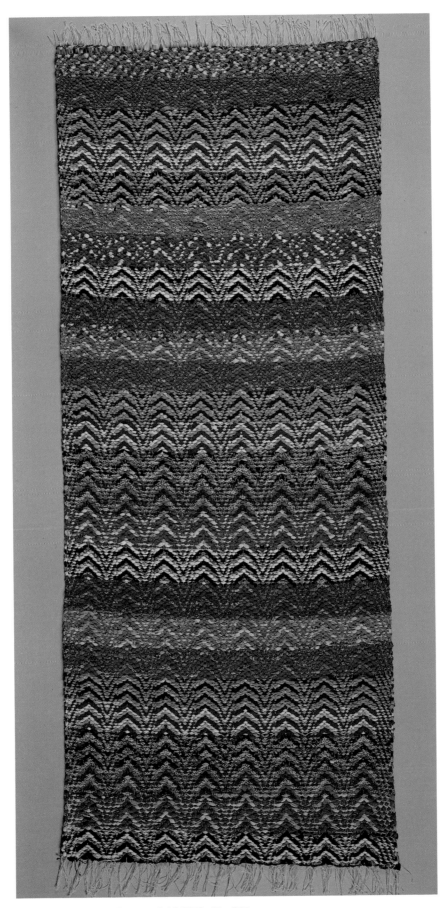

61 Edith Hakamaa, RAG RUG, 60 x 25"

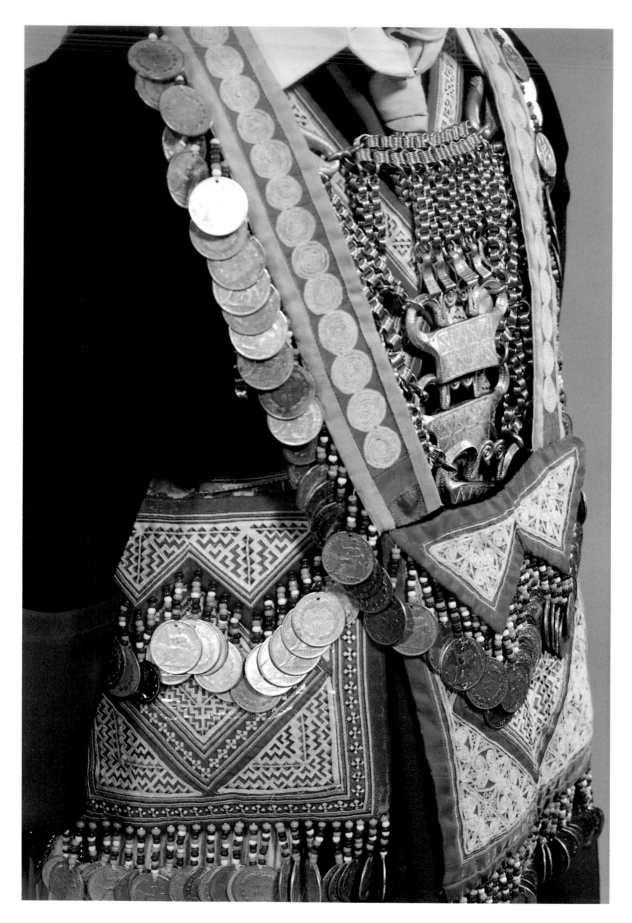

28 *Detail of White Hmong costume created by Xia Xiong in 1983 after coming to Wisconsin from Laos.*

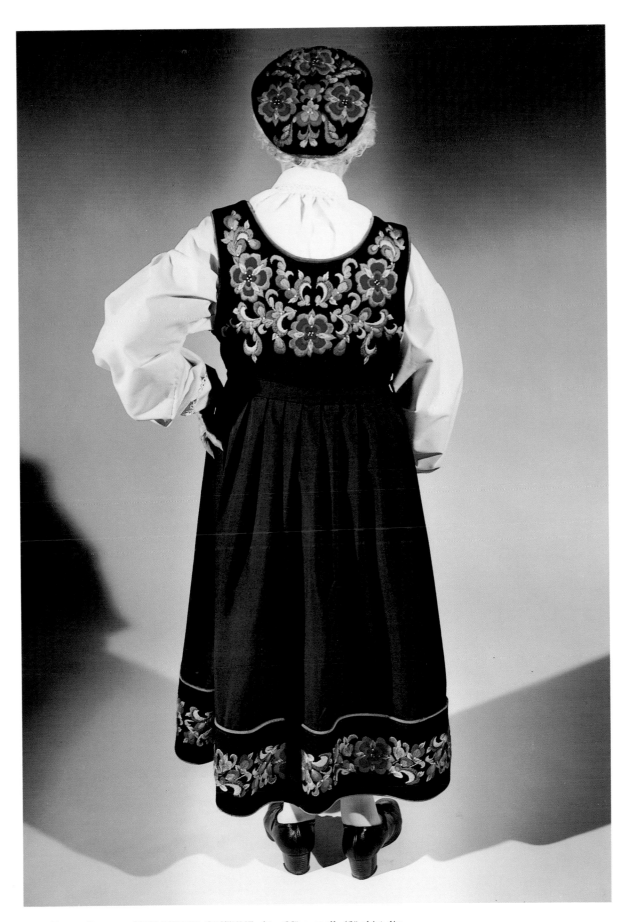

102 Oljanna Cunneen, HALLINGDAL COSTUME, 47 x 66" overall, 42" skirt dia.

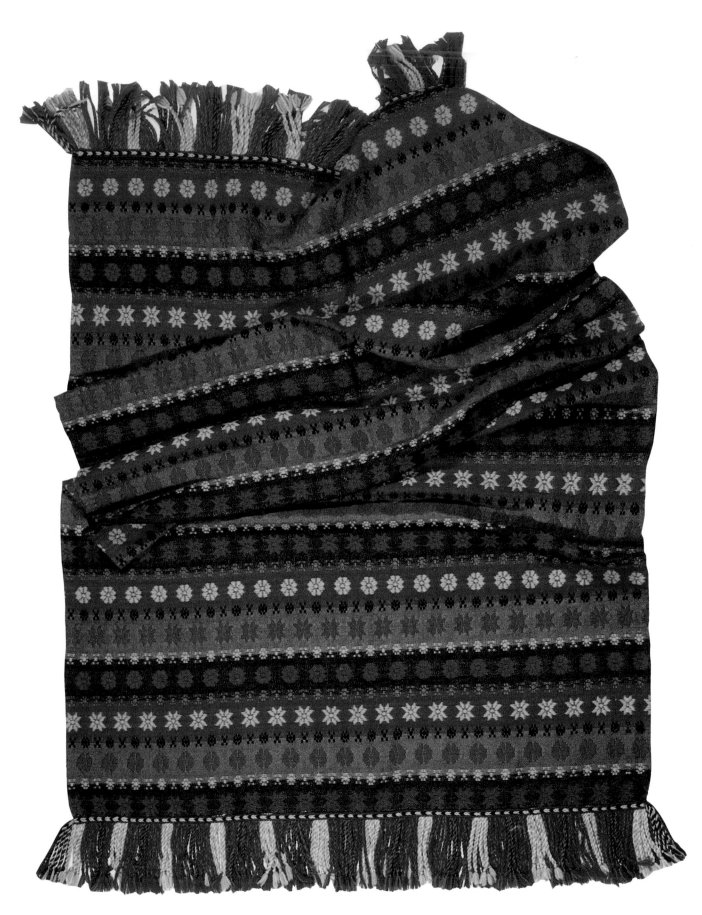

107 Vera Mednis, WOVEN SKIRTING, 32 x 60"

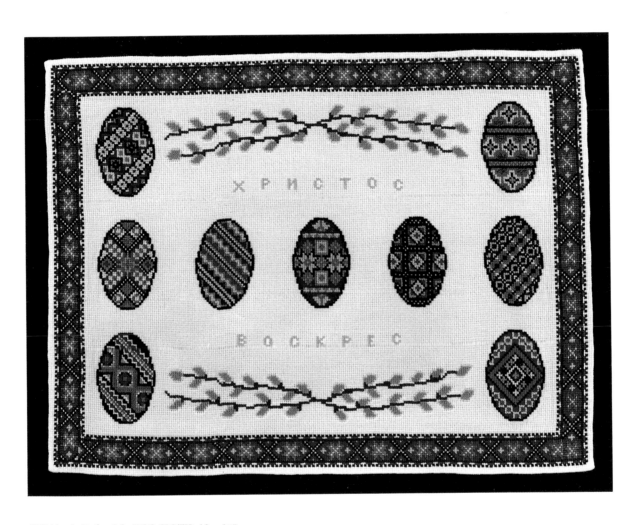

135 Maria Fafendyk, EGG CLOTH, 13 x 17"

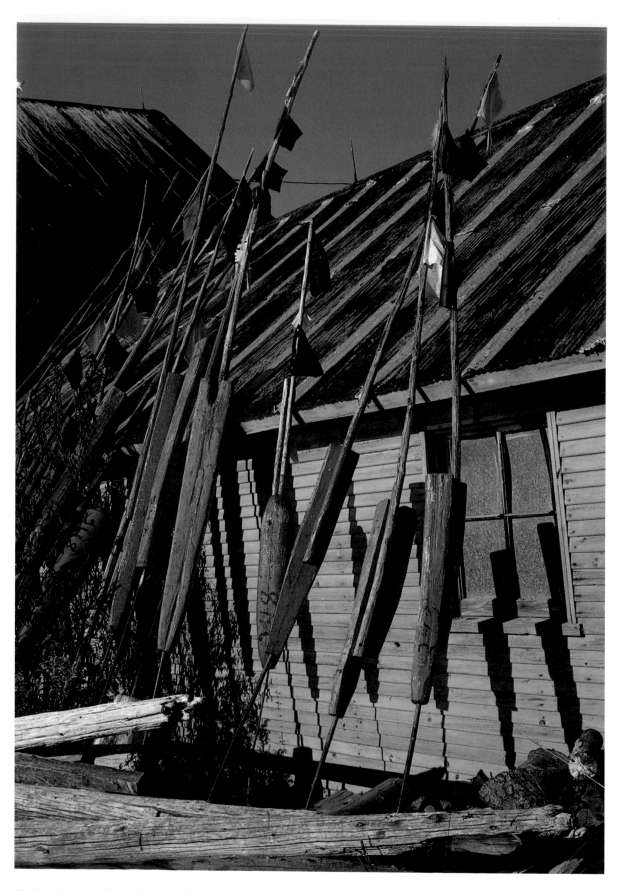

Handmade marker buoys lean against a fish shanty in Gills Rock, Door County.

201 Ivan Bambic, WHIRLIGIG, 17½ x 15¼ x 13½"

33

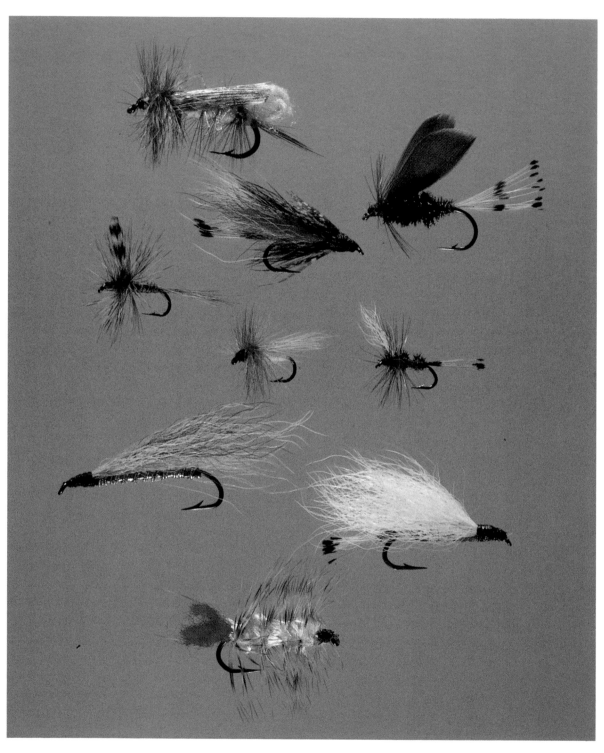

205-243 Delbert Richardson, FISHING FLIES, ⅜ x ⅜" dia. to ½ x 1¼ x 1"

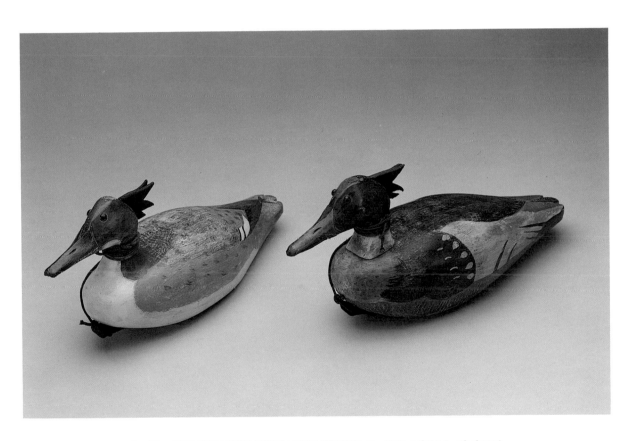

248-249 Rich Riemenschneider, RED-BREASTED MERGANSER DECOYS, 7 x 17 ½ x 5 ½ " (each decoy)

260 Ryszarda Klim, SUN PAPER CUT (WYCINANKI), 12 x 12"

CATALOGUE OF OBJECTS
AND ILLUSTRATIONS

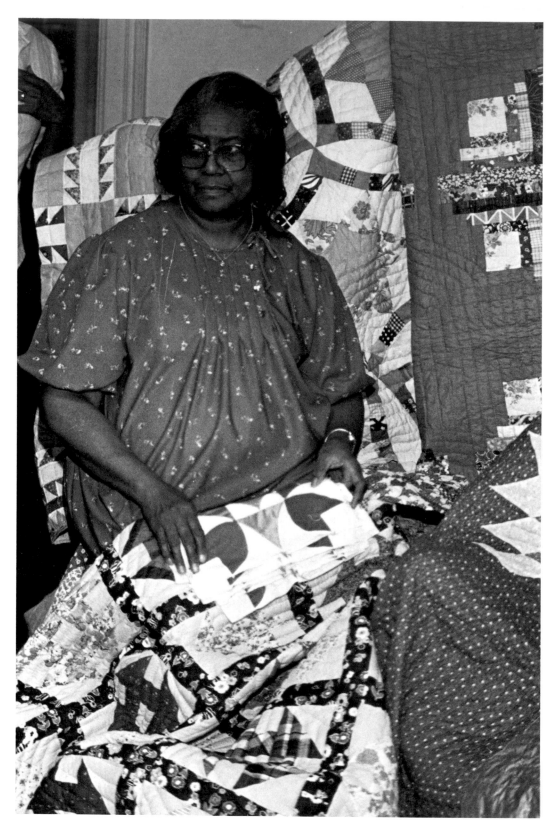

Allie Crumble holds several pieced blocks which she will use in one of her quilts.

PART I. TRADITION IN WISCONSIN FOLK ART

Since the early 1930s when the first formal exhibitions of American folk art were mounted, the term "folk art" has been variously defined. Holger Cahill characterized it as "the art of the common man." Others described it as simple, naive, or technically unsophisticated. Still others have included idiosyncratic works by self-taught or outsider artists under the category of "folk art."

Recently, scholars in the disciplines of folklore, anthropology, and art history have proposed more stringent criteria for defining folk art. They assert that folk art is 1) *traditional* in nature; 2) based upon a *communal aesthetic* shared by artists and audiences within various groups; and 3) passed along from master to student via *informal instruction*. The objects selected for inclusion in FROM HARDANGER TO HARLEYS: A SURVEY OF WISCONSIN FOLK ART conform to these criteria.

Tradition is a concept critical to a full understanding and appreciation of folk art. Tradition implies both continuity and stability over time. Like the Winnebago baskets and Latvian mittens included in this exhibition, many of Wisconsin's folk arts have been handed down from generation to generation over decades, even centuries. Although the conditions surrounding their creation and use may have changed, the art forms themselves have remained much the same. They reflect the community values of consistency, continuity, and commonality.

Wisconsin's folk arts are traditional in nature but are not fixed or unchanging. Established forms vary gradually as artists and their communities adopt new materials and technologies. Repertoires also expand as artists exercise their creativity within the limitations of the tradition. New traditions emerge even as established art forms flourish or decline.

Dimensions are in inches followed in parentheses by centimeters. Height precedes width precedes depth. Works have been loaned by the artist unless otherwise noted.

Florence Boyce Whitewing (1893-1985)
1 **PICNIC BASKET**
 Circa 1915
 Black ash splints, woven; black ash, carved and bent; aniline dyes; 14¼ x 14 x 13½ "
 (36.2 x 35.6 x 34.3 cm)
 From the Ahooska Collection, Wisconsin

The tradition of weaving Winnebago black ash baskets has been passed down over five generations in the Whitewing family. Whitewing, who wove this round-bottomed picnic basket in 1915, represents the second generation of basket weavers in the family. The single stable handle on such baskets was typically carved by men of the family who were also responsible for the preparation of the splints. This basket is distinguished by the use of aniline dyes to color some splints and by rows of looped splints.

Ethel Storm Whitewing-Weso
Wittenberg
2 **PICNIC BASKET**
 Circa 1955
 Black ash splints, woven; black ash, carved and bent; aniline dyes; 13⅞ x 14½ x 14¾ "
 (35.2 x 36.8 x 37.5 cm)
 From the Ahooska Collection, Wisconsin

Whitewing-Weso is the daughter of Florence Boyce Whitewing and a third generation Winnebago basket maker. She wove this picnic basket forty years after her mother's example also featured in the exhibition. Unlike the earlier picnic basket, this one has a square bottom, a more pronounced shoulder, and double folding handles.

Georgianna Whitewing Funmaker
Wittenberg
3 MARKET BASKET
1975
Black ash splints, woven; black ash, carved
and bent; aniline dyes; 13 x 13½ x 9″
(33 x 34.3 x 22.9 cm)
From the Ahooska Collection, Wisconsin

Constructed twenty years after Whitewing-
Weso's picnic basket, Funmaker's oblong market
basket attests to the conservative nature of folk
tradition as well as the potential for change
which exists within its limits.

Beatrice Link Soldier
Wittenberg
4 MEDICINE BASKET
1969
Black ash splints, woven; aniline dyes;
1¾ x 2¼ x 2¼″ (4.4 x 5.7 x 5.7 cm)
From the Ahooska Collection, Wisconsin

Originally created as a container to store medi-
cine, this miniature black ash basket was given to
Gloria Ahooska for the purpose of protecting
her basket collection. In order to assure the well-
being of any baskets separated from the main
group, the medicine basket must go with them.

Alma Upesleja
Milwaukee
5 MITTENS
1969
Wool, knitted; 11 x 4¼″ (27.9 x 10.8 cm)

The tradition of knitting intricately patterned
Latvian mittens extends over more than four
generations in the family of Alma Upesleja. As a
child in her Latvian homeland, Upesleja learned
to knit mittens with complex symbolic designs.
Her teacher was her grandmother Ieva Lacis. In
turn, Upesleja passed along the tradition to her
daughter, Anna Vejins. Both women continue to
knit these colorful hand coverings for the Lat-
vian community in Milwaukee.

A distinctive part of Latvian regional costume,
mittens also played a central role in the culture's
courtship rituals. A woman's value as a wife was
based in part upon the quality and quantity of
the handwork that she prepared for her dowry.

Ieva Lacis (1856-1940)
6 MITTENS
1920
Wool, knitted; 9½ x 4½″ (24.1 x 11.4 cm)
Loaned by Alma Upesleja and Anna Vejins,
Milwaukee

Anna Vejins
Greenfield
7 MITTENS
1954
Wool, knitted; 11¾ x 5½″ (29.8 x 14 cm)

Anna Vejins
Greenfield
8 CHILD'S MITTENS
1960
Wool, knitted; 9¾ x 3¼″ (24.8 x 8.3 cm)

While most Latvian mittens have large, loosely
fitting cuffs which extend over the fitted sleeves
of the traditional jacket or coat, this child's pair

of mittens features a tightly fitting ribbed cuff. In
this instance, Vejins adapted the traditional Lat-
vian design to fit under the loose cuffs of most
American outerwear. Traditions thus evolve and
change in response to new circumstances.

Eugene Stenroos
Hurley
9 BUCKSAW-IN-A-BOTTLE
1984
Glass bottle; cedar, carved and painted;
metal saw blade; string; 7⅜ x 3¼ x 1⅛″
(18.7 x 8.3 x 2.9 cm)

Just as sailors sometimes placed miniature
schooners in bottles, so did lumberjacks encase
the tools of their trade in whisky flasks. Stenroos
and his Finnish-born father-in-law, Ivar Lehto,
learned the secrets of placing bucksaws in bot-
tles from their neighbor, Steven Maki. Maki, an-
other Finn, learned the technique in the lumber
camps of Iron County in the early 1900s.
Stenroos has passed the tradition along to two
sons who have undertaken the challenge of
using still smaller bottles.

Steven Maki (1888-c. 1975)
Montreal, Wisconsin
10 BUCKSAW-IN-A-BOTTLE
1962
Glass bottle; cedar, carved and painted;
metal saw blade; string; 9 x 3¾ x 1¾″
(22.9 x 9.5 x 4.4 cm)
From the collection of Eugene Stenroos,
Wisconsin

Ivar Lehto (1892-1964)
Ironwood, Michigan
11 BUCKSAW-IN-A-BOTTLE
1956
Glass bottle; cedar, carved and painted;
metal saw blade; string; 9 x 3¾ x 1¾″
(22.9 x 9.5 x 4.4 cm)
From the collection of Eugene Stenroos,
Wisconsin

Duane Stenroos
Hurley
12 BUCKSAW-IN-A-BOTTLE
1976
Glass bottle; cedar, carved and painted;
metal saw blade; string; 4½ x 1¾ x ¾″
(11.4 x 4.4 x 1.9 cm)
From the collection of Eugene Stenroos,
Wisconsin

Bernice Gross
Hillsboro
13 KANSAS MYSTERY QUILT
Circa 1981
Cotton and polyester fabric, cut, machine
pieced, and hand quilted; polyester
batting; 103 x 86″ (261.6 x 218.4 cm)

Bernice Gross has been an active member of the
First Congregational Church quilting group
since moving to Hillsboro in 1956. The quilters
meet twice a week from March through May,
quilting from 9:00 a.m. until 4:00 p.m. each day
and then sharing a potluck supper. The money
earned through the group's quilting of bed
coverings is used to fund church projects. At
present the group includes eight regular mem-
bers ranging in age from seventy to ninety-
seven.

Bernice Gross created this "Kansas Mystery Quilt" for presentation to one of her grandsons on the occasion of his marriage. Gross selected the pattern, her grandson chose the colors, and she pieced and quilted the spread at the quilting frame in her dining room. The quilter has created similar pieces for each of her children and grandchildren.

Allie M. Crumble
Milwaukee
14 **NECKTIE QUILT**
1982
Polyester fabric, cut, hand pieced, and hand quilted; necktie parts, hand appliquéd; polyester batting; 87 x 72"
(221 x 182.9 cm)

Crumble's "Necktie Quilt" is an Afro-American variation on the familiar album or friendship quilt. It represents the male membership of Milwaukee's Metropolitan Baptist Church. Beside each tie Crumble has embroidered the name and title of the donor, beginning with the clergymen and deacons at the top and continuing with the brothers of the congregation.

Adolph Vandertie
Green Bay
15- **WOODCARVINGS**
33 **1984-1986**
Basswood, hand carved; 9½ x ⅜ x ⅜"
(24.1 x 1 x 1 cm) to 15½ x ½ x ½"
(39.4 x 1.3 x 1.3 cm)

The seemingly infinite variations of Vandertie's woodcarvings signify the role of individual creativity within the bounds of tradition. Vandertie works from a stock of basic forms and puzzles known to most woodcarvers — caged balls, linked chains, pivots, and swivels. These he combines and recombines. Over the past thirty-one years, Vandertie's mastery of the vocabulary of forms in combination with his personal genius has enabled him to create more than 2,400 unique works.

Vita V. Kakulis
Bayside
34 **BELT**
1977
Wool and linen, woven; 133 x 2"
(337.8 x 5.1 cm)

In addition to creativity, the master folk artist is valued by the community for his or her technical virtuosity. Kakulis' technical accomplishments as a Latvian weaver are attested to by this belt which she made as part of her own ethnic costume. It consists of some of the most complicated patterns from the Lielvarde region. No pattern is repeated more than once. As a result, each inch of the belt's length required one hour of weaving time, or a total of over one hundred hours.

Vita V. Kakulis
Bayside
35 **BELT**
1978
Wool, braided; 114 x 1½" (289.6 x 3.8cm)

Kakulis' belts reflect styles and techniques from various regions and locales in Latvia. Her braided green twill belt is usually worn by men from Krustpils township in the Vidzeme region. The orange and green example is a typical woman's belt from Jaunpiebalga, Latvia. The red, white, and blue belt is for women from Kakulis' home region of Valmiera.

Vita V. Kakulis
Bayside
36 **BELT**
1987
Wool, woven; 118 x 2½" (299.7 x 6.4 cm)

Vita V. Kakulis
Bayside
37 **BELT**
1987
Wool and linen, woven; 122 x 2"
(309.9 x 5.1 cm)

Betty Pisio Christenson
Neenah
38- **PYSANKY**
57 **1987**
Eggs, dyed using wax-resist technique; shellac; 2½ x 2½" dia. (6.4 x 6.4 cm dia.) to 3½ x 2¼" dia. (8.9 x 5.7 cm dia.)

Christenson's Ukrainian *pysanky* demonstrate the intricacy and technical complexity of many folk traditions. Through repeated applications of the wax-resist method of decoration, Christenson is able to create countless combinations of pattern and color. The resulting designs symbolize the resurrection of Christ in Ukrainian culture.

Ukrainian eggs like those by Christenson have taken on a meaning beyond their religious significance. *Pysanky* have become so closely identified with Ukrainian ethnicity that they also function as political symbols protesting domination of the Ukrainian homeland by the Soviet Union.

Willie G. Davidson
Milwaukee
58 **CUSTOMIZED SHOVELHEAD HARLEY-DAVIDSON WIDE GLIDE**
1982
Harley-Davidson Wide Glide, customized; 48 x 90 x 38" (121.9 x 228.6 x 96.5 cm)

The "customizing" of vehicles has emerged as a form of folk art over the last few decades. Willie G. Davidson, Design Director and Vice-President of Harley-Davidson, Inc., is a true motorcycle customizer. He is a lifelong rider and frequent participant at motorcycle events throughout the country. He understands and values the aesthetics of motorcyclists and customizers.

Throughout 1982 and 1983, "Willie G." designed and modified this Shovelhead Harley-Davidson Wide Glide for his own use. The cycle features coordinated dark maroon and black colors on the engine and chassis. Fuel tanks carry a buried Harley-Davidson bar and shield logo. A solid 16" disc style rear wheel balances a laced 21" front wheel. An 80 cu. in. (1340cc) engine equipped with twin belt drive powers the cycle. Braided stainless hoses, custom leather accessories, and a host of other features complete the custom package. Based on the positive rider response to Davidson's own custom cycle, Harley-Davidson, Inc., subsequently manufactured a limited edition of the bike which sold out immediately.

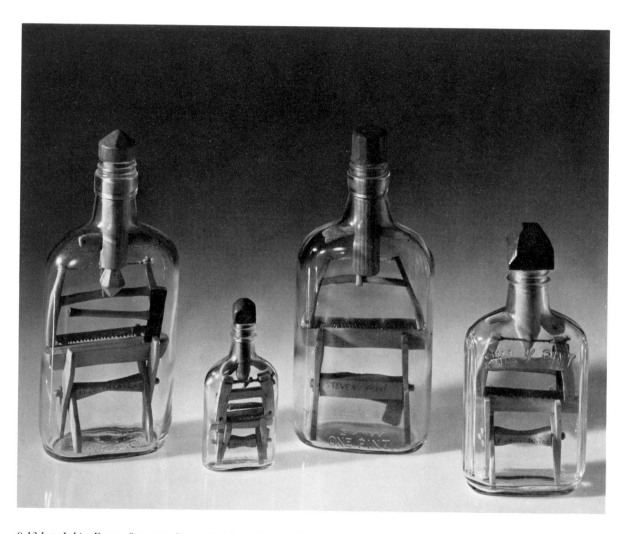

9-12 Ivar Lehto, Duane Stenroos, Steven Maki, and Eugene Stenroos, BUCKSAWS-IN-BOTTLES, 9 x 3¾ x 1¾",
4½ x 1¾ x ¾", 9 x 3¾ x 1¾", 7⅜ x 3¼ x 1⅛"

13 Bernice Gross, KANSAS MYSTERY QUILT, 103 x 86"

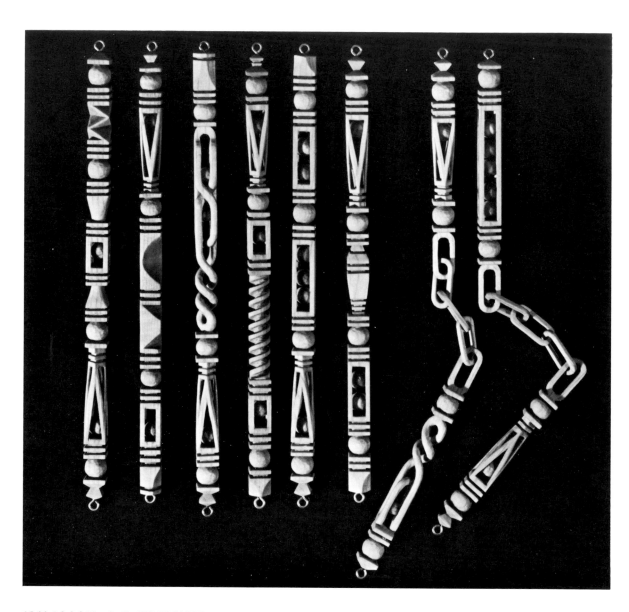

15-33 Adolph Vandertie, WOODCARVINGS, 9½ x ⅜ x ⅜" to 15½ x ½ x ½"

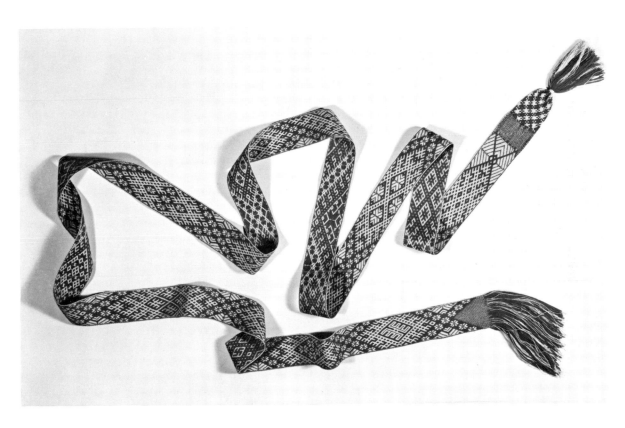

34 Vita Kakulis, LATVIAN BELT, 133 x 2"

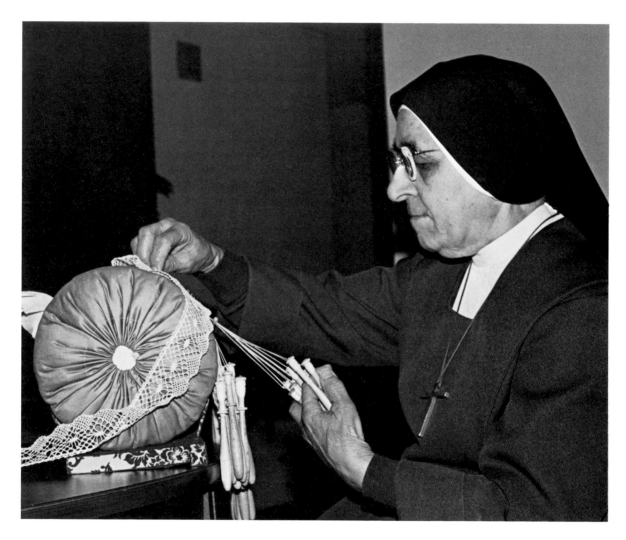

Sr. Mary Crucifix Polimeni creates bobbin lace borders for the convent's altar cloths.

PART II. COMMUNITY IN WISCONSIN FOLK ART: HOME AND FAMILY

Although created by individual artists, Wisconsin's contemporary folk arts belong to the ethnic, regional, occupational, and religious communities which have sustained these traditions.

Community audiences play an active role in shaping and reshaping the shared aesthetics governing individual folk arts. Community members accept and approve the forms, patterns, colors, and techniques appropriate to their basketry, quilting, woodcarving, and needlework. They consider and sanction the introduction of new tools and materials and other variations from earlier norms. Community members also discourage or reject idiosyncratic departures from the aesthetic canon that the group has developed. In this way, they support and sustain the cultural values embodied in their folk arts.

Within many ethnic, regional, occupational, and religious communities, a smaller unit plays an instrumental role in the transmission of artistic traditions and the teaching of traditional values and beliefs. This smaller unit is the family. Parents and grandparents frequently serve as master artists who pass along skills and techniques to younger apprentices. Other family members become the principal audience for the folk arts created. The quilts, rugs, furniture, and needlework crafted by one generation for another represent the continuation of an ethnic or religious tradition and symbolize the unity of the family past and present.

Martha Yoder
Amherst
59 **QUILT**
1981
Polyester and cotton fabric, hand quilted;
polyester batting; 102 x 91″
(259.1 x 231.1 cm)
From the collection of David Hodge,
Wisconsin

Yoder's quilt is typical of Amish needlecraft in its extreme simplicity, its use of a single color, and its exceptionally fine craftsmanship. When asked by the purchaser to sign the quilt, Yoder quilted her name, the date, her place of residence, and her zip code beneath the quilt's central feather-patterned medallion.

Tamer Givens
Milwaukee
60 **BOW-TIE QUILT**
1986
Polyester fabric, cut, machine and hand
pieced, and hand quilted; polyester
batting; 88 x 81″ (223.5 x 205.7 cm)

Tamer Givens' vibrant "Bow-tie Quilt" reflects the artist's Afro-American heritage. Though the pattern is common to both Anglo-American and Afro-American quilting traditions, Givens' use of bright red bands between vertical rows of blocks recalls a type of "strip quilt" made by black quilters in the American South. The "strip quilt,"

in turn, resembles the patterning of African textiles which were assembled from narrow strips of woven fabric. Givens' Afro-American aesthetic is further reflected in her use of bold colors, large designs, and improvisational change in the patterning.

Edith Hakamaa
Ironwood, Michigan
61 **RAG RUG**
1985
Polyester fabric, cut, sewn into strips, and
woven; string; 60 x 25″ (152.4 x 63.5 cm)

The loom on which Edith Hakamaa learned to weave in her native Finland had been in her family for generations. The loom on which she now weaves rag rugs was built by her husband Eino in 1960, the year the couple came to Wisconsin. This rag rug makes use of a pattern called *saimaan allot* (literally, "big lake wave") learned from her mother.

Alvin J. Herschberger
Westby
62 **DOUBLE ROCKER**
1986
Hickory saplings, steam bent and clinch
nailed; oak slats and rockers, sawn,
planed, and steam bent; sealer;
polyurethane finish; 43 x 38½ x 33½ ″
(109.2 x 97.8 x 85.1 cm)

Alvin Herschberger and his brother make bent hickory furniture in the Amish community in the Cashton-Ontario-Westby area. Both apprenticed with local masters. Alvin's double rocker is noteworthy for the changes made in his teacher's basic pattern. He has added rings on the rocker's back and a second piece on the arm for greater strength. Dipped seats have replaced the flat bottoms, and separated back slats provide greater comfort.

Else J. Bigton
Barronett
63 **MIRROR FRAME**
1985
Basswood, carved; 30 x 17½ x 3 ″
(76.2 x 44.5 x 7.6 cm)

Bigton and her husband Phillip Odden met while students at one of two schools in Norway where students learn traditional cabinetry and carving from a master craftsman. While Odden chose to specialize in woodcarving, Bigton opted for a concentration in furniture making. The couple collaborate on many pieces produced by the shop they operate in Barronett called Norsk Wood Works. Bigton is generally responsible for the design and building of major furniture pieces, such as hutches, tables, and chairs.

Phillip Odden
Barronett
64 **KUBBESTOL**
1982
Basswood, carved; 38 x 20″ dia.
(96.5 x 50.8 cm dia.)

Kubbestoler, or log chairs, like this one by Phillip Odden have been used in Scandinavia since medieval times. The simplicity of their production also made them a popular furnishing with Norwegian-American immigrants.

To create a log chair, a section of a tree trunk is hollowed out and carved to fit the body. A plank seat is added but loosely set so it will not cause stress when the log contracts.

Phillip Odden
Barronett
65 **MANGLETRE**
1986
Butternut, carved and joined;
5½ x 27 x 5″ (14 x 68.6 x 12.7 cm)

The Norwegian *mangletre* was originally a functional object. A predecessor to the iron, it was used to press wrinkles from damp linen. Later, the *mangletre* took on increased symbolic meaning. An elaborately carved mangle board became the expected engagement gift, carved by a young man for his intended.

Selma Spaanem
Mount Horeb
66 **HARDANGER LACE**
1970
Cotton fabric, cut, drawn, and
embroidered with cotton thread; 10 x 10″
(25.4 x 25.4 cm)

While both Spaanem's mother and aunt made Hardanger lace, she did not learn to fashion this type of needlework from either of them. Rather, about fifteen years ago, she studied with Marie Jensen, one of Mt. Horeb's acknowledged experts.

Characteristic of the Hardanger region of Norway, Hardanger lace making has become popular among other Scandinavian-American groups and among American needleworkers in general. The similarity of its basic techniques — cutting and drawing threads, darning, and overstitching — to those used by other groups has encouraged cross-cultural adaptations.

Mary Arganian
Madison
67 **ARMENIAN NEEDLE LACE DOILY**
1930
Cotton thread; 8½ ″ dia. (21.6 cm dia.)
From the collection of Janet C. Gilmore
and James P. Leary, Wisconsin

Although Arganian saw her mother create Armenian needle lace and cutwork in Turkey, she did not receive instruction in these arts until she participated in "crafts days" at her Armenian school in Lebanon. Much of her needlework is part of an ethnic tradition of lavish hospitality toward guests. Cutwork adorns tablecloths, napkins, and hand towels. Needle lace doilies decorate furniture and set off fine china.

Anna Vejins
Greenfield
68 **TABLECLOTH**
1948
Linen, cut and embroidered with linen
thread; 30 x 30″ (76.2 x 76.2 cm)

The traditional artistry of two generations of Anna Vejins' family is reflected in this drawn-work tablecloth. In 1944, before leaving her native Latvia, Vejins' mother, Alma Upesleja, raised flax on the family's farm. She processed it and wove this material. In 1948, Vejins transformed the cloth by using the traditional "pull thread" technique.

Rosa Llanas
Waukesha
69 **DESHILADO DISH TOWEL**
1965
Muslin fabric, cut, drawn, and
embroidered with cotton floss; 25 x 25″
(63.5 x 63.5 cm)

Within Wisconsin's Mexican-American communities, a form of lacy, floral openwork called *deshilado* has long been employed to decorate utilitarian items such as dish towels, napkins, tortilla covers, pillowcases, and doilies.

This dish towel incorporates colored thread to set off the substantial areas of drawnwork. The colors of the added threads are carried over into a crocheted border of fan shapes. Such needlework has provided Llanas with an expressive outlet for her creative energies as well as relaxation from the tasks associated with raising a family of fifteen children.

Sister Mary Crucifix Polimeni, S.C.S.J.A.
Milwaukee

70- **BOBBIN LACE**
72 **1933 and 1986-87**
Crochet thread, twisted; 41 x 1¼ "
(104.1 x 3.2 cm); 19 x 1½ " (48.3 x 3.8 cm);
and 150 x 1¾ " (381 x 4.4 cm)

Sister Mary Crucifix Polimeni learned embroidery and lace making as an eleven-year-old schoolgirl in Reggio Calabria, Italy. Her instructors were nuns who taught in the school she attended. The star-patterned border in the exhibition was intended to decorate an altar cloth. It was begun in the 1930s and completed fifty years later. To create her bobbin lace, Sister Mary Crucifix fastens a pattern to a cylindrical pillow. Pins placed at critical points in the pattern serve as posts around which threads attached to bobbins are twisted.

Elsie Niemi
Dane

73 **HAND TOWEL WITH TATTED BORDER**
1948
Linen towel; cotton thread, tatted;
21¼ x 14⅛ " (54 x 35.9 cm)

Elsie Niemi learned the basics of knitting and crocheting from her mother when she was about ten years old. A bit later, she learned tatting from a Finnish neighbor girl in her hometown of Hancock, Michigan. Throughout her life, Niemi has sewn clothes for her family, knitted socks and sweaters for the Red Cross, and completed hundreds of other needlework projects.

During the late 1940s and 1950s, Niemi tatted edging for linen hand towels like this one as wedding gifts for her nieces. Her handwork, though learned from fellow Finns, may reflect a greater orientation to home and family than to ethnic identity. Niemi's stitchery allows her to "make something out of nothing" in the way her mother, siblings, and friends have always done.

Elsie Niemi
Dane

74- **TATTED MEDALLIONS**
79 **1987**
Cotton thread, tatted; 1 - 1⅜ " dia.
(2.5-3.5 cm dia.)

Though Elsie Niemi created most of her tatting and embroidery in the 1950s, she has recently put her pre-1928 tatting shuttle back to use in order to create these medallions for her granddaughter. They will be attached to a cloth backing and transformed into decorative flowers on needlework stems.

Anna Wigchers
Rice Lake

80- **CANNED FRUITS AND VEGETABLES**
89 **1986**
Preserved fruits and vegetables;
each 5 x 3 x 3 " (12.7 x 7.6 x 7.6 cm)

Wigchers was born and raised on a farm in the Rice Lake area. Both of her parents were Danish immigrants. Her mother planted and cultivated a huge garden each year and maintained an apple orchard. She put up between 500 and 600 quarts of canned goods annually and entered many examples of her work in local competitions.

Like her mother, Wigchers enjoys the challenge of bringing beauty to the utilitarian tasks of growing and preserving foods. During the past year she submitted canned goods in almost every category listed in the Barron County Fair's premium book. She won blue ribbons for her canned corn, dill pickles, sauerkraut, and whole raspberries. She also garnered fifty-five ribbons for flower growing and floral arrangements submitted for judging at this year's fair.

Pascalena Galle Dahl
Mineral Point

90- **CANNED MUSHROOMS AND**
92 **TOMATO/GREEN PEPPER MIXTURE**
1986
Preserved vegetables; each 7 x 4 x 4 "
(17.8 x 10.2 x 10.2 cm)

Pascalena Galle Dahl lives in the Italian-American neighborhood of Mineral Point where she was raised. She continues to practice many of the same foodways learned during her childhood. The green pepper and tomato mixture which she prepares each year consists of produce grown in her garden. It is used as the basic sauce for cooking pork chops and chicken. It is also frequently cooked with whisked eggs to form the stuffing for a traditional fried bread called *sepoli*, often eaten as an everyday snack in the Galle Dahl household.

62 Alvin Herschberger, AMISH DOUBLE ROCKER, 43 x 38½ x 33½"

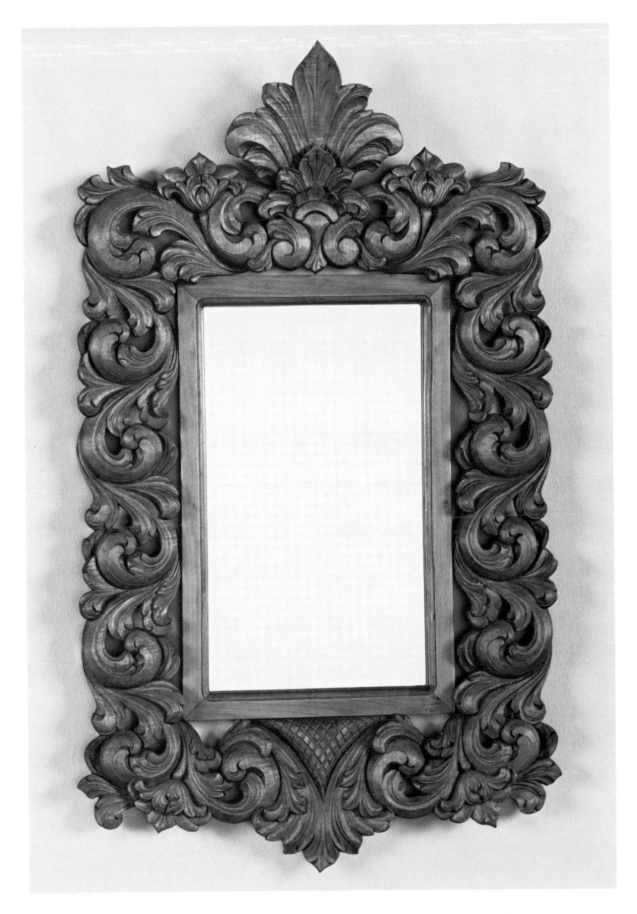

63 Else Bigton, MIRROR FRAME, 30 x 17½ x 3"

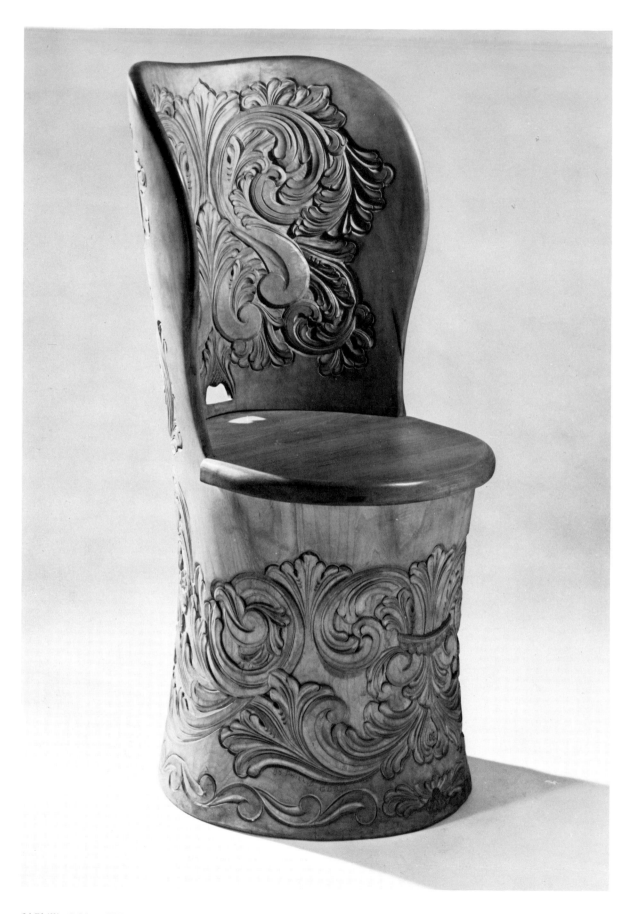

64 Phillip Odden, KUBBESTOL, 38 x 20" dia.

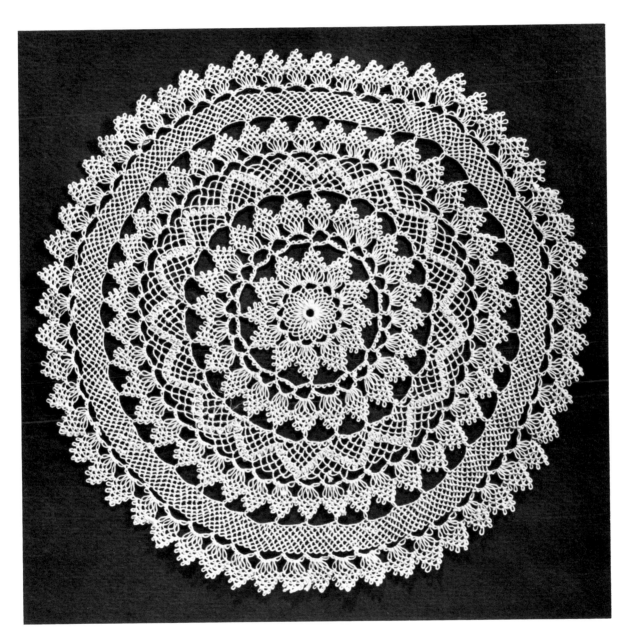

67 Mary Arganian, ARMENIAN NEEDLE LACE DOILY, 8½" dia.

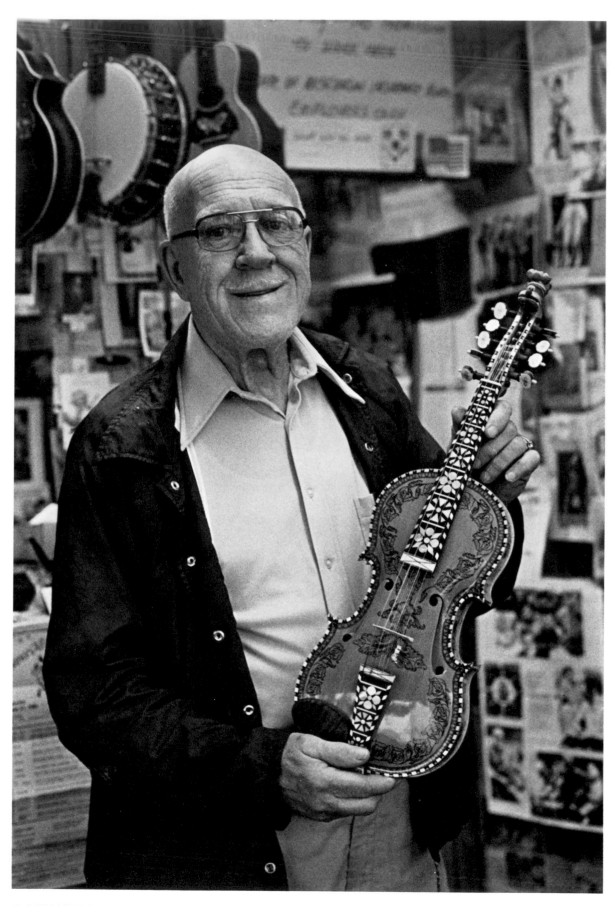

54 *C. C. ''Rich'' Richelieu holds a Hardanger fiddle made in his shop in Oregon, Wisconsin.*

PART III. COMMUNITY IN WISCONSIN FOLK ART: ETHNICITY

Many of Wisconsin's ethnic folk traditions are intended for use in the home. Their audience is limited to family and friends. Many other ethnic folk arts address larger audiences — the ethnic community as a whole and the general public. These traditional arts serve both as personal expressions and as public emblems of ethnicity.

Artifacts used in community celebrations and religious rituals possess the broadest symbolic meaning. Ethnic costumes proclaim national identity and sometimes indicate regional affiliations, marital status, and economic class. Specialized ethnic musical instruments, like Greek bouzoukis and Yugoslavian tamburitzas, represent both the group's musical heritage and the ethnic community itself.

The range of ritual objects created by Wisconsin folk artists especially for religious celebrations is extensive. Straw Christmas ornaments, wood icons, painted wedding certificates, and wheat crosses express the religious commitment of their makers. Some of these ethnic folk arts transcend the usage and meaning that religious celebrations assign them. For example, elaborately decorated eggs are an integral part of Ukrainian Easter celebrations, but they have also come to represent the ethnic community and even larger issues such as the Ukrainian struggles against political oppression.

Whether they take the form of Easter eggs, musical instruments, or national costumes, the folk arts practiced by members of Wisconsin's ethnic communities symbolize the continuing importance of ethnic identity within America's mass culture. They help to create a sense of continuity and belonging.

Charles Connors
Madison
93 **OJIBWA DANCE BUSTLE**
1985-1987
Eagle feathers; German silver, stamped and formed; cotton thread; wool; glass beads; 22 x 34¾ x 4¼″ (55.9 x 88.3 x 10.8 cm)

Among the Ojibwa, the eagle is believed to be the messenger between earth, tribe, and Great Spirit. The majestic bird also symbolizes freedom. The use of eagle feathers within Ojibwa ceremonial costume expresses regard for this mythologically significant bird and symbolizes tribal identity.

Connors' eagle feather bustle is an important part of the traditional dance outfit that he wears for ceremonials and powwows. It is worn on a belt at the small of his back. The costume also includes buckskin leggings and vest as well as eagle feather dance fans.

Charles Connors
Madison
94 **DANCE FAN**
1985
Eagle feathers; cedar, carved; white-tailed deer hide; 21½ x 9 x 3″ (54.6 x 22.9 x 7.6 cm)

Connors was raised on Bad River Reservation near Odanah. He learned Ojibwa feather work from his father, who insisted that his son first appreciate the significance of the eagle in Ojibwa religion. After years of observation, Connors was finally allowed to work with eagle feathers at the age of eleven.

Charles Connors
Madison
95 **DANCE FAN**
1976
Eagle wing; cedar, carved; white-tailed deer hide; 28 x 7½ x 4¾″ (71.1 x 19.1 x 12.1 cm)

Charles Connors
Madison
96 DANCE FAN
1987
Eagle feathers; porcupine hair; muskrat
fur; cedar knot; 16½ x 5 x 3″ (41.9 x 12.7
x 7.6 cm)

Small keepsake pouches filled with tobacco or
cedar are always placed in close proximity to
Ojibwa eagle feather work to assure its protection.

Charles Connors
Madison
97- NECKLACES
98 1985-1987
Deer antler, carved; deer tine; glass beads;
copper; brass; sinew; 11½ x 7 x ¾″
(29.2 x 17.8 x 1.9 cm) and 9¾ x 7¾ x ¾″
(24.8 x 19.7 x 1.9 cm)

Connors' necklaces complement his Ojibwa
dance regalia.

Gerald Hawpetoss
Keshena
99 VEST
1987
Velvet, lined; glass beads; 22½ x 14¾″
(57.2 x 37.5 cm)
Courtesy of John Michael Kohler
Arts Center, Wisconsin

Among the Menominee, beaded vests are worn
over large loose-fitting shirts for dances and
other festive occasions. Hawpetoss employs tra-
ditional techniques learned from his grand-
parents to create his beadwork. Traditional floral
motifs adorn this vest's front panels. The back
includes mythical figures: at the top, three ser-
pents symbolizing the bridge between this world
and the next; in the center, the Menominee thun-
derbird; at the bottom, three men seated around
a dance drum. The black background was
chosen out of respect for the sacred symbols.

Leona and Sheila Smith
Oneida and Green Bay
100 IROQUOIS DANCE OUTFIT
1987
Calico fabric; wool coating; ribbons; glass
beads; shirt: 18¼ x 34″ (46.4 x 86.4 cm);
leggings: 25 x 10″ (63.5 x 25.4 cm); apron:
12 x 12½″ (30.5 x 31.8 cm)

This boy's dance outfit was created by Sheila
Smith and her grandmother, Leona Smith. Leona
Smith sewed and beaded the loosely fitting shirt.
Sheila fashioned the woolen leggings and apron
and added the traditional beadwork and ribbon
work. The half-arc designs in the beadwork are
symbolic of the sky dome in the Iroquois crea-
tion story.

Oljanna Cunneen
Blue Mounds
101 ADAPTATION OF HARDANGER COSTUME
1980s
Wool suiting, beaded; cotton apron and
blouse with Hardanger embroidery;
commercial braid; overall: 47 x 66″
(119.4 x 167.6 cm); skirt: 38½″ dia.
(97.8 cm dia.)

Cunneen's mother was born in northern Nor-
way where there were no distinct regional
costumes. As a result, she based her *bunad* on
the costumes typical of the Hardanger district.
However, she trimmed the top of her vest with

black and gold to signify the six months of
darkness and six months of light experienced in
the north.
Cunneen began working as a guide at Little
Norway in 1960 and needed a costume. Using
her mother's *bunad* as a model, she created a
costume of her own. This costume represents
the fourth in the series of *bunads* which Oljanna
has modeled after her mother's design.

Oljanna Cunneen
Blue Mounds
102 HALLINGDAL COSTUME
Early 1970s
Wool challis apron; wool coating
embroidered with wool yarns; wool
suiting; polyester blend blouse; overall:
47 x 66″ (119.4 x 167.6 cm); skirt: 42″ dia.
(106.7 cm dia.)

Cunneen has made costumes in the traditional
styles of several Norwegian regions. She taught
a Norwegian costume-making class in Mount
Horeb in the late 1970s. The participants, all of
Norwegian descent, created *bunads* to be worn
on occasions sponsored by the local Sons of
Norway lodge.

Vita V. Kakulis
Bayside
103 VIDZEME REGION BOY'S COSTUME
1981-1986
Wool jacket and pants; linen shirt,
embroidered; wool belt, woven; wool
mittens and socks, knitted; jacket:
32½ x 58″ (82.6 x 147.3 cm); pants:
38 x 39″ (96.5 x 99.0 cm); mittens:
12½ x 6½″ (31.8 x 16.5 cm); socks:
10 x 12″ (25.4 x 30.5 cm); belt: 118 x 1¾″
(299.7 x 4.4 cm)

Kakulis learned knitting, embroidery, belt
weaving, and costume making while living in
displaced persons camps in Germany between
1944 and 1949. After coming to the United
States, she took up costume making when her
sons began attending Latvian Saturday school in
1967 and needed outfits for programs and spe-
cial events. As the boys have grown, Kakulis has
kept them in costumes, making more authentic
and intricate ones each time.

Shoua Chang Yang
Song Yang
Sheboygan
104 WHITE HMONG COSTUME
1986
Cotton skirt; polyester apron and shirt;
cotton belts and collar, embroidered with
polyester thread; overall: 40 x 54½″
(101.6 x 138.4 cm); skirt: 51″ dia.
(129.5 cm dia.)

Shoua Chang Yang's White Hmong costume was
made for the 1986 Hmong New Year celebra-
tion. She created the intricate reverse appliqué
collar and belts in traditional hot pink and acid
green. Her mother, Song Yang, fashioned the
shirt and pleated White Hmong skirt. The black
fabric with metallic threads used for the skirt
and apron panel has become popular with many
Hmong in the United States because it lends
added vibrancy to their traditional costume.

Clifford Bell
Milwaukee
105 **WALKING CANE**
1987
Driftwood, carved and inlaid with brass;
36½ x 7½ x 3" (92.7 x 19.1 x 7.6 cm)

Both his father and grandfather were skilled woodcarvers and carpenters, but Bell was inspired to carve canes by another black carver, Milwaukeean Sol Gause. Bell's canes feature stylized human and animal figures, common elements in Afro-American cane carving. His use of low-relief carving and a direct overhead perspective follows the style of other black carvers. His incorporation of inlaid elements also has precedent within the Afro-American tradition.

Clifford Bell
Milwaukee
106 **WALKING CANE**
1987
Oak, carved; cue ball, carved and burned;
42 x 3½ x 2½" (106.7 x 8.9 x 6.4 cm)

Vera Mednis
Warrens
107 **WOVEN SKIRTING**
1972
Cotton and wool, woven; 32 x 60"
(81.3 x 152.4 cm)

Mednis learned to weave as a child under the tutelage of her mother and grandmother. From her continuous exposure to their work, she developed a feel for the colors and designs — "squiggles," as she calls them — appropriate to Latvian textiles. Since coming to the United States, Mednis has continued to weave wall hangings, curtains, tablecloths, mats, doilies, and skirting for Latvian costumes.

This piece of skirting was woven on a sixteen-harness loom in an overshot pattern. Its use of earth tones reflects both Mednis' Latvian aesthetic and her personal preference.

Sigvart Terland
Frederic
108- **WOODEN SHOES AND SHOEHORNS**
111 **1985**
Shoes: birch, carved; each 2½ x 11 x 3"
(6.4 x 27.9 x 7.6 cm)
Shoehorns: basswood, carved; 18 x 1¾ x
½" (45.7 x 4.4 x 1.3 cm); oak, carved;
16¼ x 2⅛ x ¾" (41.3 x 5.4 x 1.9 cm);
birch, carved; 16⅝ x 1¾ x ⅜" (42.2 x 4.4
x 1 cm)

Terland learned to make wooden shoes from his father who had learned from his father. In Norway, such shoes were worn with thick homemade woolen socks and were the customary footwear for farm work. Wooden shoes were customarily removed upon entering the house. Shoehorns were hung beside the door frames in Norwegian homes to aid in putting the shoes back on.

Since his retirement to Frederic, Wisconsin, Terland has made over 500 shoes for family and friends. Recently he has also been "discovered" by the region's Norwegian-American community which now avidly seeks his work.

Nick Vukusich
Milwaukee
112 **BISERNICA**
1987
Bird's-eye maple and spruce, cut and
glued; maple, steamed and molded;
rosewood, mother-of-pearl, and abalone
shell, cut and inlaid; German silver frets;
26 x 8 x 2½" (66 x 20.3 x 6.4 cm)

The *bisernica* is the smallest of Serbo-Croatian stringed instruments known as tamburitzas. In tamburitza orchestras and ensembles, the *bisernica* is used to play melody and high obligato passages. Originally the *bisernica* was pear shaped; recently it has begun to take the shape of a guitar.

Among Croatian-Americans, the tamburitza has become a symbol of the group's musical heritage. Vukusich's tamburitzas are prized in Milwaukee's Croatian community. Each requires 200 hours of work, and because Vukusich works on them only part time, one tamburitza may take six to twenty-four months to complete.

Epaminontas Bourantas
Milwaukee
113 **BOUZOUKI**
1986
Rosewood, ebony, Sitka spruce, cut,
molded, and glued; bone, carved; ivorite,
inlaid; 38½ x 11½ x 6½"
(97.8 x 29.2 x 16.5 cm)

The bouzouki is a prominent instrument in Greek folk and vernacular music. Like the Yugoslavian tamburitza, it has become a "national instrument," an emblem of ethnic identity. Each of Bourantas' bouzoukis is beautifully crafted and acoustically remarkable. The artist uses only the finest woods, glues, and other materials in constructing his instruments. He makes each of the 1,003 parts which comprise a bouzouki. When completed, each instrument is tested for accuracy of tone and sound quality by a professional musician.

Ronald L. Poast
Oregon
114 **HARDANGER FIDDLE**
1986
Maple, steamed and molded; spruce,
carved and glued; burl maple; ebony;
pearl and ivorite inlay; oil varnish;
25 x 9 x 4" (63.5 x 22.9 x 10.2 cm)
Courtesy of Banjos by Richelieu,
Wisconsin

The nine-stringed Norwegian Hardanger fiddle was built and played throughout the upper Midwest from the midnineteenth through the early twentieth centuries. Thereafter, the tradition of Hardanger fiddle playing declined considerably. With the recent revival of interest in the Hardanger fiddle by Scandinavian musicians, Richelieu and his small staff of skilled craftsmen have revived the instrument's manufacture.

The Hardanger fiddles created by "Banjos by Richelieu" are based upon older Midwestern examples from Vesterheim, the Norwegian-American Museum. Articles in Norwegian publications which described the construction of the instrument served as a further source. This "Professjennel Model" by longtime Richelieu employee Ronald Poast features the traditional lion's head at the end of the neck and India ink designs on all surfaces as well as full-pattern inlay on both the fingerboard and tailpiece.

Anton Wolfe
Stevens Point
115 CONCERTINA
1979
Basswood boxes; steel reeds; aluminum
plates and action; jute paper bellows;
stainless steel corners and staves; closed
10 x 18 x 11″ (25.4 x 45.7 x 27.9 cm)
From the collection of Richard A. Ledet,
Iowa

Wolfe began tinkering with concertinas in the
1940s when his own instrument broke and he
was unable to get parts from Germany. By 1967
he had begun making the instruments part time
while working as a welder and maintenance
man. In 1980 he began making concertinas full
time.

Wolfe makes every part, with the exception of
the engraving on the outer box. The sound fol-
lows the old German standards for the instru-
ment and is valued in "Dutchman" polka bands.

Ray Polarski
Three Lakes
116 FIDDLE
1984
Curly maple, steamed and molded; spruce,
carved and glued; red ebony fingerboard
and pegs; 22 x 8⅛ x 2¼″
(55.9 x 20.6 x 5.7 cm)

Polarski's musical instruments have good action
and are light, fine in tone, and beautifully crafted
of local woods. He began his career by repairing
damaged instruments in 1928 and began build-
ing instruments in the late 1930s.

Nikola Milunovich
Milwaukee
117 ST. GEORGE SLAYING THE DRAGON
1980
Black walnut, carved; 20½ x 18½ x 1¾″
(52.1 x 47 x 4.4 cm)

As a boy in Serbia, Milunovich carved animal
figures from stone with a chisel. In a pattern
typical of many traditional artists, he set aside
carving when he reached adulthood to accom-
modate work and family. In 1979 Milunovich
began carving again. Using black walnut ob-
tained locally, he carves animals and human
characters. The latter include figures from his
youth, such as peasant musicians, spinners, and
grape pickers; heroes of the Serbian resistance
against the Turks; and religious characters.
Milunovich's depiction of St. George was in-
spired by the fact that his Saint's Day is the feast
of St. George.

Simcha Prombaum
La Crosse
118 KETUBAH
1978
Rag paper; Windsor-Newton inks; gold
foil transfer; 20¾ x 11″ (52.7 x 27.9 cm)
From the collection of Edward and Hannah
Pickett, Wisconsin

A *ketubah* is a traditional Jewish marriage certifi-
cate which records the mutual contractual
obligation of the bride and groom. This cal-
ligraphed *ketubah* by Simcha Prombaum was
presented as a wedding gift to Edward and
Hannah Pickett. The text of the *ketubah* begins
with a quotation from Rabbi Hillel taken from
the *Mishna*. It reads: "If I am not for myself,
who will be for me? But if I am only for myself,
then what am I? And if not now, when?"

Sidonka Wadina Lee
Lyons
119 HARVEST CROSS
1986-1987
Wheat, woven; 23¼ x 15½ x 4½″
(59.1 x 39.4 x 11.4 cm)

Lee began weaving crosses, spirals, horses,
hearts, and house blessings of wheat after ob-
serving these traditional art forms on a trip to
Czechoslovakia in 1964. Each woven wheat or-
nament is comprised of three basic weaving
techniques: twisted "ropes," woven "spirals,"
and braided or bunched stems from which grain-
laden heads fan out. The standard forms con-
structed by using these techniques each held
symbolic significance: simple crosses commem-
orated Christ, elaborate harvest crosses pro-
claimed "thanks to God who provides the
harvest," and fringed house blessings brought
God's favor upon the home.

Sidonka Wadina Lee
Lyons
120 CROSS
1986-1987
Wheat, woven; 15 x 10½ x 3″
(38.1 x 26.7 x 7.6 cm)

Sidonka Wadina Lee
Lyons
121 HOUSE BLESSING
1986-1987
Wheat, woven; 16 x 7 x 2½″
(40.6 x 17.8 x 6.4 cm)

Sidonka Wadina Lee
Lyons
122- STRAW-DECORATED SLOVAK
126 EASTER EGGS
1986-1987
Eggs, colored with commercial dyes;
straw, slit and glued; each 4¼ x 2¼″ dia.
(10.8 x 5.7 cm dia.)

Straw-covered eggs are known to have been
made in Moravia as early as the end of the nine-
teenth century. They were also widespread in
much of Slovakia. As part of the wheat or barley
plant, straw is associated with food and is
viewed as a source of life.

Lee had observed simple forms of this style
of egg decorating as a young girl. Following a
visit to Czechoslovakia in 1964, she turned her
hand to creating *kraslice* and to developing her
own intricate designs. Her grandmother, who
once also fashioned such eggs, offered further
instruction.

Sidonka Wadina Lee
Lyons
127- SLOVAK EASTER EGGS
129 1986
Eggs; oil paints; each 4¼ x 2¼″ dia.
(10.8 x 5.7 cm dia.)

At an early age, Lee learned to paint Easter eggs
in the traditional Slovakian manner from her
grandmother. Lee follows the practice of boiling
some eggs for the family's Easter meal and blow-
ing out others intended for sale. She paints her
eggs freehand as her grandmother did. The
floral and geometric patterns inherited from her
grandmother are traditional symbols associated
with Easter, spring, rejuvenation, and rebirth.

Stephanie Lemke
Mazomanie
130- **PISANICA**
133 **1984**
Eggs; cotton embroidery floss; each
2¼ x 1½" dia. (5.7 x 3.8 cm dia.)

When Stephanie Lemke was a child in her native Croatia, the decoration of eggs with silk thread was one of the most meaningful rituals of the Easter season. Each child in the family was allowed to select two pastel shades to be used in decorating his or her egg. Then, while Lemke's mother wound the designs onto each egg, she would talk to her children about God.

In this country, Lemke's traditional Croatian eggs no longer play a central role in her ethnic community's Easter celebration. Instead, the artist has found greater interest in her eggs among collectors. In contrast to Ukrainian *pysanky* which have grown from religious symbols into symbols of ethnic identity and nationalism, Croatian *pisanica* have lost much of their religious significance.

134 **UKRAINIAN EASTER TABLE**

The festive Ukrainian Easter table holds a number of traditional foods and other artifacts central to the religious holiday. A basket laden with foods for the Easter meal is covered with an embroidered cloth and taken to church on Holy Saturday to be blessed by the priest. The foods include rich round Easter breads with dough ornaments, eggs decorated using the traditional wax-resist technique, cheese, sausage, ham, butter, salt, and horseradish.

The Easter table is bedecked with elaborately embroidered linens. Wheat weavings may also be added to the table for the celebratory meal which breaks the long Lenten fast.

Maria Fafendyk
Sheboygan
135 **EGG CLOTH**
1981
Yuta linen; embroidery thread; 13 x 17"
(33 x 43.2 cm)

Egg cloths play a significant part in the observance of Easter within Ukrainian-American communities. They are used to cover baskets filled with foods for the Easter meal which are taken to the church to be blessed on Holy Saturday. This cloth is adorned with symbols appropriate to Easter: decorated eggs; pussy willows, the equivalent of palms in Ukrainian Lenten observances; and an inscription which translates "Christ is risen."

Maria Fafendyk
Sheboygan
136 **BASKET CLOTH**
1987
Yuta linen; embroidery thread; 14 x 14"
(35.5 x 35.5 cm)

Maria Fafendyk
Sheboygan
137- **PASKA**
138 **1987**
Bread dough, shaped and baked; 5¼ x 8"
dia. (13.3 x 20.3 cm dia.) and 3⅜ x 5¼" dia.
(8.5 x 13.3 cm dia.)

Betty Pisio Christenson
Neenah
139 **PASKA**
1987
Bread dough, braided, shaped, and baked;
4½ x 9" dia. (11.4 x 22.9 cm dia.)

Ukrainian *paska* recalls the central and symbolic role of foods in traditional religious ceremonies within many ethnic cultures. The rich round Easter bread adorned with elaborate dough ornaments is taken to church for the priest's blessing on Holy Saturday. It is eaten on Easter Sunday, when the joyous end to the Lenten fast finally arrives.

Alexandra Nahirniak
Waunakee
140- **PAIR OF EMBROIDERED NAPKINS**
141 **1956-1979**
Cloth; cotton embroidery floss; each
13 x 13" (33 x 33 cm)

Alexandra Nahirniak
Waunakee
142- **PAIR OF EMBROIDERED NAPKINS**
143 **1956-1979**
Cloth; cotton embroidery floss; each
17 x 17" (43.2 x 43.2 cm)

William Nahirniak
Waunakee
144- **PYSANKY**
158 **1970-1985**
Eggs, dyed using wax-resist technique;
2 x 1½" dia. (5.1 x 3.8 cm dia.) to
2⅜ x 1¾" dia. (6 x 4.4 cm dia.)

Ola and Ulanna Tyshynsky
Shorewood
159- **PYSANKY**
165 **1987**
Eggs, dyed using wax-resist technique;
shellac; each 2¼ x 1½" dia.
(5.7 x 3.8 cm dia.)

Animal images often appear as part of the decoration on Ukrainian Easter eggs. Fish, butterflies, lions, rams, and especially deer and horses are used to express different symbolic meanings. Deer and horses express a wish for good health and prosperity. On the eggs of Ola and Ulanna Tyshynsky, these animals are frequently combined with abstract depictions of evergreen trees which symbolize eternal youth.

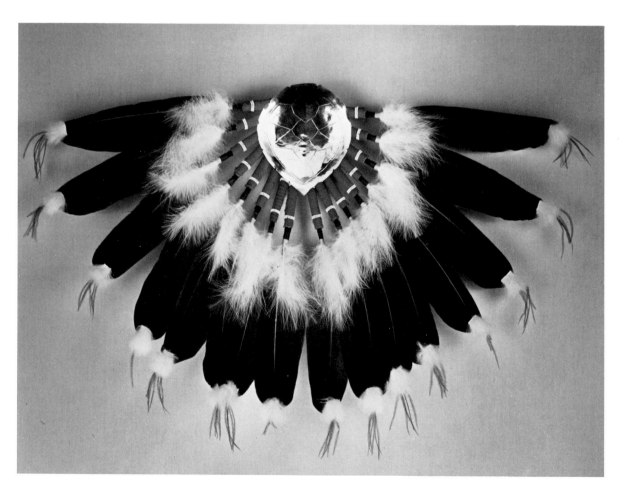

93 Charles Connors, OJIBWA DANCE BUSTLE, 22 x 33¾ x 4¼"

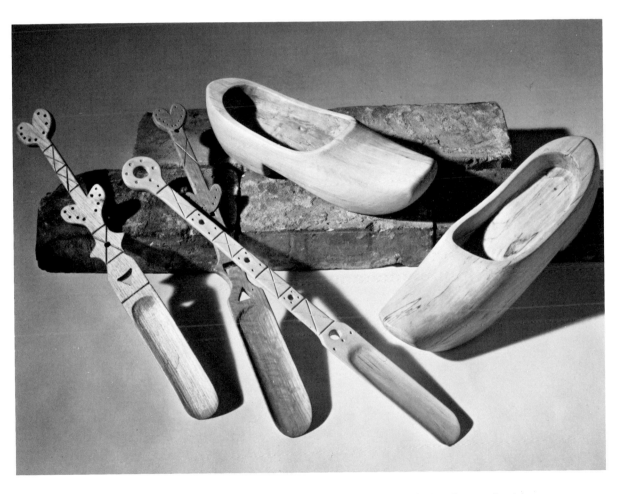

108-111 Sigvart Terland, WOODEN SHOES AND SHOEHORNS, 2½ x 11 x 3" (each shoe) and approximately 18 x 1¼ x ½" (each shoehorn)

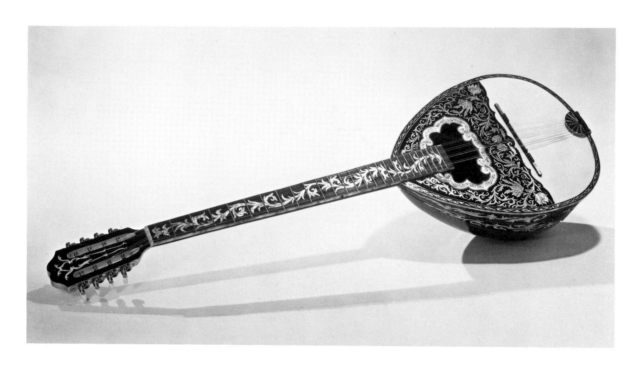

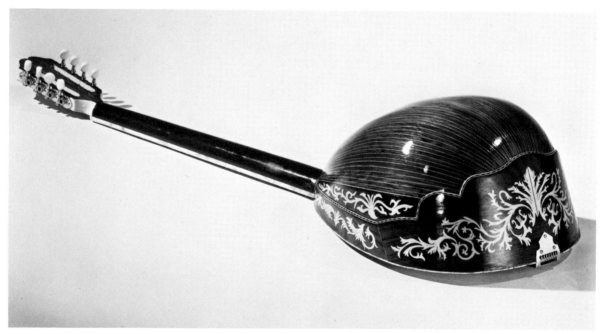

113 Epaminontas Bourantas, BOUZOUKI, 38½ x 11½ x 6½"

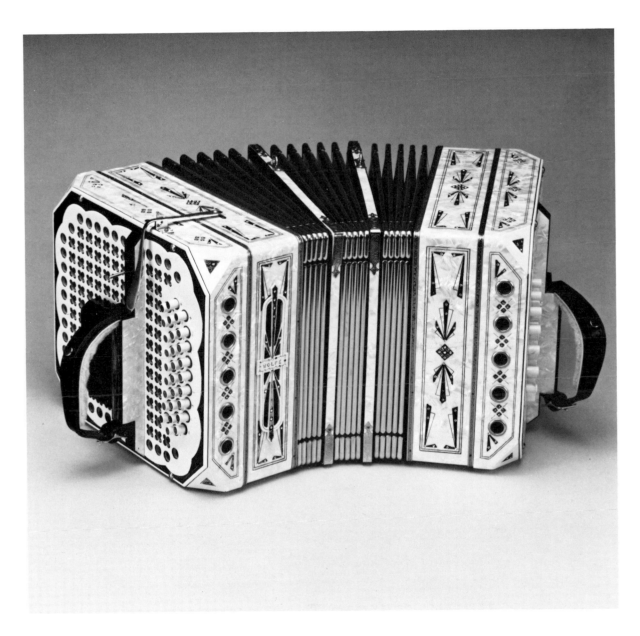

115 Anton Wolfe, CONCERTINA, 10 x 18 x 11" (closed)

117 Nikola Milunovich, ST. GEORGE SLAYING THE DRAGON, 20½ x 18½ x 1¾"

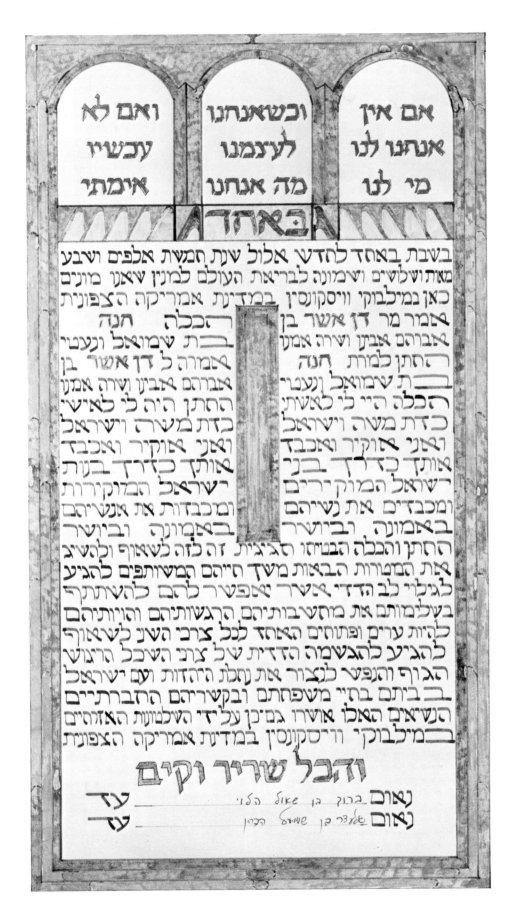

אם אין אנחנו לנו מי לנו | וכשאנחנו לעצמנו מה אנחנו | ואם לא עכשיו אימתי

באחד

בשבת באחד להדש אלול שנת חמשת אלפים ושבע מאות ושלשים ושמונה לבריאת העולם למנין שאנו מונים כאן במילבוקי ווסקונסין במדינת אמריקה הצפונית אמר מר דן אשר בן אברהם אבינו ושרה אמנו החתן למרת חנה בת שמואל ונעמי הכלה הוי לי לאשתי כדת משה וישראל ואני אוקיר ואכבד אותך כדרך בני ישראל המוקירים ומכבדים את נשיהם באמונה וביושר

רבכה חנה
בת שמואל ונעמי
אמרה ל דן אשר בן
אברהם אבינו ושרה אמנו
הכלה הוי לי לאשתי
כדת משה וישראל
ואני אוקיר ואכבד
אותך כדרך בנות
ישראל המוקירות
ומכבדות את אנשיהם
באמונה וביושר

החתן והכלה הבטיחו זה לזה לשאוף ולהשיג את המטרות הבאות משך חייהם המשותפים להגיע לגלוי לב הדדי אשר יאפשר להם להשתתף בשלימותם את מחשבותיהם הרגשותיהם והוויתיהם להיות ערים ופתוחים האחד לכל צרכי השני לשאוף להגיע להגשמה הדדית של צרכי השכל הרגוש הגוף והנפש לנצור את נחלת היהדות ועם ישראל בביתם בחיי משפחתם ובקשריהם החברתיים הנשאים האלו אשרו גמנן עליזי השלוות האזהים במילבוקי ווסקונסין במדינת אמריקה הצפונת

והכל שריר וקים

נאום ברוך בן שאול הלוי עד _____

נאום שלמה בן שמשון הכהן עד _____

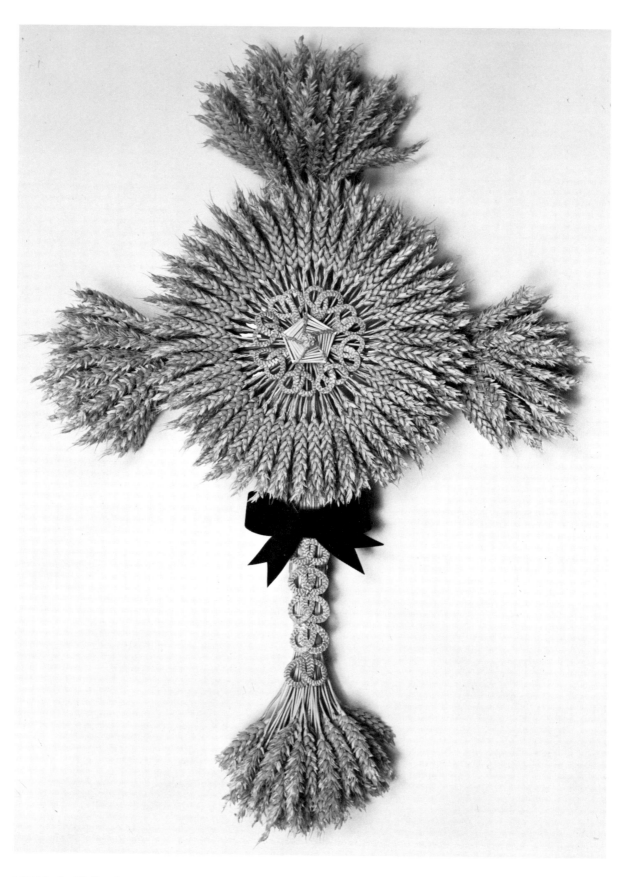

119 Sidonka Wadina Lee, HARVEST CROSS, 23¼ x 15½ x 4½"

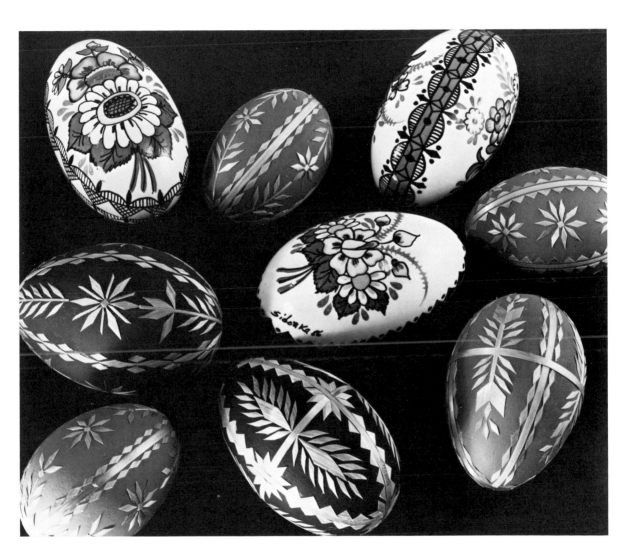

122-129 Sidonka Wadina Lee, SLOVAK EASTER EGGS, 4¼ x 2¼" dia.

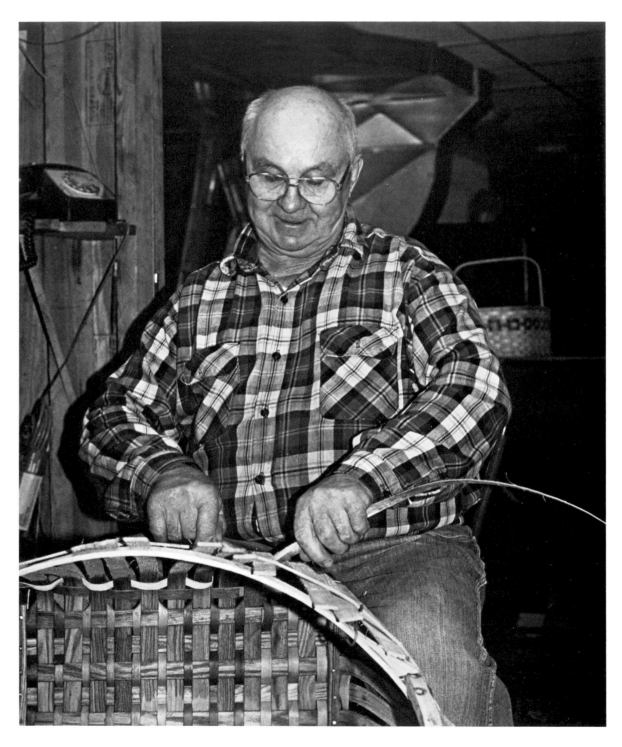

Joseph Buresh weaves a pounded black-ash feed basket.

PART IV. COMMUNITY IN WISCONSIN FOLK ART: OCCUPATION AND RECREATION

While many of Wisconsin's ethnic arts are related to holiday celebrations, the state's occupational folk arts are made for daily use. They include tools created to aid in the accomplishment of one's trade, objects fashioned to demonstrate job-related skills, and models of equipment once or presently used by the model builder. Farmers make and use feed baskets and tobacco spears. Commercial fishermen make slat nets, marker buoys, and miniatures of the fishing tugs they worked on all their lives. Lumbermen carve balls-in-cages, bucksaws-in-bottles, and logging teams like those once used to haul timber. Skilled tradesmen who learned their crafts, through apprenticeship create other objects — from hand-forged utensils to ornamental plaster work.

Like Wisconsin's occupational folk arts, the traditional arts created by the state's sportsmen and sportswomen have a strong utilitarian focus. They include many specialized types of equipment required for fishing and hunting on Wisconsin's waters and in the state's forests and fields. Hand-carved gunstocks and duck decoys, hand-tied dip nets and fishing flies, handcrafted duck boats and ice-fishing rigs represent alternatives to standardized commercial products. They are also valued reminders of earlier times when folks relied on themselves and their neighbors for the goods they needed.

Joseph Buresh
Luxemburg
166 **FEED BASKET**
1987
Oak frame; pounded black ash splints, woven; metal leg brackets; 30 x 27¼" dia. (76.2 x 69.2 cm dia.)

The tradition of making and using pounded black ash feed baskets is a vital one in the Luxemburg area. Buresh and at least one other Bohemian farmer continue to weave such baskets, and area dairymen of all nationalities use them to haul chopped hay and straw to their cattle. These sizable baskets are carried at one's side.

Ray Steiner
Argyle
167 **BASKET**
1984
Red willow, woven; 15 x 14" dia. (38.1 x 35.6 cm dia.)

Steiner weaves several types of willow baskets, ranging from oval laundry baskets to large cylindrical baskets for firewood to baskets like this one for carrying garden produce or a casserole. Steiner learned basket making from Ernest Lisser, a Swiss farmer who lived near Woodford, but his baskets differ from his mentor's in several ways. Lisser's baskets were straight-sided and had concave bottoms for added strength. Steiner's baskets have flaring sides and flat bottoms. These changes may have resulted from changes in the baskets' functions. Instead of being fully utilitarian and intended for regular hard usage,

Steiner's baskets serve a decorative as well as functional purpose.

Eino Hakamaa
Ironwood, Michigan
168 **BASKET**
1985
Cedar, split and woven; 8 x 14 x 12" (20.3 x 35.6 x 30.5 cm)
From the collection of Janet C. Gilmore and James P. Leary, Wisconsin

As a teen-ager in Finland, Hakamaa learned to make simple farm baskets from a neighbor. The baskets he now makes for the Finnish-American community in the Ironwood-Hurley area vary little from their antecedents. Though Hakamaa has been forced to substitute cedar for Finnish pine, he still finds and cuts his trees. From these he fashions cedar splints which are the sole component of his baskets. Hakamaa uses no frame, nails, or glue.

Alvin Stockstad
Stoughton
169- **TOBACCO SPEARS**
173 **1900-1985**
Brass, cast; steel, forged; galvanized sheet metal, shaped and soldered; each 7¾ x 1½ x ⅝" (19.7 x 3.8 x 1.6 cm)

In Wisconsin's tobacco belt, which extends from Vernon and Crawford Counties down into Dane County, Stockstad's tobacco spears fulfill an important function. Once tobacco plants have been harvested, they must be placed on

lath for hanging in the curing shed. Stockstad's spears are fitted over the lath in order to ease the skewering of the stalks

To make the spears, Stockstad shapes galvanized sheet metal in a press for which he has made the die and then solders the halves together. Brass or steel points cast by a local foundry or made by Stockstad himself are next soldered to the shafts. Steel tips are painted bright red since they quickly tarnish.

Carl D. Vogt
Madison
174 **MINIATURE CASE TRACTION ENGINE**
1973
Copper, shaped and silver soldered; steel and brass, formed and fastened; enamel paint; 10¼ x 22 x 8½ "
(26 x 55.9 x 21.6 cm)

When Carl Vogt was a senior in high school, he worked on a threshing crew which used a Case traction engine built around 1915. This working miniature, constructed on a scale of one inch to one foot, recalls that same piece of farm equipment. A machinist and cabinetmaker most of his life, Vogt has spent the last twenty-five years constructing miniatures. This allows him to recall his boyhood on the farm and to demonstrate occupationally based skills.

Dennis Hickey
Baileys Harbor
175- **MARKER BUOYS**
179 **Late 1970s**
Wood, carved and painted; inner tubing; metal rods; each 192 x 7 x 6"
(487.7 x 17.8 x 15.2 cm)

The Hickey family has been involved in commercial fishing for three generations. While Dennis Hickey and his brother operate one of the largest commercial fishing operations on Lake Michigan, they respect the older traditions associated with their occupation and seek to preserve them. The brothers still make much of their equipment. Dennis continues to handcraft buoys to mark the location of his gill nets.

Eino Okkonen
Herbster
180- **NET FLOATS, FISHING LINE, AND BOBBIN**
189 **1920-1955**
Cedar, carved; linen strands, twisted and tarred; oak, carved and assembled; floats: 5 x 1½ " dia. (12.7 x 3.8 cm dia.); line and bobbin: 14 x 2 x 1½ " (35.6 x 5.1 x 3.8 cm)

On Bark Point, a tiny finger of land extending into Lake Superior, Eino Okkonen, his father, and other Finnish settlers once earned a living through commercial fishing. The Okkonens made much of the equipment required for their small scale operation, including the cedar net floats which supported their gill nets during summer fishing. They also created ice-fishing gear for use throughout the winter. Eino's hand-carved bobbin holds a fishing line that he twisted from finer linen strands and then tarred for use.

John Henkelman
Merrill
190 **LOADING LOGS**
1986
Maple, hard maple, butternut, and hickory, carved and finished with tung oil; buckskin harness; 16½ x 60 x 22 "
(41.9 x 152.4 x 55.9 cm)

Henkelman worked as a logger until the age of twenty-four. For thirty years thereafter he farmed and did occasional masonry. Following his retirement, Henkelman took up woodcarving of wildlife and logging scenes. This carved assemblage depicts early logging operations. A crew top loads a logging sleigh, while another logger drives a skidding team. Henkelman sees the top-loading logger as a representation of himself.

Arthur Moe
Stone Lake
191 **MUSKIE**
1980
Wood, carved with chain saw; 24 x 96 x 15 "
(61 x 243.9 x 38.1 cm)

Art Moe began carving life-size figures with a chain saw in 1961. Since then, he has crafted about 1,000 images of animals and people that inhabit Wisconsin's north woods. Moe generally works green oak, basswood, walnut, or cottonwood. He roughs out the basic shape of his subject using a chain saw with a forty-eight-inch bar. For detailed work, he uses six smaller chain saws. Many carvings find their way to the yard of his resort, "Thor's Kitchen."

Robert C. Becker
Rice Lake
192- **COOKING UTENSILS, HOOK AND EYE**
200 **FASTENER**
1980s
Steel railroad spikes, hand forged; utensils: 9 x 1½ x 1 " (22.9 x 3.8 x 2.5 cm) to 15 x 2 x 1½ " (38.1 x 5.1 x 3.8 cm); fastener: 11½ x 1½ x ½ " (29.2 x 3.8 x 1.3 cm)

Most of Becker's business at his blacksmith shop in rural Brill involves the fabrication and repair of farm equipment. Becker also does various kinds of decorative ironwork which he learned in his native New Jersey. He has made fences, railings, planters, and spiral staircases. Each of the cooking utensils seen here was forged from a single railroad spike.

Ivan Bambic
Milwaukee
201 **WHIRLIGIG**
1981
Linden wood, carved and stained; metal; found objects; 17½ x 15¼ x 13½ "
(44.5 x 38.7 x 34.3 cm)

As a boy in Slovenia, Bambic frequently encountered noisemaker whirligigs used to scare crows away from the vineyards. Bambic continues to make these ratchetlike wind toys, but he has recently begun making elaborate ornamental whirligigs as well. The latter often depict scenes from the artist's youth in Slovenia. This blacksmith whirligig recalls a neighbor's shop which Bambic visited frequently as a child.

Ben Chosa
Lac du Flambeau Reservation
202- **PERCH DECOYS AND JIG POLES**
203 **1987**
Basswood, carved and painted; metal fins; lead weights; line; decoys: each 1½ x 6¾ x 1¾ " (3.8 x 17.1 x 4.4 cm); jig poles: each 13 x ½ " dia. (33 x 1.3 cm dia.)

Chosa continues the Ojibwa traditions of decoy making and spear fishing handed down to him by his father and grandfather. Chosa's decoys are

carefully shaped, painted, and weighted so that they look and move like fish. Suspended two or three feet under the ice, the decoys are made to swim in jerky circles. The muskies, northerns and trout attracted by the decoys are then speared.

Tom Winter
Oshkosh
204 **STURGEON DECOY**
1985
Cedar, worked on lathe, hand carved; enamel paint; 5½ x 37 x 13″ (14 x 94 x 33 cm)

Like Ben Chosa's smaller perch decoys, Winter's sturgeon decoy is intended to lure large lake fish into spearing range. The sturgeon decoys are lowered fifteen to twenty feet down under the ice on Lake Winnebago. The large size of these decoys enables ice fishermen to judge the size of the sturgeon that they are spearing. This is an important consideration, for substantial fines are imposed for fish taken under legal size limits.

Delbert Richardson
Madison
205- **FISHING FLIES**
243 **1987**
Mixed media; ⅜ x ⅜″ dia. (1 x 1 cm dia.) to ½ x 1¼ x 1″ (1.3 x 3.2 x 2.5 cm)

This assortment of Richardson's dry flies attests to his mastery of a basic repertory of fishing flies and his ability to create new variations. Richardson's specialty, the "Black Bomber," is a modification of the girtle bug pattern with wings made of white rubber bands which "stick up straight like a bomber." Other flies by Richardson make imaginative use of materials obtained from friends who farm and hunt. His "Squirrel Tail Streamer" utilizes squirrel tail and chicken hackles; the "Muddler Minnow" combines silver tinsel with deer hair clipped to form a minnowlike head; and the "Muskrat Regret" features muskrat fur and brown hackle fibers.

Emil F. Pirkel
Watertown
244 **LIVE FISH BAG**
1987
Seine twine, knotted; bone rings; nylon rope; 54 x 36″ (137.2 x 91.4 cm)

Pirkel has been making fish nets for sixty-seven years. Throughout his career, he has adapted his methods and materials to keep pace with technological innovations in fishing equipment. For example, rather than making metal hoops for his nets from scrap, Pirkel now employs commercially available versions. He has also substituted synthetic line for natural materials in fashioning the nets themselves. Despite such changes, Pirkel still prides himself on the quality and durability of his work.

Samuel Rust
Rice Lake
245 **CARVED GUNSTOCK**
1979
Walnut, carved and finished with urethanes; metal action and barrel; brass medallion, engraved; 6 x 44 x 2½″ (15.2 x 111.8 x 6.4 cm)

The designs for Rust's carved rifle stocks arise from traditions handed down to him from his uncles, both of whom were gunsmiths. Like his uncles, Rust favors the oak leaf and acorn patterns common to much German woodcarving. Rust occasionally adds small engravings, and here he has seated a brass medallion with the image of a mountain goat on the underside of the forearm.

Rich Riemenschneider
Oconomowoc
246 **COMMON PINTAIL DRAKE DECOY**
1935
Cedar and white pine, carved, glued, and painted with a mixture of white lead, raw linseed oil, tints, and turpentine; 6¾ x 16½ x 5¼″ (17.1 x 41.9 x 13.3 cm)

Riemenschneider has been carving functional decoys since the late 1920s. He has made replicas of virtually every duck and goose known to migrate along the Mississippi Valley flyway. The body of this pintail drake decoy is constructed of two pieces of cedar which have been hollowed out and then fastened with nails and glue. The hollow body yields a very light decoy.

Rich Riemenschneider
Oconomowoc
247 **LOON DECOY**
1951
White pine, carved and joined with splined dowel; oil paint; 8 x 16 x 7½″ (20.3 x 40.6 x 19.1 cm)

This loon decoy by Riemenschneider displays a simple but effective means of rendering plumage. The distinctive "checkered" feathers are made by coating a net with black paint and snapping it against the decoy's white undercoat. While wings are rendered in somewhat higher relief on this decoy than on many of Riemenschneider's other carvings, they remain sufficiently sturdy to prevent damage from hard use.

Rich Riemenschneider
Oconomowoc
248- **RED-BREASTED MERGANSER DECOYS**
249 **1937**
Cedar and white pine, carved and joined with oak dowel, squared and splined; X-chlor paint; leather crests; each 7 x 17½ x 5½″ (17.8 x 44.5 x 14 cm)

Even in these dramatic representations of colorful mergansers, the dictates of function still govern Riemenschneider's decoy carving. The feather crests extending from the backs of the birds' heads are constructed not of wood but of leather to prevent breakage in transportation and field use.

Edward Henkelman
Merrill
250- **SQUIRREL BAND AND DANCERS**
255 **1985**
Squirrel skins, stuffed and mounted; found objects; concertina player: 14¾ x 10¾ x 8½″ (37.4 x 27.3 x 21.6 cm); drummer: 10½ x 6¾ x 9¾″ (26.7 x 17.1 x 24.8 cm); fiddler: 13½ x 6 x 12½″ (34.3 x 15.2 x 31.8 cm); guitarist: 14 x 7¼ x 10″ (35.6 x 18.4 x 25.4 cm); dancers: 18 x 17 x 10″ (45.7 x 43.2 x 25.4 cm)

Ed Henkelman's stuffed squirrel musicians and dancers demonstrate his skills as hunter, taxidermist, and traditional storyteller. Henkelman notes that the animals are mounted in the poses they held when he first encountered them in the woods.

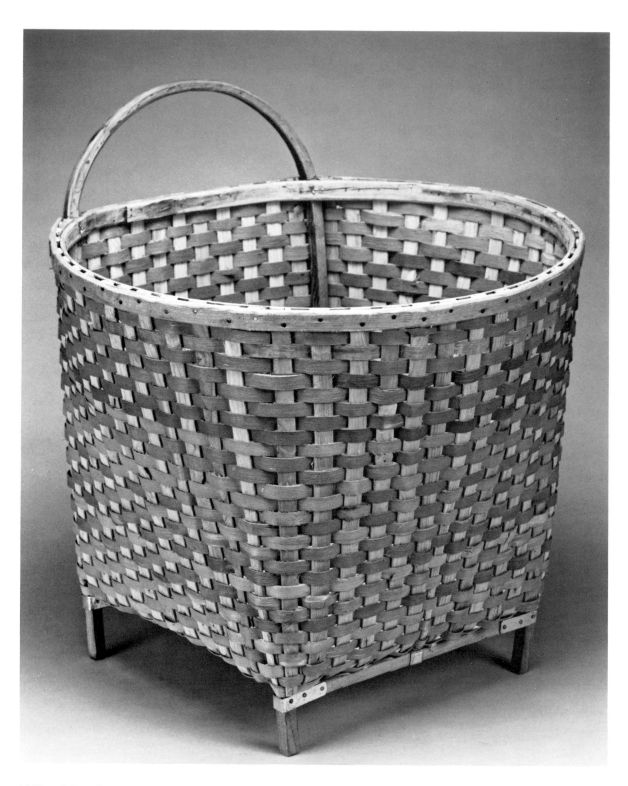

166 Joseph Buresh, FEED BASKET, 30 x 27¼" dia.

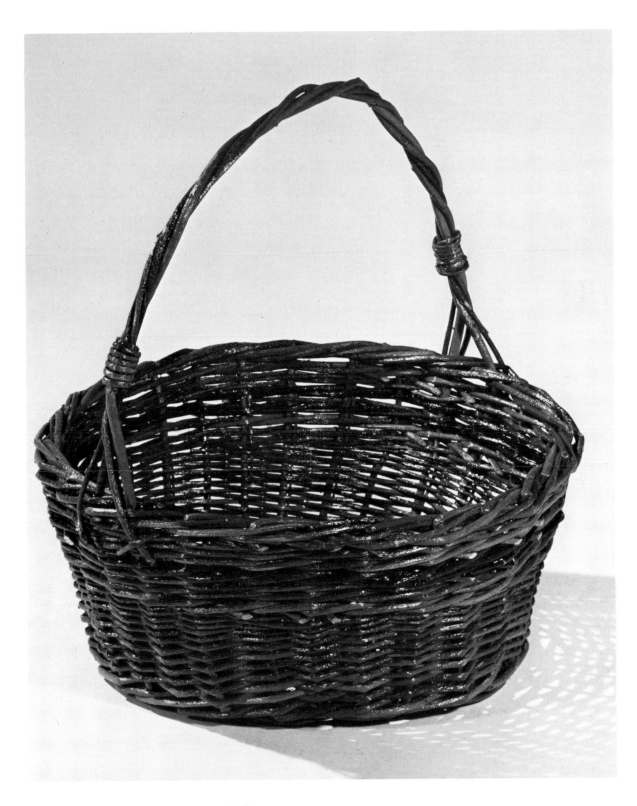

167 Ray Steiner, WILLOW BASKET, 15 x 14" dia.

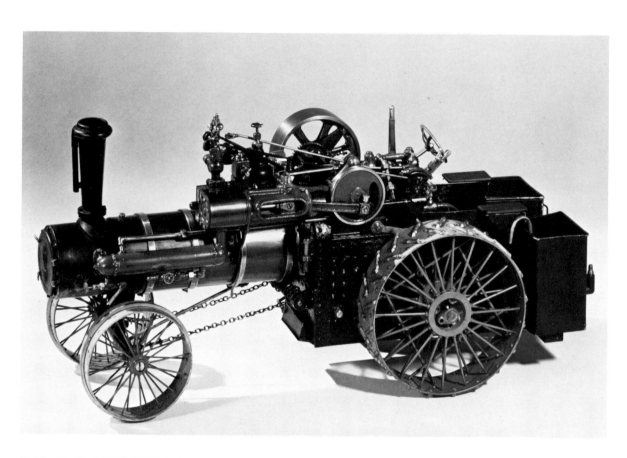

174 Carl D. Vogt, MINIATURE CASE TRACTION ENGINE, 10¼ x 22 x 8½"

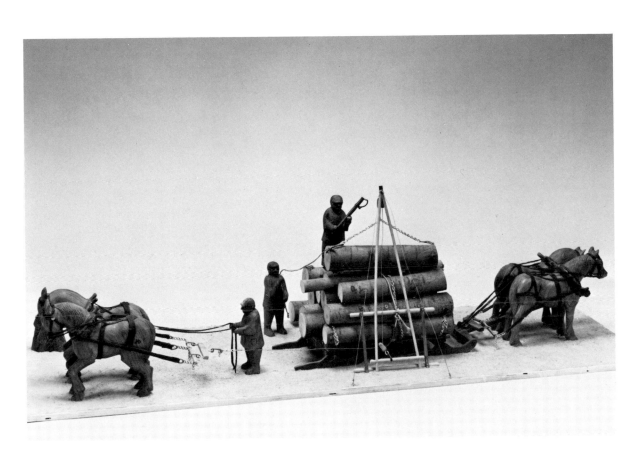

190 John Henkelman, LOADING LOGS, 16½ x 60 x 22"

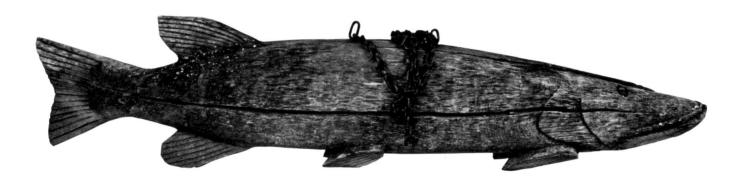

191 Art Moe, MUSKIE, 24 x 96 x 15"

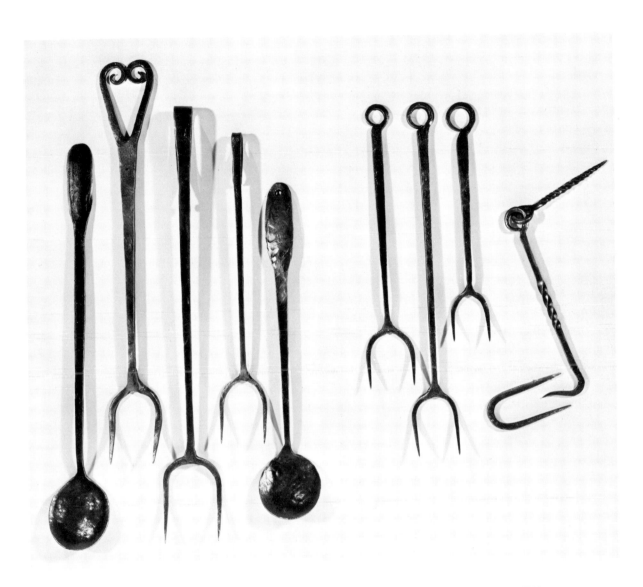

192-200 Robert C. Becker, COOKING UTENSILS, HOOK AND EYE FASTENER, 9 x 1½ x 1" to 15½ x 2 x 1½"
(utensils), 11½ x 1½ x ½" (fastener)

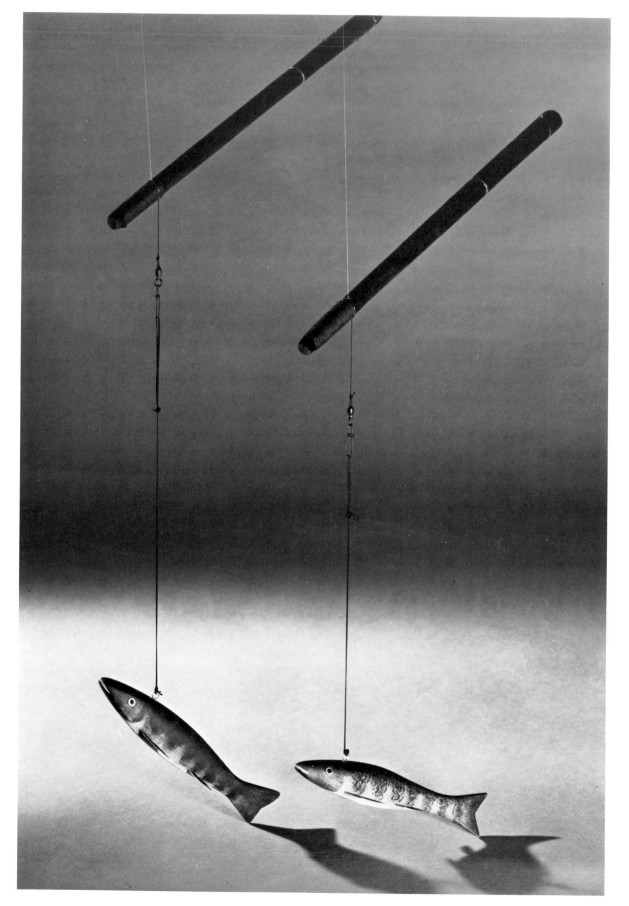

78 *202-203 Ben Chosa, PERCH DECOYS AND JIG POLES, 1½ x 6¾ x 1¾" (each decoy), 13 x ½" dia. (each pole)*

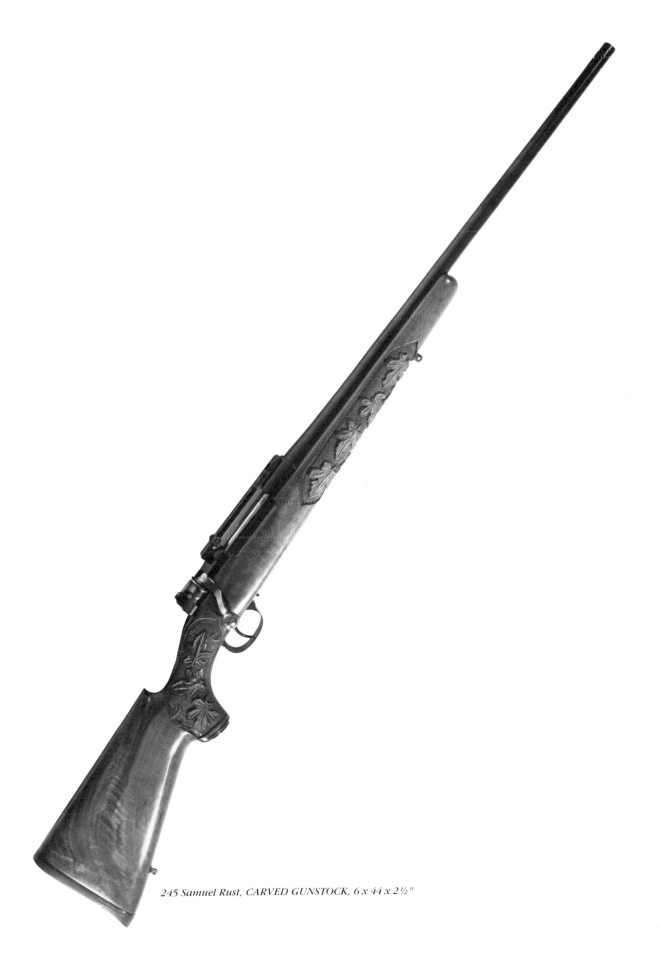

245 Samuel Rust, CARVED GUNSTOCK, 6 x 44 x 2½"

Julian Orlandini stands among his works in the workshop of Orlandini Studios, the family's ornamental plaster business.

PART V. TRANSMISSION AND TRANSITION IN WISCONSIN FOLK ART

Within Wisconsin communities, most folk arts are passed from generation to generation by informal means. Novices acquire their skills by observing and imitating the work of more senior artists, through loosely structured apprenticeships or more casual review and criticism. Through this direct interaction, artists learn the techniques and processes necessary to the making of a costume, fiddle, or fishing fly. They also master the vocabulary of forms, designs, and decorations which gives the object meaning and significance within the community.

Other methods of passing on folk arts have emerged recently. "Revivals" and "revitalizations," for example, are deliberate efforts to reclaim folk art forms no longer actively practiced within a particular community. Workshops, classes, and publications devoted to teaching traditional arts have also grown in popularity. Such efforts sometimes permit the reinstatement or continuation of a particular folk art form within the original community.

Whether transmitted through apprenticeships or other means, Wisconsin's folk arts sometimes undergo major transitions. Influences from outside the traditional community prompt the development of new forms, such as Dumbo and Winnie-the-Pooh piñatas in the Mexican-American community. At other times, outside influences cause the decline of established forms of folk expression; for example, duck hunters generally use inexpensive plastic alternatives to hand-carved decoys. Recent commercial interest in folk art has expanded the market for many traditional arts. It has, however, also led to misidentification of "country furnishings and accessories" as folk art.

Nevertheless, outside influences, especially from American popular culture, have not overwhelmed the folk arts. Wisconsin's folk artists and their communities retain control of most of their art forms. They continue to follow their own expressive needs and to weigh carefully the markets they wish to serve.

Hortensia Ojeda
Waukesha
256 **DESHILADO SAMPLER**
1964
Fabric, cut, pulled, stitched, braided, and crocheted; 17¾ x 23½" (45.1 x 59.7 cm)

When Hortensia Ojeda was about to begin working full time at a hospital, she created a sampler of her *deshilado* needlework. She hoped in this way to record the traditional designs she had mastered over the years so that she could teach them to her children and grandchildren at a later date. While none of her descendants has been able to commit the necessary time and patience to learning the openwork, Ojeda has preserved through her sampler a variety of patterns, including *la vuida* (the window), *la cascara de tomate* (tomato peel), *el granisso* (hail), and *has mi si te puedes* (make me if you can).

Julian Orlandini
Milwaukee
257 **GARGOYLE**
1967
Plaster of Paris, cast; 21 x 6 x 12" (53.3 x 15.2 x 30.5 cm)

Ornamental plaster work has been the traditional occupation of the Orlandini family for over fifty years. Julian Orlandini learned the trade from his father, who in turn had apprenticed with an Italian master in Philadelphia. This gargoyle is a duplicate of an architectural piece rescued from a building razed in the 1960s.

Ethel Kvalheim
Stoughton

238 ROSEMALED BOWL WITH LID
1984
Basswood, turned by Paul Loftness; oil
paint on oil ground; 6¾ x 7″ dia.
(17.1 x 17.8 cm dia.)

When Kvalheim moved to Stoughton, she lived
one block away from legendary rosemaler Per
Lysne. Impressed and inspired by his work, she
turned her hand to rosemaling in 1942. In this
way, she became part of the "folk movement"
which has brought rosemaling to the attention
of the public.

Now designated as a gold medalist by the
Wisconsin Rosemaling Association, Kvalheim is
a master of various regional styles. This lidded
bowl is in the style of the Hallingdal region
which is characterized by a high degree of
symmetry.

Ethel Kvalheim
Stoughton

259 ROSEMALED PORRIDGER
1985
Basswood, stave constructed by Willis
Wangsness; oil paint on acrylic ground;
10 x 10″ dia. (25.4 x 25.4 cm dia.)

In Norway, cream pudding was a popular gift
brought by visitors and was transported in lid-
ded containers called porridgers. This porridger
is painted in the Telemark style, which is charac-
terized by scroll designs and fantastic floral
motifs and incorporates more fine line work
than many other styles.

Ryszarda Klim
Milwaukee

260 SUN PAPER CUT (wycinanki)
1982
Paper, folded, cut, and glued; 12″ dia.
(30.5 cm dia.)

Ryszarda Klim began to make *wycinanki,* or pa-
per cuts, nine years after her immigration to the
United States from Poland. Klim took an active
interest in the art form after her children trav-
eled to Poland and brought back examples of
this traditional work. A former teacher, she stud-
ied books of patterns in order to learn tradi-
tional designs from the Kurpie, Lowicz,
Opoczno, and Sanniki regions of Poland. Like
many other well-educated urban emigrés who
take pride in their ethnic heritage, she continues
to practice this "revived" rural peasant art.

Ryszarda Klim
Milwaukee

261 ROOSTER PAPER CUT (wycinanki)
1977
Paper, folded, and cut; 27″ dia.
(68.6 cm dia.)

While some Polish paper cuts are purely deco-
rative, others commemorate weddings or
dances. Still others possess religious signifi-
cance. Within the last category, common motifs
include the "tree of life" and, as in this example,
roosters crowing to proclaim Easter's arrival.

The paper used in making *wycinanki* must
satisfy several criteria. It must be thin, flexible,
and sturdy and have bright, natural colors.
Ryszarda Klim sometimes obtains her paper
from Poland. At other times she dyes the paper
which she uses. In this instance, Klim has em-
ployed one of the best locally available sub-
stitutes: gift-wrapping paper.

Patricia Gutierrez de Llamas
Madison

262 PIÑATA
1987
Papier-mâché; cardboard tubing; paper,
cut, and glued; 27 x 24 x 10″
(68.6 x 61 x 25.4 cm)

The influence of contemporary popular culture
upon folk art forms is evident in Patricia Llamas'
"Winnie-the-Pooh" piñata. She learned piñata
making from her mother and aunt in her native
Mexico where she fashioned traditional shapes
such as stars and horses. Since coming to the
United States, Llamas has added new designs
inspired by cartoon characters.

Ching-Ho Leu
Madison

263- FOLDED PAPER FLOWERS
265 1987
Origami paper, folded; 1¾ x 2″ dia.
(4.4 x 5.1 cm dia.) to 3½ x 3¼″ dia.
(8.9 x 8.3 cm dia.)

An associate professor of mathematics and statis-
tics in his native Taiwan, Ching-Ho Leu is
currently a graduate student in the Statistics De-
partment at the University of Wisconsin. Leu
learned the ancient art of paper folding from his
parents at an early age. Since then he has passed
it along to his own children. For the Leu family
and other Taiwanese attending the university,
paper folding has become a popular diversion
often practiced with friends. For Ching-Ho's
son, paper folding is a bridge to Asian and West-
ern children attending Madison's multicultural
Shorewood School.

Alexander "Ike" Gokee
Bayfield

266 LACROSSE STICK
1985-1986
White ash, split, shaved, and bent;
rawhide, tied; 25 x 6 x 1″
(63.5 x 15.2 x 2.5 cm)

Approximately five years ago, renewed interest
in the traditional Ojibwa game of lacrosse
among young people on the Red Cliff Reserva-
tion prompted a "revitalization" of the art of
lacrosse stick making. "Ike" Gokee had not
played the game nor fashioned a lacrosse stick
since the 1930s, but he returned to the craft
taught to him by his father in order to equip a
local team. He is currently teaching the game's
fundamentals to interested young people and
passing along his stick-making skills to tribal
member Mike Montano.

Marvin DeFoe
Bayfield
267 **BIRCHBARK CANOE**
1986
Birchbark, stripped and sewn; cedar, split
and shaped; spruce root; pitch; 22 x 181
x 37½ " (55.9 x 459.7 x 95.3 cm)
From the collection of the Red Cliff
Buffalo Art Center, Red Cliff Reservation

By the middle of the twentieth century, the tradition of building birchbark canoes had all but disappeared among the Ojibwa. Then, approximately ten years ago, DeFoe became involved in the construction of a forty-foot Tlingit-style bark canoe. Since that time, he has talked with elders of his own tribe about their traditional canoes, has undertaken additional research, and has revived the building of birchbark canoes among the Ojibwa. DeFoe uses only bark, cedar, spruce root, and pitch for his canoes. He also follows the traditional method of construction.

Milton R. Geyer
Green Bay
268- **BLUEBILL DECOYS**
269 **1985**
Basswood and cedar, carved, wood-
burned, and joined with dowels and glue;
oil paint; each 7 x 13 x 6½ "
(17.8 x 33 x 16.5 cm)

The differences between working decoys and decorative bird carvings become apparent by comparing Milton Geyer's functional bluebills with his ornamental mallards. The bluebills are equipped with keels and anchor weights. The "decorator" mallards are flat-bottomed so they rest evenly on mantel or table. A detailed feather pattern has been carved and burned into the bluebills' wooden surface, but protruding elements are avoided in anticipation of the decoys' rough treatment during hunting. In contrast, the plumage of the mallards is rendered more delicately. Tail feathers curling away from each bird's body leave fragile openings and projections.

Milton R. Geyer
Green Bay
270- **MALLARD CARVINGS**
271 **1986**
Basswood and cedar, carved, wood-
burned, and joined with dowels and glue;
oil paint; each 6 x 16 x 7 "
(15.2 x 40.6 x 17.8 cm)

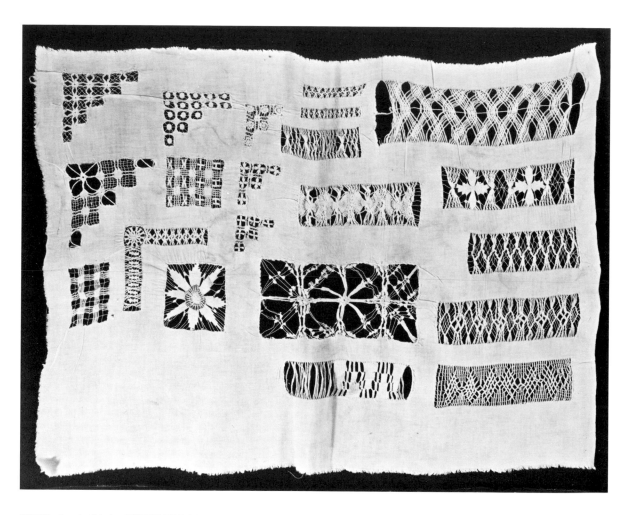

256 Hortensia Ojeda, DESHILADO SAMPLER, 17¾ x 23½"

257 Julian Orlandini, GARGOYLE, 21 x 6 x 12"

258 Ethel Kvalheim, ROSEMALED BOWL WITH LID, 6¾ x 7" dia.

266 Alexander "Ike" Gokee, LACROSSE STICK, 25 x 6 x 1"

267 Marvin DeFoe, BIRCHBARK CANOE, 22 x 181 x 37½"

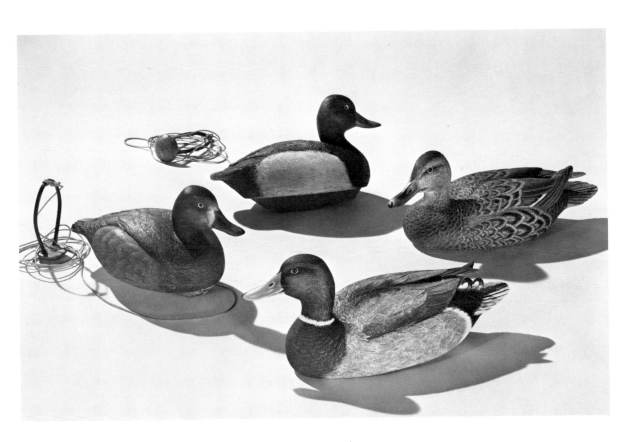

268-271 Milton Geyer, BLUEBILL DECOYS AND MALLARD CARVINGS, 7 x 13 x 6½" (each bluebill),
6 x 16 x 7" (each mallard)

WISCONSIN FOLK ARTISTS
BIOGRAPHICAL NOTES

The biographical sketches which follow are based upon field research reports prepared during the survey of Wisconsin folk arts and folk artists which preceded FROM HARDANGER TO HARLEYS: A SURVEY OF WISCONSIN FOLK ART.

Mary Arganian
Madison
Place and date of birth: Deort-yol, Adana,
 Cilicia, Turkey; 1904
Arrival in the United States: approximately 1925
Ethnic background: Armenian
Art forms: needle lace, cutwork, cookery
Catalogue number: 67

Mary Arganian was born and raised in Deort-yol in the state of Adana, the region of Cilicia in Turkey. Between twelve and fourteen years of age, she moved to Lebanon where she attended an Armenian school administered by French nuns. Following graduation from high school, Arganian taught Armenian and French for four years in Alexandret, Lebanon. At the age of approximately twenty-one, she came to the United States. In 1930, she wed Joseph Arganian. While the couple raised a family of three children in Racine, Wisconsin, Mary Arganian taught Turkish, Armenian, French, and English to Armenians. She also helped displaced persons of all nationalities to find work and housing and to obtain American citizenship. Following the death of her husband in the late 1970s, Arganian moved to Madison to be closer to her children who work or attend the university there.

Although her mother created Armenian needle lace and cutwork in the home, Arganian did not receive detailed instruction in these traditional forms of needlework until she was in her teens. Her introduction came on "craft days" held every Tuesday at the Armenian school. There she also learned to create French cutwork from the nuns. Although raised on traditional Armenian foods prepared by her mother, Arganian did not really practice Armenian cookery until after she married. Prior to that time, she was too busy caring for her mother and earning a living. Following her marriage, Arganian revived her own cooking heritage and picked up new recipes from the Armenian community in Racine.

Ivan Bambic
Milwaukee
Place and date of birth: Slovenia, Yugoslavia;
 1922
Arrival in the United States: 1950
Ethnic background: Slovenian
Art forms: whirligigs, leather work
Catalogue number: 201

Ivan Bambic grew up on a farm in Slovenia. There he often visited and assisted a neighbor who ran a blacksmith shop. He also worked as a butcher during his early years. Following World War II, Bambic spent five years in a displaced persons camp in Austria. In 1950 he emigrated to the United States and settled in Milwaukee. From the early 1950s until his recent retirement, Bambic was employed by the Pfister and Vogel Tannery. During this period, he was an active participant in Slovenian Lodge activities and the Holiday Folk Fair. He also spent part of each summer at a rural Wisconsin camp owned jointly with fellow Slovenians.

Bambic's whirligigs draw heavily upon his skills as a woodworker and reflect his Slovenian heritage. Constructed of linden wood from his summer camp, Bambic's wind toys depict such subjects as workers in a blacksmith's shop, a farmer hammering a scythe, and a pair of Slovenian folk dancers. Although turning his hand to the making of whirligigs only shortly before his retirement in the early 1980s, Bambic has found a market among fellow Slovenians for these objects which evoke homeland and heritage.

Robert C. Becker
Rice Lake
Place and date of birth: Burlington, New Jersey;
 1925
Ethnic background: German
Art forms: blacksmithing, ornamental ironwork
Catalogue numbers: 192-200

Both of Bob Becker's parents emigrated from Prussia, his father in 1907 and his mother in 1911. The couple worked on farms and in factories in Connecticut and later in New Jersey. When the Depression caused the elder Becker to lose his job in a wire mill, he returned to tenant farming. A jack-of-all-trades — farmer, carpenter, and blacksmith — Becker's father passed along many of his skills to his son.

In 1951 following wartime service in the army and periods of work as a farmer, logger, and truck driver, Bob Becker found a job in an ornamental iron shop in Burlington, New Jersey. There he learned to make railings and sharpen tools. In 1959 Becker married and traveled with his wife to visit an old army buddy in northern Wisconsin. A blacksmith shop in Brill was for sale at that time. Becker bought it, and he has worked as a blacksmith in that location ever since. One of Becker's sons is a machinist who welds and does some blacksmithing. Becker is about to take him on as a partner and hopes ultimately to turn the business over to him.

Through his shop, Becker continues to service Brill's local farming community. Most of his business involves the fabrication and repair of farm equipment. Beyond this practical work, however, Becker also does ornamental ironwork: fences, railings, spiral staircases, planters, cooking utensils, and fireplace tools. Becker's work has been his only form of advertising; his business stems from local customers who appreciate his work and reasonable prices.

Clifford Bell
Milwaukee
Place and date of birth: Milwaukee, Wisconsin;
 1955
Ethnic background: Afro-American
Art form: woodcarving
Catalogue numbers: 105-106

Clifford Bell's grandfather carved duck decoys and made wagon wheels, buckets, and other items of wood

for use on his Louisiana farm. Clifford's father is an experienced carpenter and handyman. At the age of eight, Clifford himself began carving "tiki dolls," mask-like wooden faces with protruding feet. When about fifteen years of age, Bell was inspired by the large-scale carvings of local sculptor Ed Geeter. Eventually, he drew upon books available at the library to supplement these earlier models. Several years ago, Bell discovered the carved wooden canes of Milwaukeean Sol Gause and began making walking sticks shortly thereafter.

Bell paints with oils and draws with pencil, felt-tip pens, and charcoal, but he supports himself with his woodcarving. Making use of an array of power tools including a jigsaw, buffer, and chain saw, Bell creates table bases, benches, planters, "voodoo bowls," canes, and other functional objects as well as large-scale sculptures and decorative wall pieces. Bell has recently increased his production of walking sticks and bowls due to the strong demand for these works encountered during his most recent stay with relatives in Louisiana. While he regularly sells carvings to relatives, friends, and other buyers who come to his Milwaukee home, Bell feels the Louisiana black community shows greater interest in and appreciation of his work. He is considering moving there permanently to serve this more receptive audience.

Else J. Bigton
Barronett
Place and date of birth: Aalesund, Norway; 1956
Arrival in the United States: 1979
Ethnic background: Norwegian
Art forms: furniture making, woodcarving
Catalogue number: 63

As a child in Norway, Bigton learned a variety of needlework skills both at home and in the public schools. Encouraged by her grandmother who was a weaver, Else decided to study weaving with the ultimate goal of teaching the craft for a living. In order to better prepare herself, Bigton enrolled in one of Norway's schools of traditional artistry, the Hjerleids Husflid Skole, in 1977. There she met Phillip Odden, whom she married and accompanied back to his native Wisconsin following completion of their courses. Like Odden, Bigton pursued a combined program of carving and furniture making during her first year at the school. During the second year she concentrated only on furniture making.

In 1979, upon their arrival in the United States, the couple founded a business called Norsk Wood Works. Bigton is responsible for the design and construction of such major pieces of furniture as hutches, beds, tables, chairs, and entire living room or dining room sets. The most elaborate decorative carving is done by Odden. Works produced in the shop, whether pieces of furniture or individual decorative carvings, are generally made for Norwegian-Americans from the upper Midwest.

Epaminontas Bourantas
Milwaukee
Place and date of birth: Province of Thiba,
** Greece; 1918**
Arrival in the United States: 1954
Ethnic background: Greek
Art form: bouzouki making
Catalogue number: 113

"Nunda" Bourantas was born in the province of Thiba, near Athens. When he had completed his education, Bourantas entered the Greek Air Force where he worked in airplane maintenance. He was involved in guerilla warfare against the Germans during World War II and after the war was sent to the United States by the air force to become familiar with technological advances. In the early 1950s, Bourantas retired from the

Greek military with the rank of lieutenant. Married in 1951 to an American of Greek descent, Bourantas moved to Milwaukee in 1954. There he was employed by Mitchell Field for several years. From 1956 until his retirement in 1982, he worked for Allen Bradley as a machine builder and mechanical maintenance employee.

About twenty years ago, Bourantas was given a bouzouki, an eight-stringed instrument used in Greek and Greek-American celebrations and ceremonies. He played it a little but did not like the instrument's "sour notes." Therefore, he decided to take the bouzouki apart, see how it was made, and attempt to fashion an improved version. Relying on his occupational skills in mathematics and design, on conversations with instrument makers during trips to Greece, and on occasional bits of information drawn from books, Bourantas made his first bouzouki in 1969. He has continued to make three or four of these pear-shaped stringed instruments every year since. Though he also repairs Yugoslavian tamburitzas and mandolins, Bourantas has achieved widest acclaim among Greek-American musicians throughout Wisconsin and Illinois for his bouzoukis.

Joseph Buresh
Luxemburg
Place and date of birth: Luxemburg, Wisconsin;
1915
Ethnic background: Bohemian
Art form: basketry
Catalogue number: 166

Joseph Buresh learned to make baskets from his grandfather John Mleziva. He has been making pounded black ash baskets for over thirty years, both for his own use and for sale to other farmers in the Luxemburg, Wisconsin, area. Buresh makes baskets of various sizes to fulfill a variety of functions: picnic baskets, mushroom-picking baskets, laundry baskets, cradle baskets, and feed baskets. The large, single-handled feed baskets used for carrying chopped hay and straw to the cattle are always in demand. Buresh is currently teaching his twenty-nine-year-old second cousin, Tom Mleziva of Denmark, Wisconsin, how to make the baskets so he can "keep things going."

Ben Chosa
Lac du Flambeau
Place and date of birth: Moss Lake, Lac du
** Flambeau Reservation, Wisconsin; 1929**
Ethnic background: Ojibwa, Lac du Flambeau
** Band**
Art forms: fish decoys, fishing spears
Catalogue numbers: 202-203

Ben Chosa's father and grandfather were decoy makers and spear fishermen. Chosa began fishing with his father and his father's partner as a young boy some fifty years ago. Soon afterward he began to make his first decoys, largely by trial and error but aided by a few tips and observations. Currently one of about a dozen decoy carvers on the Lac du Flambeau Reservation, Chosa fashions the likenesses of perch, blue gills, and suckers not for display but rather for actual use. Although Chosa has worked as a truck driver, furniture mover, and lawyer in the Ojibwa tribal court system, he is perhaps best known as the finest fisherman and guide on the reservation.

Betty Pisio Christenson
Neenah
Place and date of birth: Suring, Wisconsin; 1931
Ethnic background: Ukrainian
Art forms: *krizanki* and *pysanky* (decorated
** Easter eggs), *paska* (Easter bread)**
Catalogue numbers: 38-57

Betty Pisio Christenson's parents were born in the Ukraine, in the Carpathian Mountain region near the

Black Sea. Both came to the United States in 1912. They met and married in Pittsburgh and later homesteaded on cutover land in Suring, Oconto County. Christenson was one of nine children born to the couple.

When Christenson was a little girl, her mother made simple, single-color Easter eggs called *krizanki* for her children. As Christenson and her brothers and sisters grew a bit older, their mother showed them her techniques for making *krizanki* and explained to them the symbolic importance of the eggs. Although Christenson's mother had neither the tools nor the knowledge necessary for fashioning the more elaborate Ukrainian *pysanky*, she told her children of examples she had seen.

Betty Pisio Christenson began making *krizanki* following her mother's introduction and continues to make them for her family to this day. In 1974, after approximately thirty-five years of experience making the simpler eggs, Christenson saw examples of the fancier eggs while visiting relatives in Canada. Drawing upon these observations as well as materials and publications purchased from a Ukrainian specialty shop in Minneapolis-St. Paul, Christenson perfected the more elaborate *pysanky*. She has made the fancier eggs for every sibling, child, and grandchild in her family.

Charles Connors
Madison
Place and date of birth: Bad River Reservation,
 Odanah, Wisconsin; 1948
Ethnic background: Ojibwa
Art forms: feather work, dance regalia
Catalogue numbers: 93-98

Charles Connors is currently the Native American Co-ordinator and Advisor for the Wisconsin Department of Natural Resources. An active dancer at powwows and other traditional celebrations, Connors continues to create feather work dance fans, bustles, and headdresses for his own use. He is also engaged in passing along the skills he learned as a boy on the Bad River Reservation to other urban Indians. Like Native Americans Sheila Smith and Gerald Hawpetoss, Connors serves as a master artist in the Wisconsin Arts Board's Folk Arts Apprenticeship Program. He believes strongly that within the urban context "most cultural arts will diminish unless they can find an outlet that will tie them to their past and insure their future."

Allie M. Crumble
Milwaukee
Place and date of birth: Newton County,
 Mississippi; 1911
Ethnic background: Afro-American
Art form: quilting
Catalogue number: 14

Raised in Newton County, Mississippi, Allie Crumble and her husband moved in 1944 to Milwaukee where they raised ten children. A member of the Metropolitan Baptist Church, Allie Crumble teaches quilting for the church's senior program. Since her husband's death in 1983, she has shared a home with her ninety-four-year-old mother, Minnie Lofton.

It was from her mother that Allie Crumble learned to piece together cloth for quilting at the age of seven. Her mother insisted that she devote herself to her "little nine-patch" rather than go outside to play. She cut paper pattern pieces as guides for cutting the cloth and supervised her daughter's work very closely, requiring her to take apart and resew any pieces improperly assembled. After she had mastered piecing, Crumble began quilting at about the age of nine or ten. Shortly thereafter, her mother taught her to embroider. Finally, at the age of twelve, Crumble learned to crochet at school and created a green and pink handbag which her friends greatly admired.

For many years, Crumble turned out approximately one quilt each month. Each quilt required two weeks for piecing and two weeks for quilting; she worked six hours per day, six days a week. She has made only three quilts since her husband's death in 1983. She does not make quilts to order, preferring instead to make favorite traditional patterns or to create new ones of her own. The latter she delights in naming almost as much as making. Crumble makes her quilts for her family and sells some to members of the local black community who have learned of her work by word-of-mouth.

Oljanna Cunneen
Blue Mounds
Place and date of birth: Vermont, Wisconsin;
 1923
Ethnic background: Norwegian
Art forms: traditional costumes, needlework
Catalogue numbers: 101-102

Oljanna Cunneen's mother was an artist at all types of handwork, and she taught her daughter to keep her hands busy. Cunneen believes that the ability to use one's hands is hereditary, but she has supplemented her innate skills and her mother's early instruction in handwork by taking classes, attending workshops, and exchanging information with friends on Norwegian embroidery, costumery, and rosemaling.

Born in Dane County, Cunneen's first marriage took her to California where she worked as a photographer for the air command service during World War II. Following her return to Dane County, she married a second time and "retired" to housework. In 1961, Cunneen began working during the summers as a guide at an outdoor ethnic museum in Wisconsin called Little Norway. At the museum, she soon gained a reputation as a great storyteller. This exposure has led to numerous speaking engagements in which she regales her audience with Norwegian dialect stories from the Ole and Lena cycle. She also creates troll dolls which she incorporates in her storytelling performances.

Pascalena Galle Dahl
Mineral Point
Place and date of birth: Mineral Point,
 Wisconsin; 1918
Ethnic background: Italian
Art forms: gardening, canning, cookery
Catalogue numbers: 90-92

Pascalena Galle Dahl's father and mother emigrated from Spadola, a small village in the southern Italian province of Cantanzarro. They bought land for a small farm in the Mineral Point area and raised a family which grew to include fifteen children. All of the Galle children were expected to help with the chores, and Pascalena helped her mother with the cooking as well as outdoor work. She particularly enjoyed feeding the chickens and pigs, as well as planting, tending, and harvesting the two large gardens in which the family grew beans, tomatoes, peppers, assorted greens, basil, corn, cabbage, cauliflower, broccoli, eggplant, and other vegetables.

Pascalena married Earl Dahl in 1944. The couple worked in Madison until the latter years of the decade. They then returned to Mineral Point where they operated a dry cleaning business, worked for Burgess Battery, and ran their own drive-in restaurants until retiring in 1981. Dahl and three of her siblings still live in the same Italian neighborhood where they were raised. Together they continue to practice the same foodways which they learned in their youth. According to Dahl, "we all grow and can the same things and we do it just like our mother." In addition, the Galle sisters bake the same breads as their mother did, enjoy homemade wine made by one of their husbands, and prepare the same special Italian sausage, the recipe for which remains a family secret.

Willie G. Davidson
Milwaukee
**Place and date of birth: Milwaukee, Wisconsin;
1933**
Ethnic background: Scottish
Art form: motorcycle customizing
Catalogue number: 58

Willie G. Davidson represents the third generation of the Davidson family associated with Harley-Davidson, Inc. Currently the Vice-President and Design Director of the Wisconsin-based corporation, Davidson has been an avid rider from an early age. He studied fine arts at the University of Wisconsin and later received a Bachelor of Professional Arts-Industrial Design from the Art Center College of Design in Pasadena, California. According to Davidson, the degree "blended my fine arts talents with my motorcycle interest, giving me the tools to create Harley-Davidson's rolling sculpture."

Davidson's custom motorcycles, created for his own use, reflect not only his own artistic training but also an aesthetic shared by other riders and customizers. Davidson's continuing participation in motorcycle events across the country allows him to keep abreast of the new directions in custom design and to play an important role in the creative design process he directs at Harley-Davidson.

Marvin DeFoe
Bayfield
Place and date of birth: Chicago, Illinois; 1957
Ethnic background: Ojibwa
Art form: birchbark canoes
Catalogue number: 267

In 1977 Marvin DeFoe took part in a project which involved building a forty-foot Tlingit-style birchbark canoe and paddling it down the Mississippi River. The canoe, now in a museum in Toronto, was constructed of cedar from Mt. Hood, Oregon, and birchbark from Wisconsin.

In the ten years since his involvement with this project, DeFoe has maintained his interest in bark canoes. He has talked with Ojibwa elders about his tribe's traditional canoes and undertaken additional research on his own. Working from this base, DeFoe has constructed a number of Ojibwa birchbark canoes. In the process, he has revived the art form within his tribe. He has gone on to demonstrate traditional birchbark canoe building for the National Park Service at Apostle Islands National Lakeshore and at various schools and museums. He and his wife Diane also fashion makuks, baskets, and other smaller artifacts of birchbark.

Maria Fafendyk
Sheboygan
Place and date of birth: Ukraine; 1925
Arrival in the United States: 1964
Ethnic background: Ukrainian
**Art forms: cross-stitch embroidery, holiday
breads**
Catalogue numbers: 135-138

Maria Fafendyk began helping her mother with her traditional embroidery at the age of six. By the time she reached adolescence, she was an accomplished needleworker. Maria Fafendyk and her husband Stefan spent the years immediately following World War II as displaced persons in Germany. In 1953 they moved to England, and in 1964 they came to the United States. Shortly after their arrival in this country, the Fafendyks moved to Sheboygan where Maria's husband worked at Plastics Engineering Company and she was employed by Wigwam Mills.

Fafendyk has been embroidering pillows, tablecloths, napkins, blouses, and rugs with Ukrainian geometric designs and figurative motifs for many years.

Since her recent retirement she has been able to devote additional time to her embroidery. She has also passed along her skills and techniques to her daughters, but they find that they do not have time to do the work. Fafendyk's embroidery is admired by members of the Milwaukee and Chicago Ukrainian-American communities. Occasionally she participates in ethnic events such as the International Institute's Holiday Folk Fair in Milwaukee.

Milton R. Geyer
Green Bay
**Place and date of birth: Green Bay, Wisconsin;
1912**
Ethnic background: German
Art form: duck decoys
Catalogue numbers: 268-271

When Milton Geyer was a boy in Green Bay, the east side of town was largely marshland and sloughs where prairie chickens and ducks abounded. Geyer's father and four older brothers hunted and trapped the marshes, and young Milt was fascinated by the form and color of the ducks which they brought home. At the age of sixteen, Geyer began to hunt and trap on his own. Prompted by the rising cost of store-bought decoys during the Depression, Geyer began making his own decoys. He emulated the examples set by other bird carvers in the Green Bay area. These included his father as well as Jack Van Caughenburgh, who sold sporting goods and made decoys commercially, and Jack Kearney, who was a commercial fisherman and market hunter.

Geyer made his first decoys for himself and his brother, but over the years other hunters and collectors grew familiar with his work and began to purchase as many as a dozen bird carvings at a time. Geyer, who does not consider himself to be a commercial producer, has made approximately 250-300 decoys over the last fifty years. He now makes nonfunctional "decorator" decoys as well as the working birds he has always carved.

Geyer worked for thirty-nine years for the Bay West Papermill making paper towels and related products. Retired in 1976, he remains an avid hunter and active supporter of organizations such as Ducks Unlimited.

Tamer Givens
Milwaukee
Place and date of birth: Minden, Louisiana; 1920
Ethnic background: Afro-American
Art form: quilting
Catalogue number: 60

Tamer Givens was raised in Minden, Louisiana. By the age of fourteen, she was helping her mother by making her own clothing and bedding. Throughout the years, Givens continued her needlework, making bed sheets, pillowcases, and quilts. She used cotton grown on the land her family farmed as batting for the quilts. She also cut and sewed clothing for other people as a means of making additional money.

Six years ago, Givens came to Milwaukee from Oakridge, Louisiana, to be with her children. She is currently an active member of a craft group organized by Velma Seales at the Hampton Gardens housing complex. The group consists of six black women who meet regularly to socialize and to quilt bedcoverings pieced by members. Currently, Givens' goal is to create a quilt for each of her children.

Alexander "Ike" Gokee
Bayfield
**Place and date of birth: Red Cliff Reservation,
Wisconsin; 1918**
Ethnic background: Ojibwa
Art form: lacrosse sticks
Catalogue number: 266

When "Ike" Gokee was a boy during the 1920s and 1930s, informal games of lacrosse were common on the Red Cliff Reservation. Weightier contests against the youth of the Bad River Reservation were also regular occurrences. Gokee learned to make lacrosse sticks of white ash and rawhide from his father and other members of the community. As the game's popularity faded on the reservation, Gokee's involvement also declined and he devoted himself to his work as a lumberjack. However, about four or five years ago, when a number of young people became interested in reviving the game, Gokee set to work once again, making new lacrosse sticks and teaching apprentice Mike Montano the techniques and construction process. The pair hope to have enough sticks to outfit a team for practices and competitions during the coming springs and summers.

Bernice Gross
Hillsboro
Place and date of birth: Greenwood Township,
** Vernon County, Wisconsin; 1903**
Ethnic background: Czechoslovakian
Art form: quilting
Catalogue number: 13

Bernice Gross was born and raised on a farm about two and one-half miles from Hillsboro, Wisconsin. As a young girl, she learned to crochet and embroider from her mother. Several years before she was married in 1922, she helped her mother and aunt piece and tie a few quilts composed of scrap fabrics. For white cloth, they used flour sacks and sugar sacks which they washed and bleached. Such simply patterned utility quilts were usually created in the home and not within the social context of a quilting bee.

Following her marriage, Gross moved two farms down the road from the farm where she grew up. She helped her husband tend dairy cattle for thirty-four years before they sold the property to their daughter Shirley and her husband. In 1956 Bernice and her husband moved to Hillsboro where she began attending the regular meetings of the First Congregational Church quilting group.

Edith Hakamaa
Ironwood, Michigan
Place and date of birth: Kauhajoki, Finland;
** 1921**
Arrival in the United States: 1960
Ethnic background: Finnish
Art form: woven rag rugs
Catalogue number: 61

The weaving tradition in the family of Edith Hakamaa has been passed along from mother to daughter over a number of generations. She was taught to weave rugs and linen tablecloths by her mother while a girl of only ten in her native Finland. The loom on which she learned to weave is reputedly several hundred years old. According to family tradition, it was acquired by trading flour with itinerant weavers during a period of starvation in Finland.

After immigrating to a farm in Wisconsin's Iron County with her husband, Hakamaa continued to make and sell her weavings much as she did in Finland. While many of her rugs were created for family and friends, she also sold rugs to local people — frequently Finnish-Americans — who came to her house to choose and buy. She now places less emphasis on selling her rugs. However, as an active member of the Finnish-American community which sits astride the Wisconsin-northern Michigan border, she continues to weave often and to demonstrate her skills at various events. Indeed, two rooms on the second floor of the Hakamaa home hold balls of cloth strips, finished rugs, and her loom.

Eino Hakamaa
Ironwood, Michigan
Place and date of birth: Kauhajoki, Finland;
** 1911**
Arrival in the United States: 1960
Ethnic background: Finnish
Art form: cedar basketry
Catalogue number: 168

Eino Hakamaa was raised on a farm in Finland. He lost his father at an early age and, as an adolescent, spent a good deal of time with a neighbor, Matti Maensivu. Matti was in his eighties but was still a fine basket weaver. Hakamaa learned the making of simple functional baskets from his elderly friend at the age of fourteen or fifteen, and he has continued to make them ever since. Although he has never sold any of his baskets, preferring to give them away to family and friends, he is widely known and appreciated for his skills in northern Wisconsin's Finnish community.

Hakamaa married his wife Edith in 1939 and together they raised dairy cattle and small grain on their farm in Finland. He also worked during the summers as a house carpenter. In 1960 the Hakamaas immigrated to the United States, joining relatives who had earlier come to Wisconsin. They settled on a farm in Iron County's Oma Township, south of Hurley. In 1966, following several instances of bad luck on the farm, the Hakamaas moved to Ironwood, Michigan, just across the state line, and Eino Hakamaa took a job with a sawmill. He worked at the mill until his retirement.

Eino and Edith Hakamaa are active members of a Finnish-American community which straddles the Wisconsin and Michigan segments of the Gogebic Iron Range. They are frequent participants in ethnic programs held at "Little Finland" in Kimball, Wisconsin. Eino Hakamaa has also demonstrated basket making at ethnic events in urban areas including Milwaukee.

Gerald Hawpetoss
Keshena
Place and date of birth: Keshena, Wisconsin;
1952
Ethnic background: Menominee
Art forms: beadwork, dance regalia
Catalogue number: 99

Gerald Hawpetoss was born in Keshena on the Menominee Reservation, but he lived in Milwaukee while a young boy. There he contracted rheumatic fever, which prompted his parents to send him back to Keshena to live with his grandparents. From his grandmother and grandfather, Hawpetoss learned traditional arts including the tanning of hides and the making of moccasins and other dance regalia as well as beadwork, singing, and drumming.

Hawpetoss' mother was a Christian and his father was "from the traditional line." Though raised as a Catholic in Milwaukee, Hawpetoss came to follow the drum religion on his return to the reservation. He met his wife Marjorie, a Navajo, while both were dancing at Wisconsin Dells. Marjorie Hawpetoss is an accomplished rug weaver. Both she and her husband are passing along their artistic traditions to their children.

Edward Henkelman
Merrill
Place and date of birth: Marathon County,
** Wisconsin; 1909**
Ethnic background: German
Art form: tall-tale taxidermy
Catalogue numbers: 250-255

Edward Henkelman's father, Adolph, was a forester in Germany, and according to Ed he "knew how to do things." Henkelman's older brother tanned hides and mounted trophy animals. As might be expected given his family background, Ed Henkelman hunted and

trapped from an early age and also learned basic taxidermy. After receiving basic instruction from his father and brother in the mounting of animals, he took a mail-order course from the Northwestern School of Taxidermy.

Henkelman has tanned hides and performed conventional taxidermy off and on throughout most of his life, but since retiring from farming and working in the woods, he has been able to devote a significant amount of time to it. Henkelman incorporates his tall-tale teller's sense of humor into his taxidermy. Over the last five years, he has fashioned not only a squirrel band and dancers, but also a mermaid and an "African moth." Each of these creatures enhances Henkelman's status as a local "character" as well as his skill as a hunter and taxidermist.

John Henkelman
Merrill
Place and date of birth: Hewitt, Wisconsin; 1905
Ethnic background: German
Art form: woodcarving
Catalogue number: 190

John Henkelman worked as a logger until the age of twenty-four. For thirty years afterwards, he farmed and did occasional stone, brick, and block masonry. Following his retirement in 1970, Henkelman took up woodcarving in order to keep himself occupied. Like other carvers in northern Wisconsin, Henkelman attempts to "carve what I know." Adhering to a regional and occupational aesthetic, he concentrates on natural motifs, wildlife, and logging scenes. Henkelman keeps most of his pieces for himself and gives others away to relatives. At the same time, he has acquired a local reputation as a woodcarver over the last sixteen years and has sold a number of pieces of his work to community members who value the life style and occupations characteristic of the region.

Alvin J. Herschberger
Westby
Place and date of birth: Ohio; 1959
Ethnic background: Amish
Art form: bent hickory furniture
Catalogue number: 62

Alvin Herschberger recalls bent hickory furniture in the Amish community in Ohio where he was raised. During the late 1970s, following his family's migration to the Cashton-Ontario-Westby area of Wisconsin, he apprenticed with Aden Yoder, a local furniture maker who eventually became his father-in-law. Herschberger has been making furniture on his own for five years and has his own shop.

While Herschberger specializes in rockers of bent hickory, he also makes coffee tables, end tables, high chairs, baby cribs, and other pieces of furniture. He sells a good deal of his work locally, within both the Amish and English communities. He also sells his furniture through a hardware store in Westby and occasionally to passing tourists and antique retailers.

Dennis Hickey
Baileys Harbor
Place and date of birth: Sturgeon Bay,
** Wisconsin; 1942**
Ethnic background: Norwegian and German
Art form: marker buoys
Catalogue numbers: 175-179

Dennis Hickey's grandfather emigrated from Norway and settled in the Baileys Harbor area where he fished commercially for most of his life. Hickey's father was brought up in the occupation and, as an adult, fished first with his father, then with his brother, and later with another local fisherman. When fish stocks suffered severe depletion during the 1950s, Hickey's

father sold his rig and went to work at a Sturgeon Bay shipyard.

Though they were brought up in the trade, Dennis Hickey and his brother Jeff never intended to become commercial fishermen. Dennis graduated from the University of California at Los Angeles, worked as a meat cutter for Safeway Stores in California, and served in the navy. Then, in 1965, both Dennis and Jeff Hickey returned to Baileys Harbor where they went to work for their father's former colleague, Cliff Wenniger. In 1967 they bought their own gill-net boat and began fishing on their own. In 1969 they bought out Wenniger and acquired his boat and equipment.

The Hickeys claim to be the last commercial fishermen on Lake Michigan who use pound nets to earn their living. Much of their handwork is directed toward producing and maintaining the complicated and expensive nets, floats, leads, and poles required by this technique. In addition, Dennis and Jeff Hickey also fashion their own scoop nets for lifting their catch from the pound nets, carve their own wooden floats, and carve and assemble their own gill-net buoys.

Vita V. Kakulis
Bayside
Place and date of birth: Valmiera, Latvia; 1936
Arrival in the United States: 1949
Ethnic background: Latvian
Art forms: traditional costumes, woven and
** braided belts**
Catalogue numbers: 34-37, 103

In 1944 at the age of eight, Vita Kakulis left Latvia aboard a refugee train led by her father. In the spring of 1945, after arriving in Germany by ship and moving from one displaced persons camp to another, the Kakulis family settled in a camp in the American zone. Following the war, Vita came to the United States with her family. They lived first in Massachusetts and thereafter in Ohio, New Mexico, and Washington, D.C. In 1961 Kakulis married a Milwaukee man whom she had met while visiting her sister. The recipient of a degree in business administration from the University of New Mexico, she has worked periodically as a computer business analyst while raising her family.

Kakulis learned knitting, embroidery, belt weaving, and costume making in the displaced persons camps in Germany, attending classes offered by people who had studied in the Latvian folk art institutes. The costumes were required for participation in concerts performed in the camps.

Kakulis sewed her own clothing during high school and sewed for her family after marrying, but she did not return to belt weaving and costume making until her sons began attending Latvian school in 1967 and needed costumes for festive events. Since then, she has made approximately four costumes for each son. In 1978, when the Latvians were the featured ethnic group at the Holiday Folk Fair, Kakulis began making her own costume. For several years in the early 1980s, she studied belt weaving and weaving on larger looms with Erma Jamsons who has run a Latvian handicraft school in Milwaukee for many years. Since that time, Kakulis has exhibited her works at Latvian conventions and occasionally taught belt weaving at her children's Latvian summer camp near Three Rivers, Michigan.

Ryszarda Klim
Milwaukee
Place and date of birth: Bialystok, Poland; 1929
Arrival in the United States: 1964
Ethnic background: Polish
Art forms: *wycinanki* (paper cutting), egg
** decorating, straw ornaments, crocheting, and**
** woodburning**
Catalogue numbers: 260-261

Ryszarda Klim learned to knit and crochet as a young girl in Poland, fashioning doilies and table coverings with fishermen's net needles. She also learned to make *pajaki*, decorations made from rye straw. After attending high school and a two-year teacher's college in Poland, Klim became a teacher in her home village. Following the birth of her second child in the mid-1950s, Ryszarda retired from full-time teaching and, in 1964, immigrated to the United States with her family.

Although trained in various other traditional arts as a child in Poland, Klim did not begin to make *wycinanki* or paper cuts until 1973, after her children brought her examples of this work from Poland. Based upon these examples and other designs culled from books, Klim developed a repertoire of designs representing numerous regions in Poland. While not part of her own upbringing, paper cutting represents for Klim a means of recalling the traditions of her native country.

Ethel Kvalheim
Stoughton
Place and date of birth: Pleasant Springs
Township, Dane County, Wisconsin; 1912
Ethnic background: Norwegian
Art form: rosemaling
Catalogue numbers: 258-259

Ethel Kvalheim was raised on a farm about nine miles from Stoughton. The mother of two boys, Kvalheim worked as a housemother at the Oregon School for Girls in Oregon, Wisconsin, between 1957 and 1975.

When she was first married, Kvalheim lived only one block from famed Stoughton rosemaler Per Lysne. Impressed and inspired by his work, Kvalheim turned her hand to rosemaling around 1942 when her children were old enough to allow her some spare time in the evenings. She modeled her work on that of Lysne and on other examples that she found in the Stoughton area. Kvalheim's interest in models for her work led her to Vesterheim, the Norwegian-American Museum, in Decorah, Iowa, circa 1947. She attended the museum's first Nordic Fest a year later and soon after participated in the second rosemaling workshop ever held at Vesterheim. Norwegian rosemaler Sigmund Areseth taught the workshop, and it marked a turning point in her work and in that of many other American rosemalers.

Today, Kvalheim paints primarily for her own enjoyment and avoids custom work. Working primarily during the winter months, she paints a variety of handmade wooden objects from bowls to cupboards. She sells her work by word-of-mouth and often has little work on hand because of the demand. Kvalheim has been designated a gold medalist by the Wisconsin Rosemaling Association and for the past four years has rosemaled the trunk which the association raffles off during its annual exhibit in conjunction with Stoughton's *Syttende Mai* celebration.

Ieva Lacis
(See Alma Upesleja)

Sidonka Wadina Lee
Lyons
Place and date of birth: Milwaukee, Wisconsin;
1947
Ethnic background: Slovakian
Art forms: decorated Easter eggs, wheat weaving
Catalogue numbers: 119-129

Sidonka Wadina Lee was raised in a predominantly Slovak neighborhood in Milwaukee's industrialized Menomonee River Valley. Both of Lee's grandmothers, Johanna Birksadsky and Anna Wadina, had emigrated from Slovakia and continued to practice traditional arts learned in the mother country, especially baking and fancy embroidery. At the age of two, Lee began visiting her grandmother Birksadsky regularly, walking down the block to help with the baking and the making of Slovak dumplings. An early participant in the International Institute during the 1940s, Birksadsky not only carried on traditions in her home but also gave regular programs and demonstrations on Slovak culture in area schools. As the eldest grandchild and the one who demonstrated the strongest interest in her cultural heritage, Lee became Birksadsky's protégée, accompanying her to programs, dancing in the Holiday Folk Fair, and in 1964 returning with her to Czechoslovakia to visit relatives.

Sidonka Wadina Lee learned to paint Easter eggs from Johanna Birksadsky at an early age. Lee first became acquainted with wheat weaving and the straw decoration of eggs during her 1964 visit to Czechoslovakia. With the help of her grandmother, who had practiced both art forms as a child, she learned to create the weavings by disassembling and reassembling examples she had been given by a cousin in Slovakia and similar old country keepsakes in the possession of Milwaukee neighbors. Her experimentation occasionally jogged her grandmother's memory regarding techniques and prompted her to explain the symbolism associated with various patterns. Today, Lee has succeeded her grandmother as an instructor for the International Institute. She teaches wheat weaving and sells her hand-painted and straw-decorated Easter eggs to various Slovak and Czech groups throughout the state.

Ivar Lehto
(See Eugene Stenroos)

Stephanie Lemke
Mazomanie
Place and date of birth: Podbrezje, Yugoslavia;
1948
Arrival in the United States: 1972
Ethnic background: Croatian
Art form: *pisanica* (decorated Easter eggs)
Catalogue numbers: 130-133

Stephanie Lemke was brought up on a small, self-sufficient farm in the hilly inland area of Ozal in Yugoslavia. At the age of fifteen, she left home to study motel management on the Adriatic Coast. She was offered a job in a West German motel by tourists vacationing in the area, and in 1966, at the age of seventeen, she left Yugoslavia for West Germany. Lemke lived there for six years and, during that time, met her husband, an American in the military. She came to the United States with him in 1972. In 1974, they moved to Cross Plains, Wisconsin. Late in 1977 they moved to the house in Mazomanie where Lemke and her son still live.

Although familiar with the practice of egg decorating since childhood, Stephanie Lemke did not begin making thread-decorated eggs until she married and moved to this country. Encouraged by a woman who wished to sell the eggs in her Cross Plains gift shop, she began making the eggs regularly. They were very popular in the local community. Over several years she was able to raise substantially the price for each egg and to move her sales from the gift shop to her home. While there is a definite interest in Lemke's decorated eggs among collectors and, to a lesser extent, among Croatian-Americans, she is no longer able to produce them on a large scale due to surgery for rheumatoid arthritis. Now she makes the eggs only on an individual basis for very special people. She also hopes to teach the technique and symbolism of Croatian egg decorating to the daughters of friends.

Ching-Ho Leu
Madison
Place and date of birth: Tainan, Taiwan; 1949
Arrival in the United States: 1985
Ethnic background: Taiwanese
Art form: origami (paper folding)
Catalogue numbers: 263-265

Ching-Ho Leu is an associate professor of mathematics and statistics at a university in Tainan, Taiwan. He is currently completing his sixth semester of graduate study in the Statistics Department at the University of Wisconsin in Madison. Leu expects to complete his graduate work in two or three years, at which time he will return to his position in Taiwan.

Leu learned origami paper-folding techniques from his parents when he was about six or seven years of age. His wife, Hui-Yuan Leu, also learned paper folding from her mother at an early age. The couple has passed along the art form to their two sons, ages nine and five. The family currently practices paper folding for fun. Occasionally the Leus create origami forms during social gatherings with other Taiwanese natives who are studying statistics at the university.

The Leus' oldest son, Wei-Cheng, also practices his paper folding at Shorewood School where he is in fourth grade. Among students attending the elementary school, paper folding is a popular informal activity engaged in by Asian and Western children alike.

Patricia Gutierrez de Llamas
Madison
Place and date of birth: Tepic Nayarit, Mexico;
 1955
Arrival in the United States: 1980
Ethnic background: Mexican
Art form: piñatas
Catalogue number: 262

Patricia Llamas watched her mother and great-aunt make piñatas for her when she was growing up. She became actively involved in creating the candy- and trinket-filled containers used for birthday and Christmas celebrations when she had children of her own. Llamas has created piñatas for her own family and for festivities sponsored by international student groups and for sale to others of both Mexican and non-Mexican descent. While Llamas has made piñatas with bodies constructed of clay pots during visits back to Mexico, she typically substitutes papier-mâché when making piñatas in this country.

Rosa Llanas
Waukesha
Place and date of birth: near Torreon Gomez
 Palacio, Mexico; 1902
Arrival in the United States: circa 1922
Ethnic background: Mexican
Art forms: needlework, especially *deshilado*
 work
Catalogue number: 69

Rosa Llanas was born on a farm near Torreon Gomez Palacio in Mexico in 1902. She came to the United States circa 1922. After living in Texas and Arkansas for a number of years, Llanas moved to Wisconsin in 1940. She lived first in the Green Bay area, where she and her family picked sugar beets, and then in Waukesha, where her husband found work in a foundry. Llanas has worked in the home all her life and has raised a family of fifteen children. She remains very much involved with her extended family in southeastern Wisconsin and spends considerable time at La Casa de Esperanza's Senior Center.

Rosa Llanas learned *deshilado* needlework and crocheting from Mexican friends and neighbors while living in Arkansas and Wisconsin between 1934 and 1945. For many years thereafter, despite the demands of chopping wood, grinding corn for tortillas, and sewing all of her children's clothing, Llanas continued to practice both forms of needlework as a way of relaxing and as a way of demonstrating her domestic skills. She also taught three of her daughters to decorate dish towels, napkins, tortilla covers, and doilies using *deshilado* and crocheting techniques. Llanas' daughter Mary recalls that whenever it rained while they were working in the sugar beet fields, the younger women would wait out the storm doing needlework.

Because *deshilado* drawnwork is very hard on the eyes, both Rosa Llanas and her daughters now practice this form of needlework only occasionally. However, all continue to crochet, and Llanas uses heavy yarns to make blankets and afghans for her grandchildren and great-grandchildren.

Steven Maki
(See Eugene Stenroos)

Vera Mednis
Warrens
Place and date of birth: Riga, Latvia; 1939
Arrival in the United States: 1951
Ethnic background: Latvian
Art form: weaving
Catalogue number: 107

Vera Mednis' family lived in the country near Riga, Latvia, at the time of her birth. The family fled Latvia during the evacuation of 1944 when she was five years old. After seven years in displaced persons camps in Germany, Mednis immigrated to Milwaukee with her family. In 1959, Mednis met and married her husband Edmunds. For eighteen years thereafter she worked as a secretary and her husband as a storekeeper and steel plant worker. In 1977, the Mednis family realized a long-cherished dream: they bought and moved to a farm near Warrens. There, with fellow members of their ethnic group, they have built a "primitive Latvian religion" church in which they hold quarterly meetings and celebrate festive events. Since moving to the country, the couple has supported themselves by selling their traditional artwork.

At an early age, Mednis learned weaving from her mother, who in turn had learned it from her mother. After coming to the United States, she also began making Latvian-style pottery. Although not strictly traditional since they are not salt-glazed, Mednis' ceramics retain many Latvian design motifs, forms, and color combinations. She has passed along some of her weaving skills to her daughter Mara, and she has taught her husband Edmunds to do traditional leather work. All participate in local, statewide, national, and international Latvian gatherings and celebrations. They sell their works in the closely knit but widely dispersed Latvian communities throughout the country.

Nikola Milunovich
Milwaukee
Place and date of birth: Bos Grahova, Serbia,
 Yugoslavia; 1925
Arrival in the United States: 1950
Ethnic background: Serbian
Art form: woodcarving
Catalogue number: 117

Nikola Milunovich was born and raised in Serbia. During World War II his family was forced to hide in the mountains. After the war they moved to Italy. There Milunovich met and married his Serbian wife Sophie. The couple came to Milwaukee in 1950. Nikola has worked as an overhead crane operator at the Harnischfeger factory since 1957 and is an active member of Steelworkers' Local 1114.

While Milunovich chiseled animal figures out of stone as a young boy, he set aside his carving activities

throughout most of his adult life. He resumed carving in 1979. At that time, he turned from stone to black walnut as a medium and expanded his repertoire to include human figures which recall his Serbian heritage. Milunovich carves primarily in the evenings and on weekends and occasionally fills slack moments on the job with carving. Though he has made a few pieces to order, Milunovich is not interested in selling his carvings and keeps most of his works for himself.

Arthur Moe
Stone Lake
Place and date of birth: La Crosse, Wisconsin;
 1927
Ethnic background: Norwegian
Art form: chain-saw carving
Catalogue number: 191

Arthur Moe's father Clarence was a carpenter, cabinetmaker, and building contractor who tinkered with gunsmithing. He carved decorations on gunstocks and did some checkering as well as pearl and ivory inlay. When Art Moe was six years old, his father gave him a knife and advised him, "Keep it sharp and you'll never cut yourself." Art began whittling animals almost immediately; his first one was a toad, probably out of pine. He has continued whittling on and off throughout most of his life, occasionally fashioning gun racks and door handles from deer antlers.

Art Moe did his first chain-saw carving of a bear in 1961, translating the whittling skills developed over a lifetime to a new technology and larger scale. Like other north-woods carvers, Moe specializes in images of the region's wildlife, such as muskies, eagles, and snapping turtles; images of regional characters, including hunters, fishermen, loggers, and Indians; and images stemming from his Norwegian ethnic heritage, like Vikings and creatures from Norse mythology. Moe is highly regarded by his regional audience and is the winner of various chain-saw carving competitions in the area, including one associated with the Lumberjack World Championships in Hayward. He has donated some of his carvings to the Lion's Club, the Chamber of Commerce, and the Birchwood Bluegill Festival. Others he has sold to customers at his resort. However, most of his carvings decorate the grounds of his home and place of business.

Alexandra Nahirniak
Waunakee
Place and date of birth: Bukovina, Ukraine; 1899
Arrival in the United States: 1950
Ethnic background: Ukrainian
Art forms: cross-stitch embroidery, costume
 making
Catalogue numbers: 140-143

Alexandra Nahirniak learned egg decorating and traditional needlework from her mother as a young girl in the western Ukraine. She worked as a schoolteacher and married an Orthodox priest. Throughout her life in the Ukraine, Nahirniak created embroidered pillows, table linens, and costumes in the floral style of her native Bukovina and in the geometric style of the mountain Hutsula among whom she and her husband lived while serving a parish.

Following her family's immigration to this country, Nahirniak continued to embroider cloth for household use and to make costumes for display at public ethnic events. She now resides in a rest home and is no longer able to do cross-stitch or other forms of embroidery, but her family retains the needlework she created years ago as treasured heirlooms.

William Nahirniak
Waunakee
Place and date of birth: Bukovina, Ukraine; 1922
Arrival in the United States: 1949
Ethnic background: Ukrainian
Art form: *pysanky* (decorated Easter eggs)
Catalogue numbers: 144-158

William Nahirniak began to decorate eggs as a child in the Ukraine. His family devoted evenings during the three or four weeks prior to Easter to the task of preparing *pysanky* for themselves and their friends. Nahirniak's first task as a young boy was to draw crosses and stars on the eggs while others worked on more intricate designs. By high school age, he was able to complete entire eggs.

Egg decorating was very much a part of Easter preparations during Nahirniak's youth in the Ukraine, but for many years following his arrival in this country, he did not decorate eggs in the traditional manner. Then, when his wife Donna admired some *pysanky* they saw in Chicago in 1970, he returned to the practice and taught both his wife and their two children its intricacies. In addition to teaching his family this valued ethnic art form, Nahirniak has conducted local classes and demonstrations for Ukrainian students and other interested persons.

Elsie Niemi
Dane
Place and date of birth: Hancock, Michigan;
 1912
Ethnic background: Finnish
Art form: tatting
Catalogue numbers: 73-79

Both of Elsie Niemi's parents were born in Finland. Her father immigrated to the "copper country" of Michigan's Upper Peninsula to work in the mines. Later he was able to bring his wife and son to the United States. Elsie Niemi was born in Hancock, Michigan. When she was about two years old, her family moved to an eighty-acre farm near Trout Creek. After her father died in 1933, the family was able to keep possession of the farm only by pooling all of the children's earnings. By this time, Niemi had been working as a domestic in Detroit and Chicago for five years. She returned to Trout Creek in 1935 and spent the next five years in the employ of the cooperative store. Following her marriage in 1940, she and her husband moved to Minnesota, New York, and Massachusetts. In 1950 they returned to Minnesota. Following her husband's death in 1958, Niemi returned to working for the cooperative store in Superior. In 1970 she took a proofreading position with the University of Wisconsin's Agricultural Extension division in Madison in order to be closer to her sons who were working and attending school there. She retired in 1977.

As a child, Niemi spent much of her spare time cutting rags to be woven into rag rugs by her aunt. She also learned basic needlework skills from her mother and from neighbors in the Finnish community. These skills have served her well, for she has been actively engaged in various needlework projects ever since.

Phillip Odden
Barronett
Place and date of birth: Shell Lake, Wisconsin;
 1952
Ethnic background: Norwegian
Art form: woodcarving
Catalogue numbers: 64-65

After attending college in River Falls, Phillip Odden worked in Montana for a period of six or seven years. He did hunting, trapping, fishing, and surveying for the forest service. During the summers, he fought forest fires in Alaska. Inspired by Eskimo and other Native

American carvings he observed there, Odden began carving bone, horn, and soapstone. Then, during the winter of 1976 while visiting relatives in Norway, Odden learned of the hundred-year-old Hjerleids Husflid Skole, one of two trade schools in the country where a small number of students could learn traditional cabinetry and carving from a master carver. With the assistance of his relatives, Odden gained admittance to the program and spent two years at the school. There he learned both carving and furniture making. Later he focused exclusively on carving.

Following completion of the program, Odden and his wife, fellow classmate Else Bigton, returned to Wisconsin where they established Norsk Wood Works in Barronett. Odden generally creates the most elaborate decorative carvings sold by the wood shop and is responsible for the more complicated carvings on the furniture which Bigton designs and builds. The majority of their work is made to order for the Norwegian-American community in the upper Midwest.

Hortensia Ojeda
Waukesha
Place and date of birth: General Cepeda, Mexico; 1916
Arrival in the United States: circa 1923
Ethnic background: Mexican
Art forms: needlework, especially *deshilado*
Catalogue number: 256

Hortensia Ojeda was born on a farm near Monterey, Mexico, just across the border from Laredo, Texas. When she was about seven years of age, Ojeda and her family moved to Texas. In 1937 they moved to the area of Green Bay, Wisconsin, to pick sugar beets. Ojeda was married in Green Bay in 1938, lived in West Bend for several years afterwards, and then moved to Waukesha where her husband worked for International Harvester. She worked for Memorial Hospital in Waukesha for twenty-three years before retiring about three years ago. She now works part time as a teacher's aide at La Casa de Esperanza's Day Care Center.

Ojeda was eleven or twelve years old when she learned to do *deshilado* work from neighbors and friends of her mother. She used the intricate openwork technique to decorate tablecloths, pillowcases, dish towels, and handkerchiefs. Unfortunately, because *deshilado* work is so hard on the eyes, Ojeda has stopped practicing this demanding form of needlework. She continues to crochet, however, making doilies and tablecloths with fine thread and afghans with heavier yarn.

Eino Okkonen
Herbster
Place and date of birth: Bark Point, Bayfield County, Wisconsin; 1903
Ethnic background: Finnish
Art forms: traditional fishing boats and gear
Catalogue numbers: 180-189

Eino Okkonen's parents were born in Finland and immigrated to Ely on the Minnesota Iron Range in the 1890s. Around 1900, they traveled by boat with other Finnish homesteaders to Bark Point, a finger of land jutting out into Lake Superior. Many of the Finns who settled on the point were experienced fishermen, and before long almost every family had built fishing piers at the base of the point's steep cliffs.

Okkonen started fishing with his father and brother in his early teens. He produced traditional equipment, including boats, lines, floats, and bobbins, as they were needed. Often he collaborated with relatives and other more specialized craftsmen. Okkonen fished out of Cornucopia during summers and winters until 1955 when the fisheries began to decline. He then worked on Lake Superior iron ore boats seasonally until 1967.

Julian Orlandini
Milwaukee
Place and date of birth: Milwaukee, Wisconsin; 1934
Ethnic background: Italian
Art form: ornamental plaster work
Catalogue number: 257

Julian Orlandini's father, Matthew, was born in 1904 in Lizano, Belvedere, Italy, in the mountains of the north central part of the country. The male members of his extended family were stonemasons or glass blowers. In 1912, the family came to the United States and settled in Vineland, New Jersey. Six years later, Matthew Orlandini apprenticed with an ornamental plaster worker named Fermighi and worked in the Philadelphia area until he had mastered the trade. Subsequently he traveled to jobs in various parts of the country. In the late 1920s he stopped in Milwaukee while enroute to Minneapolis and found work on the Eagle's Club building. While in Milwaukee, Matthew Orlandini married, and in 1936, he opened his own shop there.

Julian Orlandini began spending time in his father's shop at the age of five, mixing plaster and cement. By the age of fourteen, he was working during the summers in the shop. After graduating from high school, he served in the navy and took courses in architecture. Finding himself not much of a student, Julian Orlandini rejoined his father in 1964. In 1970, Matthew Orlandini retired from the business.

Julian Orlandini continues the tradition of Orlandini Ornamental Plaster into its fiftieth year. Although he has no children, he has passed along his skills to several nephews who have come to work for him. Together they undertake residential work, small commercial jobs, and some original and restorative work for churches. Orlandini avoids very large jobs because his skilled help is limited and because he prefers to be at the work bench and on the scaffold himself. Recognized as an Italian craftsman by the local community, he participates regularly in events like Festa Italiana where he demonstrates his skills and distributes samples of his work.

Emil F. Pirkel
Watertown
Place and date of birth: Town of Farmington, Jefferson County, Wisconsin; 1913
Ethnic background: German
Art form: net making
Catalogue number: 244

Emil Pirkel was raised on a farm and has been interested in fishing since boyhood. At the age of seven, Pirkel learned how to tie knots from Johnny Schwab, a neighbor who wove fish nets. Soon after, Pirkel began making his own nets, using shuttles and gauges fashioned from cigar-box wood. During those early years, Pirkel made hoops for his nets from pump rods and other scrap machinery. He constructed handles from ash or oak saplings. While he continues to make gauges from used refrigerator pans, Pirkel now employs commercially manufactured shuttles of steel or plastic, readily available metal hoops and handles, and eighty-pound test synthetic fish line for his nets.

Drawing on his over sixty-five years of experience, Pirkel continues to make dip nets, landing nets, and live bags for springtime river fishing and winter ice fishing. While weaving nets primarily for his own use, Pirkel has also sold his nets to other fishermen since the late 1930s. He prides himself on the durability of his nets as compared with their store-bought counterparts. A natural adjunct to his passion for fishing, Pirkel's net making grew out of a regional tradition dating back to a period when recreational fishing gear was not readily available from commercial sources.

Ronald L. Poast
(See C. C. "Rich" Richelieu)

Ray Polarski
Three Lakes
Place and date of birth: Three Lakes, Wisconsin;
1915
Ethnic background: Austrian and Polish
Art form: fiddle making
Catalogue number: 116

As long as he can remember, Ray Polarski has been "handy with a jacknife." He carved cedar fans, whistles, and a wooden fiddle while a youngster and remembers seeing area lumberjacks — especially Finns — carving chains, balls-in-cages, and canes with dice in the handles. Like many other instrument makers, Polarski began his career repairing damaged instruments. He repaired his first fiddle at the age of thirteen, and shortly thereafter, he fixed the instrument of an old French Canadian in return for a lesson in how to play "Little Brown Jug." Polarski is a "hoedown" fiddler who plays with the instrument tucked against his chest rather than below his chin. He follows in the footsteps of his father who played the button accordion and concertina at dances, weddings, and house parties.

While Polarski started repairing fiddles in 1928, he did not begin constructing them until the late 1930s. Since that time he has made about fifty instruments, some of which he has given to his siblings and his children and some of which he has sold. Because there is little market for his work in northern Wisconsin, Ray Polarski continues to treat his fiddle making as a means of passing the time rather than as a business. Nonetheless, his instruments are highly regarded by family members, friends, and the local community of senior citizens with a taste for old-time music.

Sister Mary Crucifix Polimeni, S.C.S.J.A.
Milwaukee
Place and date of birth: Boswell, Pennsylvania;
1908
Ethnic background: Italian
Art form: bobbin lace
Catalogue numbers: 70-72

Sister Mary Crucifix was born in 1908 in Boswell, Pennsylvania. In 1919, she returned to Reggio Calabria, Italy, with her family. It was there that she learned embroidery and lace making from the nuns who taught in the school she attended. She continued to practice lace making over the next fourteen years. During this period, she entered the Order of the Sisters of Charity of St. Joan Antida and taught for one year in Italy and one year in Malta. In 1933, she immigrated to Milwaukee. In the United States she soon became too busy with other activities and put aside her lace making.

In the late 1970s, nearly forty years after she stopped making bobbin lace, Sister Mary Crucifix was asked by school and ethnic organizations to demonstrate her lace-making skills at ethnic festivals and similar events. She complied and resumed work on a star-patterned border for an altar cloth that she had begun in the 1930s. She is presently working on the lace trim of an altar cloth for the chapel of her convent.

Simcha Prombaum
La Crosse
Place and date of birth: Chicago, Illinois; 1954
Ethnic background: Jewish
Art form: calligraphy
Catalogue number: 118

Simcha Prombaum has been interested in Hebrew calligraphy nearly all his life. At first, he simply copied examples of work that he observed in various places. When he began to devote more serious effort to this traditional art form, Prombaum supplemented his earlier observations with research based on published examples. A major influence on his calligraphy was the well-known Boston calligrapher Jonathan Kremer. As a result of Prombaum's efforts and those of other younger artists like him, there are now more examples of calligraphed wedding certificates and similar religious artifacts within Wisconsin Jewish communities than there were when he was first introduced to the tradition.

Delbert Richardson
Madison
Place and date of birth: Lancaster, Wisconsin;
1907
Ethnic background: English
Art form: fly tying
Catalogue numbers: 205-243

During World War II, when Delbert Richardson was unable to buy commercially made fishing flies, he and his brother Walter sent for materials from a tackle shop in Illinois. They learned to make flies "by guess and by gosh," getting tips from old-timers like Hilden Haig of Madison and occasionally looking at books. Delbert Richardson has continued to make dry flies for catching river trout and lake fish ever since. He obtains squirrel tails, wood duck feathers, chicken hackles, and other necessary materials from friends who hunt or farm. These unlikely elements he transforms into fishing flies at a table set up in a spare bedroom.

After working for thirty-five years as a letter carrier and nineteen years as a clerk and repairer of fishing gear at Petrie's Sporting Goods, Richardson is now retired. However, he still enjoys his reputation as the best maker of fishing flies in the area.

C. C. "Rich" Richelieu
Oregon
Place and date of birth: Owen, Clark County,
Wisconsin; 1909
Ethnic background: Norwegian
Art forms: banjo and fiddle making
Catalogue number: 114

"Rich" Richelieu began to play his father's "little violin" at the age of four. At thirteen, influenced by the jazz age and by the widespread use of tenor banjos in old-time party bands, Richelieu began playing the banjo. After doing occasional repair work on his own banjo and those of friends, he built his first instrument in 1932. Richelieu continued to produce banjos on a part-time basis thereafter, working on his instruments during time away from his positions as an electrical engineer for RCA and the Civil Aeronautics Administration and as a sales representative for an engineering firm. He also played banjo in Dixieland-style big bands and various pick-up aggregations and began to collect banjos of various makes and models.

In the late 1960s, following his retirement, Richelieu began making plans to devote all of his time to banjo making. In 1973 the first Richelieu banjos were produced at a small shop in Oregon, Wisconsin. Richelieu and his staff of three craftsmen, including Ronald L. Poast, produce a stock five-string banjo. All the rest are tenors, important instruments in Wisconsin old-time bands — especially Norwegian bands. During the past six years, Richelieu's shop has also begun to create Hardanger fiddles, the elaborately decorated, nine-stringed instruments widely played by Norwegian Americans in the upper Midwest from the midnineteenth through the early twentieth century. Working from examples at the Norwegian-American Museum and from published articles, Richelieu and his associates have revived the making of Hardanger fiddles in order to meet the needs of Scandinavian musicians in the area who have returned to the instrument in the last fifteen years.

Rich Riemenschneider
Oconomowoc
Place and date of birth: Milwaukee; 1913
Ethnic background: Swiss
Art form: duck decoys
Catalogue numbers: 246-249

Rich Riemenschneider was attending college when his father passed away in the early 1930s. Financially unable to complete his education, Riemenschneider went into the canned food business, earning $14 per week. Eventually he began a food brokerage firm which he built up and sold by the time he reached the age of fifty-three. Since that time, Riemenschneider has lived on a thirty-acre tract of land encircling Lake Sybil in rural Waukesha County south of Oconomowoc. For several years he ran a game farm on the property and was involved in organizing waterfowl shows for decoy carvers.

When Riemenschneider was about fourteen years old, his uncle Tony Grueninger promised to take him duck hunting if he would caulk the skiff and replace the heads on some decoys. He eagerly complied and began a career of decoy carving which has continued to this day. Inspired by the decoys of local carvers, Riemenschneider fashions ''working'' decoys of wood and cork. Initially his audience consisted of friends and family members, but since his retirement he has achieved regional and national recognition through his participation in decoy carvers' and collectors' events. In his basement, he maintains ''The Duck Hunters Hall of Fame,'' which boasts a Riemenschneider replica of virtually every duck and goose in the Mississippi Valley flyway.

Samuel Rust
Rice Lake
Place and date of birth: Rice Lake, Wisconsin;
** 1934**
Ethnic background: German
Art form: carved gunstocks
Catalogue number: 245

When Sam Rust was a boy, he spent a great deal of time in the garage and basement workshops of his uncles, Lee and Pat Scherz. The two brothers were accomplished woodworkers who made, modified, and decorated gunstocks. Sam helped his uncles with sanding and other basic tasks. From them, he learned how to fit a gun's metal ''action'' into a wooden stock. He also learned a range of decorative patterns, including checkering and oak leaf motifs. Rust carved his first gunstock at the age of nine and has been steadily involved in the craft ever since.

Rust is currently director of the Rice Lake housing authority and an avid country and gospel singer and songwriter. He works on his guns primarily in the evenings and on weekends. While he carves primarily for himself, he has made numerous gunstocks for his children, relatives, and friends. Rust estimates that he has carved between 100 and 150 stocks over the years and has worked on many others. Although most of his customers hear of his work by word-of-mouth, Rust has made guns for sportsmen and collectors ''from Maine to California.'' Still, his largest audience remains the hunters within the region who value his reasonable prices and willingness to repair or rebuild heirloom guns for them.

Leona and Sheila Smith
Oneida and Green Bay
Place and date of birth: Green Bay, Wisconsin;
** 1910. Green Bay, Wisconsin; 1962**
Ethnic background: Oneida
Art forms: Iroquois beadwork and dance regalia
Catalogue number: 100

Although born in Green Bay, Sheila Smith traveled throughout much of her childhood. Three years ago, when Smith returned to the Oneida Reservation in northern Wisconsin with her family, she discovered that no one there wore traditional costume. In response to this situation, Smith decided to remake her own dance outfit by decorating it with historically correct beadwork designs. Since that time, Smith and her grandmother Leona have continued to create traditional dance outfits representative of the Oneida Tribe of the Iroquois Confederacy.

Selma Spaanem
Mount Horeb
Place and date of birth: Mount Horeb, Wisconsin,
area; 1912
Ethnic background: Norwegian
Art forms: needlework, especially Hardanger
** and Battenburg lace making, tatting,**
** crocheting, and knitting**
Catalogue number: 66

Selma Spaanem, like many young girls of her generation, learned various forms of needlework as a child in the home. She cross-stitched flour sacks, learned to knit and crochet, and did some tatting with a small shuttle. Through the years, she has continued to do needlework of one type or another for her own entertainment. In addition to the kinds of work already noted, Spaanem has also tried bobbin lace making, needle lace making, and drawn-thread embroidery.

While both Selma Spaanem's mother and aunt made Hardanger lace, she did not learn this particular style of needlework directly from them. Instead, her teacher was Marie Jensen, a Mount Horeb expert. Nevertheless, Spaanem retains prized examples of her mother's and her aunt's lace and refers to it frequently. Since learning this traditional Norwegian form of needlework, Spaanem has practiced it continuously. She has also experimented with various complex decorative stitches to ''spice up'' the cutwork. She has taught knitting and crocheting at the vocational school in Mount Horeb and has served as the instructor for Hardanger lace-making classes at crafts shops in Verona and Madison.

Ray Steiner
Argyle
Place and date of birth: Argyle, Wisconsin; 1914
Ethnic background: Swiss
Art form: willow basketry
Catalogue number: 167

Ray Steiner learned to make willow baskets from his neighbor Ernest Lisser, a farmer in the area near Woodford. Lisser had made willow utility baskets in his native Switzerland, earning twenty-five cents per day for his efforts. After his wife passed away, Lisser turned to making baskets for laundry, gardening, and feeding cattle in order to earn a little extra money. Steiner offered to cut willow for Lisser and asked the older man to make a few baskets for him. However, Lisser insisted that Steiner learn basket making himself and taught him the basics of his craft.

Over the past twelve years, Steiner has made hundreds of willow baskets of his own. He picks the willow in late fall and continues his basket making into the spring. While he makes baskets primarily for his family, many local people buy his work. His daughter also sells some of his baskets for him at craft fairs and bazaars. A Swiss-American himself, Steiner regards his making of Swiss willow baskets as a means of preserving his cultural heritage. As a result, he is passing along the craft to his fourteen-year-old grandson.

Duane Stenroos
(See Eugene Stenroos)

Eugene Stenroos
Hurley
Place and date of birth: Kimball, Wisconsin;
 1917
Ethnic background: Finnish
Art form: bucksaws-in-bottles
Catalogue numbers: 9-12

Eugene Stenroos still resides on the dairy farm where he was born. In addition to farming, he worked for fifteen years in the iron mine at Montreal, Wisconsin, and for another fifteen years for Forestland Lumber Company.

Stenroos learned to make miniature bucksaws-in-bottles from an old bachelor neighbor, Steven Maki, around 1950. Maki was born in Lelimailla, Finland, in 1888 and settled in Iron County, Wisconsin, in 1906. He worked as a lumberjack, carpenter, and miner. It was in the lumber camps that he learned to place the miniaturized tools in bottles. In addition to teaching Stenroos, Maki also showed Stenroos' father-in-law, Ivar Lehto, how to make the bucksaws-in-bottles. Like Maki, Lehto was born in Finland. He came to this country in 1912, settling first in Minnesota and later in Ironwood, Michigan. He worked all his life as a farmer and logger.

Over the past thirty-five years, Stenroos has made approximately one hundred bucksaws-in-bottles. He has never sold his work, choosing instead to give it away to family and friends. The miniature bucksaws occupy places of honor in the homes of the Stenroos children and other relatives. In addition, Stenroos' son, Duane, and another son have carried on the tradition.

Alvin Stockstad
Stoughton
Place and date of birth: Stoughton, Wisconsin;
 1922
Ethnic background: Norwegian
Art form: tobacco spears and axes
Catalogue numbers: 169-173

Tobacco axes are used to cut down tobacco plants at harvest time; tobacco spears are fitted on the ends of household laths so that the stalks can be more easily strung on the wooden strips for drying. When Alvin Stockstad was a boy, his father Oscar raised tobacco in Dane County. The tobacco spears he used in the 1920s fit too tightly, so he had to refashion them. Eventually, Oscar Stockstad turned from refitting these specialized tools to making his own. These he sold to neighbors and to stores in Wisconsin's tobacco belt which runs from Vernon and Crawford Counties down into Dane County. Alvin Stockstad began to help his father as a young boy in the late 1920s and has continued to create tobacco spears and axes up to the present.

The making of tobacco axes and spears is seasonal. Stockstad begins work each year in late spring and completes his stock of wares by early July. The tools are built to last for several seasons, but Stockstad sells approximately 200 annually. These sales are a valued source of income now that Alvin is retired after thirty years as an employee of General Motors in Janesville.

Sigvart Terland
Frederic
Place and date of birth: Helleland, Stavanger
 region of Norway
Arrival in the United States: 1926
Ethnic background: Norwegian
Art forms: wooden shoes, shoehorns
Catalogue numbers: 108-111

Sigvart Terland learned to make wooden shoes from his father Peder who in turn had learned the craft from his father. Between the ages of nine and nineteen, while living on the family farm in the Stavanger region of Norway, Terland made shoes of birch for himself, his parents, grandparents, and five siblings.

Terland worked on the family farm until 1926 when he came to the United States and joined his two aunts and a sister who were living in Minneapolis. He got a job in a foundry and eventually became skilled at testing metals. In 1941, Terland moved to Washington, D.C., where he worked as a metallurgist for the navy. After 34 years, he retired and moved to Frederic, the childhood home of his wife.

Although when he was a boy Terland made shoes only during the long Norwegian winters, since his retirement he has worked at the craft on a year-round basis. Utilizing specialized tools forged by a Norwegian blacksmith in 1948, Terland has made approximately 250 pairs of shoes over the last six or seven years. He continues to make wooden shoes for himself, his wife, local Norwegian-Americans, and other acquaintances. Recently Terland has been "discovered" by the region's larger Norwegian-American community which seeks his work as keepsakes and items for gift shops.

Ulanna and Ola Tyshynsky
Shorewood
Place and date of birth: Prince George's County,
 Maryland; 1951. Milwaukee, Wisconsin; 1958
Ethnic background: Ukrainian
Art form: *pysanky* (decorated Easter eggs) and
 holiday breads
Catalogue numbers: 159-165

Ulanna Tyshynsky was born a year after her parents immigrated to the United States. The family moved to Milwaukee in 1952, and at the age of twelve an aunt taught her to decorate Easter eggs using the highly involved Ukrainian wax-resist method. By the early 1970s, Tyshynsky had become very active in the creation of *pysanky*. She has remained so for the past fifteen years, passing along the traditional art form to her younger sister, Ola.

Recognized as an excellent artist by the Milwaukee Ukrainian community, Ulanna Tyshynsky has demonstrated her work at the city's Holiday Folk Fair and in the Milwaukee Public Museum's "European Village" exhibit. Both sisters also bake the elaborately decorated Easter and Christmas breads characteristic of the Ukrainian holiday celebrations. A mortgage service specialist by occupation, Ulanna Tyshynsky is a member of the local branch of the Ukrainian National Women's League of America.

Alma Upesleja
Milwaukee
Place and date of birth: Laudona County, Latvia;
 1906
Arrival in the United States: 1949
Ethnic background: Latvian
Art forms: knitted mittens, weaving
Catalogue numbers: 5-6

Alma Upesleja was born and raised on a farm in Laudona County, central Latvia. In 1931, she married and went to live with her husband's family about 28 miles away. There Alma's daughter Anna was born in 1932. In 1944, the family fled Latvia by horse and buggy, traveling 124 miles to the Baltic Sea where they crossed into Germany. They spent five years in displaced persons camps before immigrating to the United States in 1949. The Upeslejas worked on a farm in Virginia for two years. In 1951, they moved to Milwaukee where Alma's brother-in-law was earning a better living doing factory work. While in Latvia and Virginia, Upesleja did farm work including tending dairy cows. In Milwaukee she worked in a factory, a bank, and at St. Mary's Hospital before retiring.

In Latvia during her childhood, Upesleja, like every other family member, was expected to contribute to

the group's well-being. When not yet ten years of age, she began helping her mother sew the family's clothing, pinning and basting the pieces together and doing simpler work on a sewing machine. Her mother taught her to raise and process flax and to weave it into linen cloth. She also taught her to raise sheep, process the wool into yarn, dye it, and weave or knit with it. Upesleja learned the intricacies of knitting traditional Latvian mittens from her maternal grandmother Ieva Lacis, with whom she often spent several weeks each summer.

Upesleja continues to knit Latvian mittens today, exchanging them with friends for other artwork, giving them as gifts, and selling them at church bazaars and benefits. A tireless handworker, she also weaves rugs, pillow covers, and wall hangings, crochets afghans, and sews clothing for her grandchildren. She has passed along all of her skills as a needleworker to her daughter Anna Vejins.

Adolph Vandertie
Green Bay
Place and date of birth: Lena, Oconto County, Wisconsin; 1911
Ethnic background: Belgian
Art form: woodcarving
Catalogue numbers: 15-33

When Adolph Vandertie was eight years old, his uncle Jules bought him a jackknife. Like all the other boys, Vandertie whittled slingshots, willow whistles, toys, and boats. He and his friends also cut designs into willow sticks and then peeled off the bark to make a pattern. A few years later, the Vandertie family moved from Lena to Green Bay, then a busy railhead. The town boasted three hobo jungles at that time, and Vandertie visited these frequently without his parents' knowledge. There he saw hobos carving wooden chains, balls-in-cages, and pliers from single pieces of wood. Vandertie carved his first caged ball when he was about twelve years old and continued carving during his teenage years. He set aside his whittling throughout most of his adult life, returning to it only in 1955 when, having given up smoking, he had to do something with his hands.

Over the past thirty-one years, Vandertie has carved approximately 2,400 pieces. He has never sold any of his work, though he has given away some small items. Instead, Vandertie has kept most of his woodcarvings in his home, which has now become a veritable museum. Vandertie's family members all enjoy his work, and one of his sons, David, also carves, whittles, and sketches.

Anna Vejins
Greenfield
Place and date of birth: Kraukli County, Latvia, 1932
Arrival in the United States: 1949
Ethnic background: Latvian
Art forms: knitted mittens, cutwork
Catalogue numbers: 7-8, 68

In 1944, at the age of twelve, Anna Vejins fled from Latvia with her parents, going by horse and buggy to the Baltic Sea where they crossed into Germany. Following five years spent in displaced persons camps, the family came to the United States. For several years, they worked on a farm in Virginia. When Vejins' parents moved to Milwaukee in 1951 to pursue better wages, she remained in Virginia to complete high school and work as a nurse's aide. During a visit to Milwaukee in 1955, she met the man she would marry. Later that year, she moved to Milwaukee and the couple were wed. When Vejins' second child went off to college, she returned to school to take drafting courses and took a position as a draftsperson at Harnischfeger.

For the past fourteen years, she has designed and written specifications for the company's hoists.

In Latvia, Vejins knitted at home before entering grade school. She learned to knit and embroider fancier pieces in a second-grade home economics class. During her family's confinement in displaced persons camps, she learned more handwork techniques from her mother, including fancy drawnwork. When her own children were born, Vejins sewed their clothing and knit mittens for them. Though she has had less time to sew and knit since returning to work, she has completed two Latvian costumes for herself, assisted her mother and daughter with their costumes, and improvised costumes for her two grandchildren. She also keeps her grandchildren supplied with modified Latvian mittens featuring a ribbed, tightly fitting cuff. She continues to create mittens off and on while watching television or talking on the phone. Vejins often displays her mittens at Milwaukee's Holiday Folk Fair. She and Vita Kakulis have organized the fair's Latvian exhibits for the past six years.

Carl D. Vogt
Madison
Place and date of birth: Nelson, Wisconsin; 1919
Ethnic background: German and Norwegian
Art form: miniature farm machinery
Catalogue number: 174

Carl Vogt's father was both a farmer and carpenter. As a young man, Carl frequently helped him fix used equipment for work on the farm. The skills Vogt developed during his youth on the farm served him well when he reached adulthood. He worked for Gisholt Machine Company in Madison between 1940 and 1948. Thereafter, he worked in a cabinet shop for twenty-five years before buying the business and running it himself until his retirement.

Over the last twenty-five years, Vogt has crafted miniature engines of exceptional detail and quality. He specializes in engines once used on farms to power threshing machines, pumps, cream separators, etc. These he displays and demonstrates at engine shows and thresherees throughout the summer, where his work is frequently recognized with ribbons and other awards.

Nick Vukusich
Milwaukee
Place and date of birth: Ironwood, Michigan; 1923
Ethnic background: Croatian
Art form: tamburitza making
Catalogue number: 112

Nick Vukusich grew up hearing and playing tamburitza music in the Croatian community in Ironwood, Michigan. Following graduation from high school in 1941, he moved to Milwaukee where he worked for Kearney Trecker and Unit Crane and Shovel before spending thirty-four years as a welder with General Electric's Hotpoint plant.

Vukusich learned woodworking, especially the use of planes and squares, from his grandfather while spending summers with him in Mellen, Wisconsin. Approximately twenty years ago, Vukusich applied these skills to the construction of his first tamburitza. He patterned this instrument after an old one which he disassembled to investigate the precise method of construction. Since that time, Vukusich has built tamburitzas during his spare time in a small shop in his basement. He has made approximately twenty-five instruments in all for family members and for musicians in Milwaukee's Croatian-American community. One of Vukusich's tamburitzas was recently raffled off at a Croatian music gathering in Milwaukee, an indication of the group's regard for his craftsmanship.

Florence Boyce Whitewing
(See Ethel Storm Whitewing-Weso and
 Georgianna Whitewing Funmaker)

Ethel Storm Whitewing-Weso
Georgianna Whitewing Funmaker
Wittenberg
Place and date of birth: Wittenberg, Wisconsin;
 1911. Wittenberg, Wisconsin; 1948
Ethnic background: Winnebago
Art form: black ash basketry
Catalogue numbers: 1-3

Members of the Whitewing family have long been among the finest basket makers of the Winnebago. Alice Warclub Big Thunder represents the first generation of the Whitewing family to weave traditional black ash baskets. She taught her daughter, Florence Boyce Whitewing (1893-1985),and her granddaughter, Violet Big Thunder Whitewing (born in 1920), to make baskets. The latter learned the tradition only after returning to Wisconsin from the Winnebago reservation in Nebraska where basket making was no longer practiced.

Florence Boyce Whitewing, in turn, taught her daughter, Ethel Storm Whitewing-Weso to fashion baskets, and both of them passed the tradition along to Violet's daughter, Georgianna Whitewing Funmaker. Violet Big Thunder Whitewing has also instructed her granddaughter, Shelby Visintin, in the weaving of Winnebago baskets, thus making five generations of basket weavers within the Whitewing family.

Anna Wigchers
Rice Lake
Place and date of birth: near Rice Lake,
 Wisconsin; 1918
Ethnic background: Danish
Art form: canning
Catalogue numbers: 80-89

Anna Nelsen Wigchers was born on a farm in the Rice Lake area in 1918. Her parents had emigrated from Denmark to Wisconsin and became dairy farmers. The eldest of five children, Wigchers was responsible for the garden, kitchen work, and child rearing from an early age. When she was twenty-one, she began doing housework for several well-to-do Rice Lake families. In 1945, she married and moved to Illinois where she and her husband worked for a printing shop. In 1950, they returned to Rice Lake, and she took a job with Minnesota Mining and Manufacturing in Cumberland. The couple returned to dairying in 1961 and stayed on the farm until shortly before her husband's death in 1976. Since then Wigchers has "retired" to full-time needlework, gardening, and canning. She and a neighbor also operate a small craft shop stocked with her creations.

Wigchers recalls her mother planting and cultivating a huge garden each year as well as maintaining an apple orchard. She raised beans, beets, carrots, cucumbers, tomatoes, ground-cherries, and apples and made mustard and pepper relishes, applesauce, butter, and raspberry, strawberry, gooseberry, and currant jams. Like her mother, Wigchers tends a sizable garden which includes many of the same fruits and vegetables as well as cabbage, lettuce, peas, and squash. She also grows a tremendous variety of flowers among her vegetables. While her mother put up 500-600 quarts of canned goods each year and entered many of them in local competitions, Wigchers has recently cut back her own gardening and canning efforts. She now preserves only enough food for her own use and for competition at the Barron County Fair.

Thomas Winter
Oshkosh
Place and date of birth: Stephenson, Michigan;
 1931
Ethnic background: German and Swedish
Art forms: fish and waterfowl decoys
Catalogue number: 204

Tom Winter was raised in the Upper Peninsula of Michigan, just north of the border towns of Marinette and Menominee. Many men in the area made and used decoys for spearing northern pike and for hunting ducks and geese. As a young boy, Winter began making his own fish and waterfowl decoys as well. In later years, he began to collect decoys. He also came to know many fine makers in Michigan, Wisconsin, and Minnesota, including the late Art Bergman of Van Dyne, Wisconsin. From these varying sources, Winter learned specific designs and techniques which he incorporated into his own carving. While his earliest fish and bird carvings were rather rough, functional artifacts, his more recent efforts — especially his duck, goose, and loon decoys — are sought after by collectors for decorative display.

Although Winter's sturgeon decoys are as well crafted as his bird carvings, their "ugly" appearance restricts their use to the ice-fishing shanty. They are essentially larger versions of the "coaxers" or "teasers" long made around Lake Winnebago.

Anton Wolfe
Stevens Point
Place and date of birth: Moquah, Bayfield
 County, Wisconsin; 1922
Ethnic background: Czechoslovakian
Art form: concertina making
Catalogue number: 115

Anton Wolfe began tinkering with concertinas in the early 1940s when his own instrument broke and replacement parts from Germany were not available due to the war. Slowly but surely over the next twenty-five years, he began to construct his own instruments. In 1967, shortly after his mother's death, Wolfe gave up farming in Bayfield County and moved to Stevens Point. He purchased equipment and parts from Rudy Patek, who had made concertinas in Chicago, and began making the instruments part time. In 1980, Wolfe began to devote all of his time to making concertinas. He now operates a shop which occupies a former grocery store.

Wolfe makes all of the parts of his concertinas except for engraving the outer boxes. He produces instruments in a variety of standard keys but generally avoids custom work because it is too time consuming. Wolfe works on the production of individual concertina parts for much of the year. When he has built up an adequate stock, he works steadily to assemble the instruments. Because the sound of Wolfe's instruments follows the old German standard rather than approximating that of a piano accordion, his concertinas are sought after by German-American or "Dutchman" style polka bands.

Shoua Chang Yang
Song Yang
Sheboygan
Place and date of birth: Laos; 1959. Laos; 1933
Arrival in the United States: 1978; 1980
Ethnic background: White Hmong
Art forms: traditional costumes and needlework
Catalogue number: 104

Shoua Chang Yang began learning the needlework traditions of the White Hmong at the age of nine or ten. Her mother, Song Yang, as well as cousins and friends served as her teachers. As she became more expert in the techniques of appliqué and reverse appliqué, she made belts and collars for her own costumes and those

of her family. Working primarily in the evenings after returning from the fields, she and her mother created traditional costumes for the New Year celebration and other ceremonies.

When the war in Southeast Asia disrupted the lives of the highland Hmong people, Shoua Chang Yang and Song Yang fled to refugee camps in Thailand, where Shoua Chang Yang spent approximately three years between 1975 and 1978. While in the camps, she created *paj ntaub* for sale to American buyers. Since her arrival in the United States, she has continued to create traditional White Hmong costumes for herself and her family. She is assisted by Song Yang who sews larger pieces including shirts and skirts.

Martha Yoder
Amherst
Place and date of birth: Haven, Kansas; 1935
Ethnic background: Amish
Art form: quilting
Catalogue number: 59

Martha Yoder was born in Haven, Kansas. She was raised in an Amish settlement in Indiana where she learned quilting from her mother. Over the past fifteen years, while living in Amish communities in Iowa, Minnesota, and Wisconsin, Yoder has been an active quilter. She creates quilts for her family, for the Amish community's auctions to benefit its schools and relief society, and for "English" people who place orders. Examples of her work were featured in the exhibition *"Amish Quilts from Central Wisconsin"* in 1986 at the Priebe Gallery of the University of Wisconsin-Oshkosh.

SELECT BIBLIOGRAPHY

FOLK ART: GENERAL REFERENCES

Ames, Kenneth L. *Beyond Necessity: Art in the Folk Tradition.* Winterthur, Delaware: Henry Francis du Pont Winterthur Museum, 1977.

Bronner, Simon J. *American Folk Art: A Guide to Sources.* New York: Garland Publishing, Inc., 1984.

Camp, Charles. *Traditional Craftsmanship in America.* Washington, D.C.: National Council for the Traditional Arts, 1983.

Dewhurst, C. Kurt, Betty MacDowell, and Marsha MacDowell. *Religious Folk Art in America: Reflections of Faith.* New York: E. P. Dutton, 1983.

Dorson, Richard M., ed. *Folklore and Folklife: An Introduction.* Chicago: University of Chicago Press, 1972.

Glassie, Henry. *Pattern in the Material Folk Culture of the Eastern United States.* Philadelphia: University of Pennsylvania Press, 1968.

Grobman, Neil R. *Wycinanki and Pysanky: Forms of Religious and Ethnic Folk Art from the Delaware Valley.* Pittsburgh: Pennsylvania Ethnic Heritage Studies Center, Occasional Paper No. 1, 1981.

Jones, Michael Owen. *The Hand Made Object and Its Maker.* Berkeley: University of California Press, 1975.

Newall, Venetia. *An Egg at Easter: A Folklore Study.* Bloomington: Indiana University Press, 1971.

Quimby, Ian M. G., and Scott Swank, eds. *Perspectives on American Folk Art.* New York: W. W. Norton, 1980.

Teske, Robert T. "What Is Folk Art? An Opinion on the Controversy." *El Palacio: Magazine of the Museum of New Mexico* 88 (Winter 1983): 34-38.

Upitis, Lizbeth. *Latvian Mittens: Traditional Designs and Techniques.* St. Paul: Dos Tejedoras, 1981.

Vlach, John Michael. "American Folk Art: Questions and Quandaries." *Winterthur Portfolio* 15 (1980): 345-55.

_____. *The Afro-American Tradition in the Decorative Arts.* Cleveland: Cleveland Museum of Art, 1978.

Vlach, John Michael, and Simon J. Bronner, eds. *Folk Art and Art Worlds.* Ann Arbor: UMI Research Press, 1986.

WISCONSIN FOLK ART AND MATERIAL CULTURE

Alexander, Martha. "Norwegian Nineteenth Century Heritage in Stoughton." *Wisconsin Academy Review* 30:2 (March 1984): 31-34.

Armour, David A. "Beads in the Upper Great Lakes: A Study in Acculturation." In *Beads: Their Use by Upper Great Lakes Indians — An Exhibition.* Grand Rapids: Grand Rapids Public Museum, 1977.

Barden, Thomas. "Putting Flesh on the Bones of the Past: Halsey Rinehart, Artist and Storyteller." *Wisconsin Academy Review* 30:2 (March 1984): 59-63.

Garte, Edna. *Circle of Life: Cultural Continuity in Ojibwa Crafts.* Duluth: St. Louis County Historical Society, Chisholm Museum, and Duluth Art Institute, 1984.

Henning, Darrell D., Marion J. Nelson, and Roger L. Welsch. *Norwegian-American Woodcarving of the Upper Midwest.* Decorah, Iowa: Vesterheim/The Norwegian-American Museum, 1978.

Hmong Art: Tradition and Change. Sheboygan: John Michael Kohler Arts Center, 1986.

Leech, Leslie, Stephen Polyak, and Robert Ritzenthaler. "Woodland Indian Beadwork." In *The Art of the Great Lakes Indians.* Flint, Michigan: Flint Institute of the Arts, 1973.

Leeds-Hurwitz, Wendy. "Folk Toys in the Milwaukee Public Museum." *Wisconsin Academy Review* 30:2 (March 1984): 19-22.

Lyford, Carrie. *Ojibwa Crafts.* Stevens Point, Wisconsin: R. Schneider Publisher, 1982.

March, Richard. "Wisconsin Arts Board Encourages Folk Arts." *Wisconsin Academy Review* 32:2 (March 1986): 31-34.

Nelson, Marion J. "The Material Culture and Folk Arts of the Norwegians in America." In Ian M. G. Quimby and Scott Swank, eds. *Perspectives on American Folk Art.* New York: W. W. Norton, 1980.

Ritzenthaler, Robert E. "The Building of the Chippewa Indian Birch-Bark Canoe." *Milwaukee Public Museum Bulletin* 19:2 (November, 1950).

Teske, Robert T. "Wisconsin Folk Art: Values Made Visible." *Wisconsin Academy Review* 32:2 (March, 1986): 34-39.

Tishler, William. "Built from Tradition: Wisconsin's Rural, Ethnic, Folk Heritage." *Wisconsin Academy Review* 30:2 (March, 1984): 14-19.

Whyte, Bertha Kitchell. *Craftsmen of Wisconsin.* Racine: Western Publishing Company, 1971.

COMPARATIVE SOURCES FROM OTHER STATES:

Beck, Jane C., ed. *Always in Season: Folk Art and Traditional Culture in Vermont.* Montpelier: Vermont Council on the Arts, 1982.

Cannon, Hal, ed. *Utah Folk Art: A Catalogue of Material Culture.* Provo, Utah: Brigham Young University Press, 1980.

Dewhurst, C. Kurt, and Marsha MacDowell, "The Folk Arts of Illinois." *Chicago History* 10 (Winter 1981-1982): 198-204.

_____. *Rainbows in the Sky: The Folk Art of Michigan in the Twentieth Century.* East Lansing: Michigan State University, 1978.

_____. *Michigan Folk Art: Its Beginnings to 1941.* East Lansing: Michigan State University, 1976.

Hand to Hand, Heart to Heart: Folk Arts in Rhode Island. Providence: Rhode Island Heritage Commission, n.d.

Jones, Suzi, ed. *Webfoots and Bunchgrassers: Folk Art of the Oregon Country.* Eugene: Oregon Arts Commission, 1980.

Made by Hand: Mississippi Folk Art. Jackson: Mississippi Department of Archives and History, 1980.

Ohrn, Steven. *Passing Time and Traditions.* Des Moines: Iowa Arts Council, 1982.

Siporin, Steve. *Folk Art of Idaho.* Boise: Idaho Commission on the Arts, 1984.

Wadsworth, Anna. *Missing Pieces: Georgia Folk Art, 1770-1976.* Atlanta: Georgia Council for the Arts and Humanities, 1976.

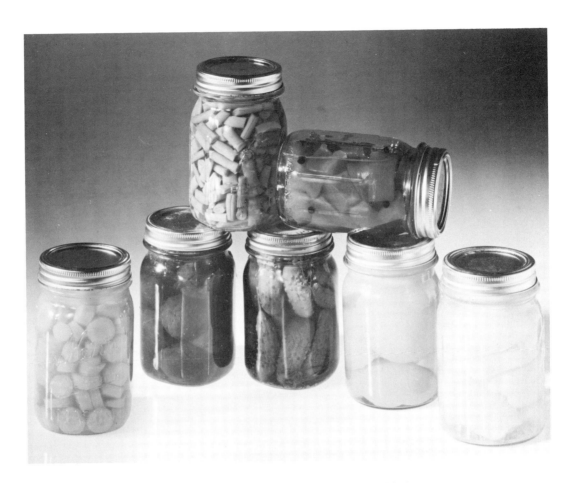

80-89 Anna Wigchers, CANNED FRUITS AND VEGETABLES, 5 x 3 x 3" (each jar)

Typeset by OEC Graphics, Oshkosh, Wisconsin
 Typestyles: ITC Garamond, Belwe

Plates by Wisconsin Graphic Plate Corporation, Sheboygan, Wisconsin

Printed by Universal Lithographers, Inc., Sheboygan, Wisconsin

 80# Centura Dull Text
 100# Centura Dull Cover

Photo Credits:

Bayens Photo Company (cover: Hardanger lace; cat. nos. 9-12, 15-33, 34, 62, 64, 67, 80-89, 93, 102, 105-106, 107, 108-111, 113, 114, 117, 118, 119, 122-129, 167, 174, 192-200, 201, 202-203, 245, 250-255, 256, 257, 258, 260, 268-271)

Jon Bolton (cover: motorcycle; cat. nos. 1-2, 13, 14, 61, 63, 115, 135, 166, 190, 191, 248-249, 266, 267)

Eric Dean (cat. nos. 5-7, 205-243)

P. Richard Eels (White Hmong costume detail)

Janet C. Gilmore (field photographs of Clifford Bell, marker buoys)

Eric R. Johnson (cat. nos. 38-57)

James P. Leary (frontispiece, field photographs of Joseph Buresh, Sr. Mary Crucifix, Gerald Hawpetoss, Sidonka Lee, Julian Orlandini, C. C. Richelieu)

Milwaukee Public Museum (field photograph of Allie Crumble)